LYNDA CARTER · DEBBIE ALLEN · PATRICIA SCHROEDER · DOMINIQUE DAWES · JO CAROLE LAUDER · PHYLLIS GREENBERGER · WENDY RIEGER · SARAH BRADY · DIANE REHM · DOR

CONNIE MORELLA · COKIE ROBERTS · BARBARA MIKULSKI · BERNADINE HEALY · DINA MERRILL · HELEN THOMAS · LANEY OXMAN · GAIL BE

OR MERRILL · CHARLENE DREW JARVIS · ALMA GILDENHORN · NANCY CHISTOLINI · SALLY QUINN · CLAIRE DRATCH · IDA RUBEN · CAROL SCHWA SOLE

PATRICIA SCHROEDER · DOMINIQUE DAWES · JO CAROLE LAUDER · PHYLLIS GREENBERGER · WENDY RIEGER · SARAH BRADY · DIANE REHM · DOROTHY HEIGHT · KITTY KELLEY · S

ERTS · BARBARA MIKULSKI · BERNADINE HEALY · DINA MERRILL · HELEN THOMAS · LANEY OXMAN · GAIL BERENDZEN · ELEANOR CLIFT · NESSE GODIN · DEBBIE DINGELL · MARIE JO

VIS · ALMA GILDENHORN · NANCY CHISTOLINI · SALLY QUINN · CLAIRE DRATCH · IDA RUBEN · CAROL SCHWARTZ · ALMA JOHNSON POWELL · SOLEDAD O'BRIEN · MADELEINE ALBRIGH

DAWES · JO CAROLE LAUDER · PHYLLIS GREENBERGER · WENDY RIEGER · SARAH BRADY · DIANE REHM · DOROTHY HEIGHT · KITTY KELLEY · SALLY SMITH · CATHERINE REYNOLDS · J

NE HEALY · DINA MERRILL · HELEN THOMAS · LANEY OXMAN · GAIL BERENDZEN · ELEANOR CLIFT · NESSE GODIN · DEBBIE DINGELL · MARIE JOHNS · JOY ZINOMAN · CHARITO KRUV

CHISTOLINI · SALLY QUINN · CLAIRE DRATCH · IDA RUBEN · CAROL SCHWARTZ · ALMA JOHNSON POWELL · SOLEDAD O'BRIEN · MADELEINE ALBRIGHT · ELLEN SIGAL · CATHY HUGHE

PHYLLIS GREENBERGER · WENDY RIEGER · SARAH BRADY · DIANE REHM · DOROTHY HEIGHT · KITTY KELLEY · SALLY SMITH · CATHERINE REYNOLDS · JOAN RIVERS · LETITIA BALDRIDG

EN THOMAS · LANEY OXMAN · GAIL BERENDZEN · ELEANOR CLIFT · NESSE GODIN · DEBBIE DINGELL · MARIE JOHNS · JOY ZINOMAN · CHARITO KRUVANT · WILHELMINA COLE HOLLA

RE DRATCH · IDA RUBEN · CAROL SCHWARTZ ALMA JOHNSON POWELL · SOLEDAD O'BRIEN · MADELEINE ALBRIGHT · ELLEN SIGAL · CATHY HUGHES · DENYCE GRAVES · ABBE LANE · JA

R · SARAH BRADY · DIANE REHM · DOROTHY HEIGHT · KITTY KELLEY · SALLY SMITH · CATHERINE REYNOLDS · JOAN RIVERS · LETITIA BALDRIDGE · JUDY WOODRUFF · PHYLLIS RICHM

L BERENDZEN · ELEANOR CLIFT · NESSE GODIN · DEBBIE DINGELL · MARIE JOHNS · JOY ZINOMAN · CHARITO KRUVANT · WILHELMINA COLE HOLLADAY · LESLIE MILK · MAXINE ISAAC

CHWARTZ · · ALMA JOHNSON POWELL · SOLEDAD O'BRIEN · MADELEINE ALBRIGHT · ELLEN SIGAL · CATHY HUGHES · DENYCE GRAVES · ABBE LANE · JACKIE BONG-WRIGHT · LYNDA JO

HM · DOROTHY HEIGHT · KITTY KELLEY · SALLY SMITH · CATHERINE REYNOLDS · JOAN RIVERS · LETITIA BALDRIDGE · JUDY WOODRUFF · PHYLLIS RICHMAN · SUZANNE FARRELL · N

· NESSE GODIN · DEBBIE DINGELL · MARIE JOHNS · JOY ZINOMAN · CHARITO KRUVANT · WILHELMINA COLE HOLLADAY · LESLIE MILK · MAXINE ISAACS · BARBARA HARRISON · JUD

N POWELL · SOLEDAD O'BRIEN · MADELEINE ALBRIGHT · ELLEN SIGAL · CATHY HUGHES · DENYCE GRAVES · ABBE LANE · JACKIE BONG-WRIGHT · LYNDA JOHNSON ROBB · ANN CURR

ITTY KELLEY · SALLY SMITH · CATHERINE REYNOLDS · JOAN RIVERS · LETITIA BALDRIDGE · JUDY WOODRUFF · PHYLLIS RICHMAN · SUZANNE FARRELL · NORA POUILLON · BETTY FRIEDA

ELL · MARIE JOHNS · JOY ZINOMAN · CHARITO KRUVANT · WILHELMINA COLE HOLLADAY · LESLIE MILK · MAXINE ISAACS · BARBARA HARRISON · JUDITH VIORST · ANN HAND · ELEAN

MADELEINE ALBRIGHT · ELLEN SIGAL · CATHY HUGHES · DENYCE GRAVES · ABBE LANE · JACKIE BONG-WRIGHT · LYNDA JOHNSON ROBB · ANN CURRY · LYNDA CARTER · DEBBIE ALLE

ERINE REYNOLDS · JOAN RIVERS · LETITIA BALDRIDGE · JUDY WOODRUFF · PHYLLIS RICHMAN · SUZANNE FARRELL · NORA POUILLON · BETTY FRIEDAN · CONNIE MORELLA · COKIE ROBE

N · CHARITO KRUVANT · WILHELMINA COLE HOLLADAY · LESLIE MILK · MAXINE ISAACS · BARBARA HARRISON · JUDITH VIORST · ANN HAND · ELEANOR MERRILL · CHARLENE DREW JA

· CATHY HUGHES · DENYCE GRAVES · ABBE LANE · JACKIE BONG-WRIGHT · LYNDA JOHNSON ROBB · ANN CURRY · LYNDA CARTER · DEBBIE ALLEN · PATRICIA SCHROEDER · DOMINIQ

· LETITIA BALDRIDGE · JUDY WOODRUFF · PHYLLIS RICHMAN · SUZANNE FARRELL · NORA POUILLON · BETTY FRIEDAN · CONNIE MORELLA · COKIE ROBERTS · BARBARA MIKULSKI · BER

LMINA COLE HOLLADAY · LESLIE MILK · MAXINE ISAACS · BARBARA HARRISON · JUDITH VIORST · ANN HAND · ELEANOR MERRILL · CHARLENE DREW JARVIS · ALMA GILDENHORN · NA

AVES · ABBE LANE · JACKIE BONG-WRIGHT · LYNDA JOHNSON ROBB · ANN CURRY · LYNDA CARTER · DEBBIE ALLEN · PATRICIA SCHROEDER · DOMINIQUE DAWES · JO CAROLE LAUDE

ODRUFF · PHYLLIS RICHMAN · SUZANNE FARRELL · NORA POUILLON · BETTY FRIEDAN · CONNIE MORELLA · COKIE ROBERTS · BARBARA MIKULSKI · BERNADINE HEALY · DINA MERRIL

E MILK · MAXINE ISAACS · BARBARA HARRISON · JUDITH VIORST · ANN HAND · ELEANOR MERRILL · CHARLENE DREW JARVIS · ALMA GILDENHORN · NANCY CHISTOLINI · SALLY QUIN

NG-WRIGHT · LYNDA JOHNSON ROBB · ANN CURRY · LYNDA CARTER · DEBBIE ALLEN · PATRICIA SCHROEDER · DOMINIQUE DAWES · JO CAROLE LAUDER · PHYLLIS GREENBERGER · WEN

ZANNE FARRELL · NORA POUILLON · BETTY FRIEDAN · CONNIE MORELLA · COKIE ROBERTS · BARBARA MIKULSKI · BERNADINE HEALY · DINA MERRILL · HELEN THOMAS · LANEY OXMA

HARRISON · JUDITH VIORST · ANN HAND · ELEANOR MERRILL · CHARLENE DREW JARVIS · ALMA GILDENHORN · NANCY CHISTOLINI · SALLY QUINN · CLAIRE DRATCH · IDA RUBEN · CA

ANN CURRY · LYNDA CARTER · DEBBIE ALLEN · PATRICIA SCHROEDER · DOMINIQUE DAWES · JO CAROLE LAUDER · PHYLLIS GREENBERGER · WENDY RIEGER · SARAH BRADY · DIANE RE

TTY FRIEDAN · CONNIE MORELLA · COKIE ROBERTS · BARBARA MIKULSKI · BERNADINE HEALY · DINA MERRILL · HELEN THOMAS · LANEY OXMAN · GAIL BERENDZEN · ELEANOR CLIF

HAND · ELEANOR MERRILL · CHARLENE DREW JARVIS · ALMA GILDENHORN · NANCY CHISTOLINI · SALLY QUINN · CLAIRE DRATCH · IDA RUBEN · CAROL SCHWARTZ · ALMA JOHNSON PC

DEBBIE ALLEN · PATRICIA SCHROEDER · DOMINIQUE DAWES · JO CAROLE LAUDER · PHYLLIS GREENBERGER · WENDY RIEGER · SARAH BRADY · DIANE REHM · DOROTHY HEIGHT · KI

ELLA · COKIE ROBERTS · BARBARA MIKULSKI · BERNADINE HEALY · DINA MERRILL · HELEN THOMAS · LANEY OXMAN · GAIL BERENDZEN · ELEANOR CLIFT · NESSE GODIN · DEBBIE D

· CHARLENE DREW JARVIS · ALMA GILDENHORN · NANCY CHISTOLINI · SALLY QUINN · CLAIRE DRATCH · IDA RUBEN · CAROL SCHWARTZ · ALMA JOHNSON POWELL · SOLEDAD O'BRIEN

SCHROEDER · DOMINIQUE DAWES · JO CAROLE LAUDER · PHYLLIS GREENBERGER · WENDY RIEGER · SARAH BRADY · DIANE REHM · DOROTHY HEIGHT · KITTY KELLEY · SALLY SMITH

BARBARA MIKULSKI · BERNADINE HEALY · DINA MERRILL · HELEN THOMAS · LANEY OXMAN · GAIL BERENDZEN · ELEANOR CLIFT · NESSE GODIN · DEBBIE DINGELL · MARIE JOHNS

LMA GILDENHORN · NANCY CHISTOLINI · SALLY QUINN · CLAIRE DRATCH · IDA RUBEN · CAROL SCHWARTZ · ALMA JOHNSON POWELL · SOLEDAD O'BRIEN · MADELEINE ALBRIGHT

Extraordinary Women

FANTASIES REVEALED

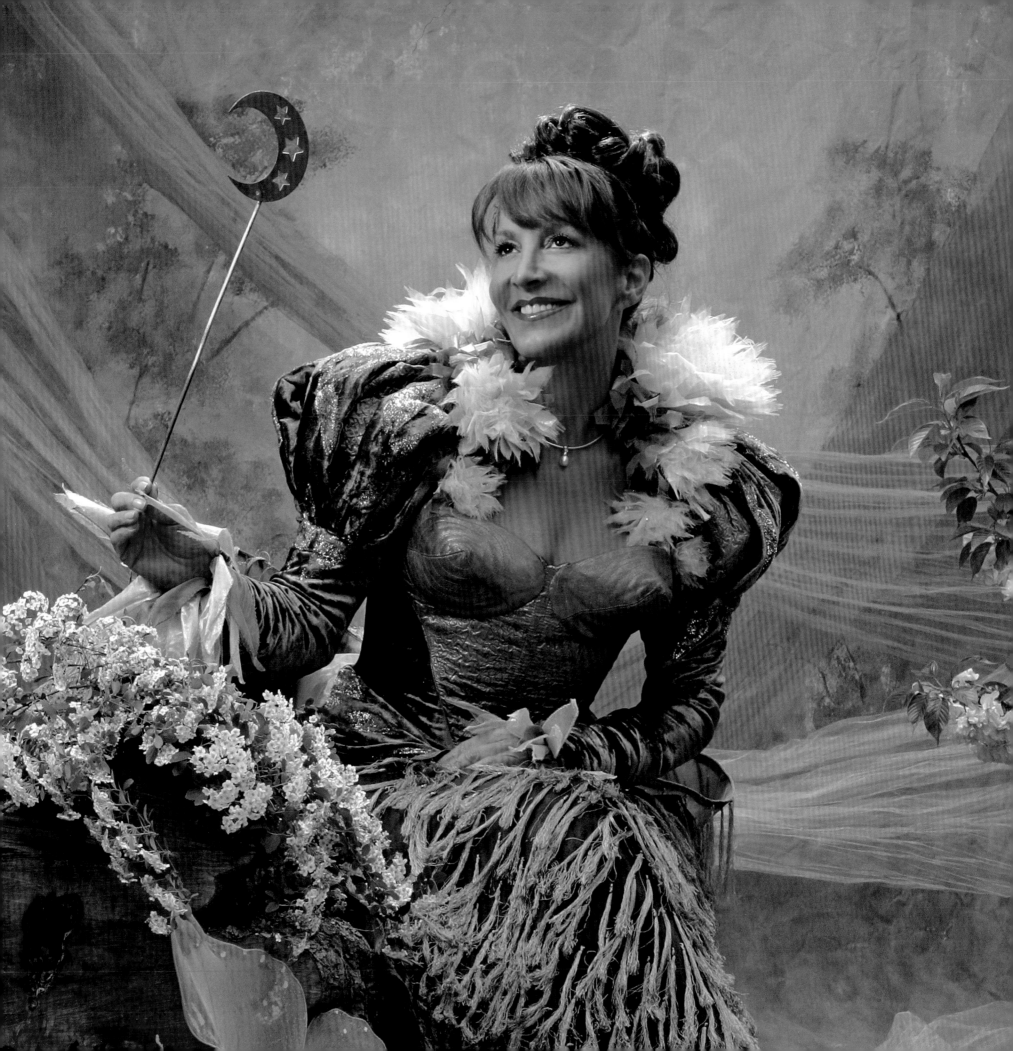

ExtraordinaryWomen

FANTASIES REVEALED

Produced by
Ilene Leventhal and Francine Levinson

Photographs by Clay Blackmore

Text by George Nicholas

STEWART, TABORI & CHANG

New York

Editor: Marisa Bulzone
Designer: Antonio Alcalá and Helen McNiell, Studio A, Alexandria, VA
Production Manager: Jane Searle

Library of Congress Cataloging-in-Publication Data

Nicholas, George.
 Extraordinary women : fantasies revealed / produced by Ilene Leventhal and Francine Levinson ; photographs
by Clay Blackmore ; text by George Nicholas.
 p. cm.
ISBN 1-58479-476-3
 1. Women--Biography--Miscellanea. 2. Women in public life--Biography--Miscellanea. 3. Women--Portraits.
4. Women in public life--Portraits. 5. Women--Psychology--Miscellanea. 6. Fantasy. I. Leventhal, Ilene. II.
Levinson, Francine. III. Blackmore, Clay. IV. Title.

HQ1123.N53 2006
305.42092--dc22

 2005027883

Published in 2006 by
Stewart, Tabori & Chang
An imprint of
Harry N. Abrams, Inc.

The text of this book was composed in Garamond.

Printed and bound in China
10 9 8 7 6 5 4 3 2 1

HNA
harry n. abrams, inc.
a subsidiary of La Martinière Groupe

Harry N. Abrams, Inc.
115 West 18th Street
New York, NY 10011
www.hnabooks.com

We dedicate this book to our families.

To our children, who grew up together:
Lisa and Scott Friedlander
Suzanne and David Greenleigh
Brian and Bonnie Leventhal
Shawn Leventhal
Monica Levinson
Stephanie and Howard Mantelmacher

To our precious grandchildren:
Cole Samuel Friedlander
Jaclyn Rose Friedlander
Lily Bae Greenleigh

With all our love,
Ilene and Francine

Contents

Acknowledgments

This book required the talents and cooperation of literally scores of people. Credits can be found in the back of the book, but we must single out a few people whose contributions were always beyond even our demanding expectations.

First, Clay Blackmore, who took the wonderful pictures in this book and believed enough in the idea to jump headfirst into this vortex of powerful personalities and never-enough time. Through it all, he proved himself the consummate professional and inspired artist we knew him to be.

Janice Standish requires special thanks, because by doing what she does so well her efforts go totally unseen. Her exquisite digital retouching is present in every image of this collection. She has not changed a single person in these photographs; she has only helped to idealize each of their dreams for their and your viewing pleasure.

Jack Reznicki Photography quickly stepped in to help when Clay had a scheduling conflict; together their collaboration resulted in our wonderful cover.

Norm Leventhal handled all the nuts-and-bolts legal aspects and at the same time was an all-purpose advisor who strongly believed in this project from its inception.

Mel Levinson lent his accounting skills and his constant support.

Marcella (yes, she is single-name person, but that is not the only way she is singular) worked magic as stylist (hair and makeup) on the lion's share of these shots. We cannot thank her enough.

Annalisa Rosmarin, always there when needed, was a tremendous help as a photo stylist.

George Nicholas gave us a voice, while letting the women featured retain theirs. Many of our subjects are writers, and naturally have strong opinions on the text. He passed muster.

Antonio Alcalá took all of the above and added design and direction, making it into the cohesive volume you are reading now.

Marisa Bulzone, our incredibly supportive editor at Stewart, Tabori and Chang, gave us the energy we needed for the homestretch.

Finally, we must once again and most emphatically thank all of the subjects of this book, and their wonderful, hard-working assistants.

Introduction

"This all started as a phone call between two girlfriends."

They sit before me, nearly swallowed up in the giant bamboo rockers that have migrated over fifty years from outdoor porch furniture to my office, and talk at once. Ilene and Francine. Francine and Ilene. They couldn't be more different, and yet are so alike. So alike that I'm not going to tell you which one I'm quoting. Suffice it to say that one has a reputation for brevity and directness, the other for loquaciousness—and directness. One believes things happen because she goes out and gets them done, the other that things happen for a reason—that reason being her getting things done. Or as they say—"Two paths to the same end."

"Once we say we're going to do something, that's it—we do it." And just what did they do? They convinced fifty-eight women to give them, as the initial letter stated, "a little of your time (less than half a day), some of your imagination and your permission to be photographed." It's a wide-open premise: tell us what more you'd like to do or be, in this universe or an alternate one, and make it something you'd be willing to act out before a camera. It's no wonder that Ilene and Francine were constantly surprised—and challenged—for the eighteen months they spent putting this book together. Surprised by the range of interests of their subjects and challenged to find a way to show it, as they shot everywhere from the Library of Congress to the Barnum & Bailey Circus.

Still, first and foremost, this book is a vehicle to raise money for two charitable organizations—the newly merged Metropolitan Police Boys and Girls Clubs of Greater Washington, DC/the Boys and Girls Club of Greater Washington and the Hand To Hand Eviction Prevention Program administered by the Community Ministries of Montgomery County. But the vehicle has become instructive, too, and—we all hope—inspirational. "We thought it would be fun to discover the fantasies of accomplished women, and interesting enough that we could use it to raise money. But it's gone from simply being fun to having a real point. Our hope is that in learning about these women, others will feel inspired to have the drive and inner strength to believe in themselves, too."

Many, many firsts are recorded in these pages, as in "the first woman to…" Too many, as it's hard to believe that in 2005 we could still be talking to so many "first" women. Does my fourteen-year-old daughter understand what a sea change took place just before her birth, how still incomplete it is, and how hard-won it really was? I hope this book will help her to understand.

Before that "phone call between girlfriends" Francine and Ilene had worked together, but never as full-time partners. With their separate and long histories of helping others, I imagined them sizing each other up in a sort of *High Noon* philanthropic shoot-out. But you see, that's a guy's point of view. They each saw someone they wanted to work with out of respect for what the other had already accomplished. Then came partnership. No shoot-outs. Even after all the work involved in putting this together, no shoot-outs. Not even a challenge. In my office, they step on each other's words to describe the other's strength. One has more connections to reach people. The other is a little more dogged in getting the subjects to participate. The reason each rushes to praise the other is that they have complete trust between them. "We never doubt the other person will follow through."

What began as a leap of faith became fact, as borne out by their making this book a full-time job. In most cases, both were at the photo shoots. They found every location, got all the permits, worked round the clock. (I have the 4:00 A.M. e-mails to prove it.) Their enthusiasm must have been infectious, because the subjects all gave of their time graciously, warmly answered all kinds of questions and worked just as hard to help us create as good a product as we could.

I'm going to go out on a limb to say that you couldn't have done this same book about men. I don't see the openness, the willingness to name a fantasy, the nerve to be photographed playing it out. That vulnerability represents a type of strength that I think is uniquely female.

Finally, while this is a book about the achievements of women, it is not a women's book. Many a man can read and learn. I hope they will. I know I did.

George Nicholas

Portraits

Alma Johnson Powell · *Supernumerary*

Her fantasy: to be a supernumerary in the opera—on stage, in the public eye, but with no lines to speak.

This from a woman who, before being thrust onto the biggest stage of all, did graduate work in speech pathology and audiology at Emerson College in Boston and upon graduation worked as the staff audiologist for the Boston Guild of the Hard of Hearing. Her favorite quote comes from the Bible: "Hold fast to that which is good." She married Colin Powell in 1962 and raised her family in many, many places in the United States and around the globe. While spending long periods of life overseas and on military bases stateside, she served as president of the Armed Forces Hostess Association, the army liaison to the National Red Cross, and advisor to the Red Cross of the Military District of Washington.

As a child she lived in books and the world of stories and imagined herself a great actress. Yet she carved out a real role for herself that can hold its own against the drama, and melodrama, of any opera: chair of the board of America's Promise—The Alliance for Youth; vice chair, Board of Trustees, the John F. Kennedy Center for the Performing Arts; and past advisory board member, the Hospitality and Information Service. She then wrote two children's books of her own: *My Little Wagon* and *America's Promise*.

Is her fantasy a respite from her public life, or an odd echo of the way she has moved through the world, quietly supporting others while accomplishing so much?

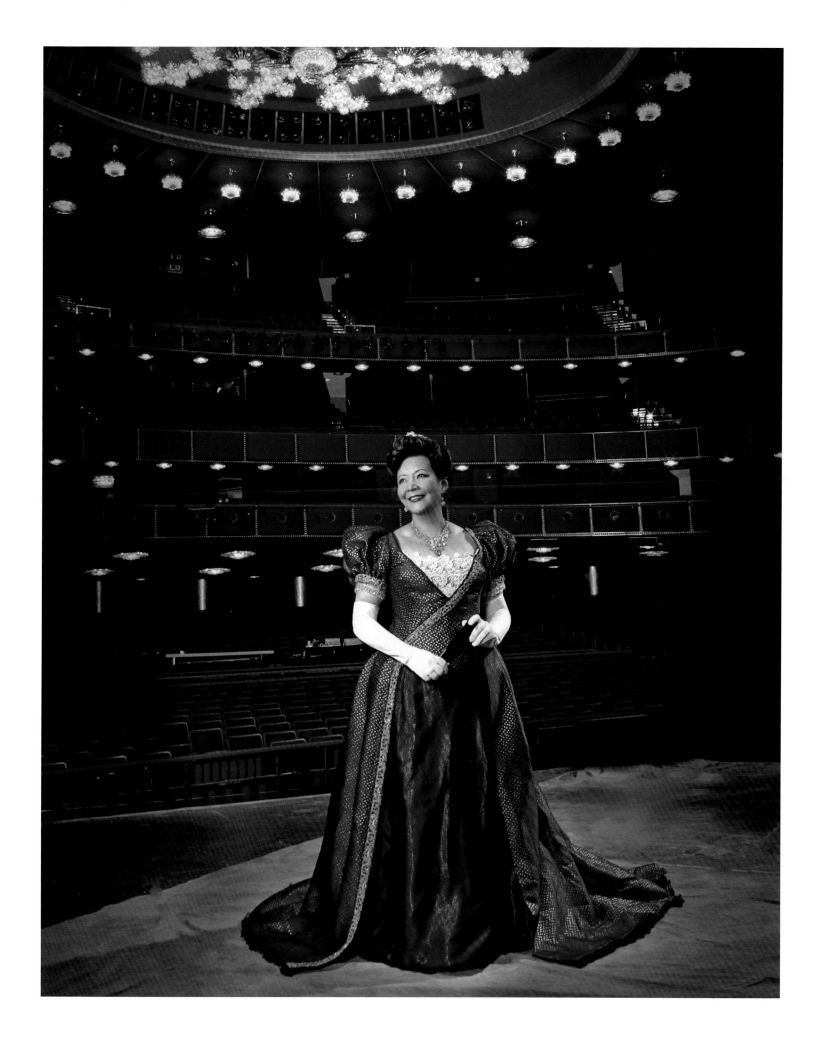

Soledad O'Brien · *Eight hours of sleep*

Soledad O'Brien anchors CNN's flagship morning program *American Morning with Soledad O'Brien and Miles O'Brien.* Prior to that, she was the anchor for NBC News' *Weekend Today.* Add her previous early morning MSNBC stint, and that's eight years of not sleeping in—and counting.

"Strangely enough, one of the nice things about my job is the hours. After I pick the girls up, we all play in the park, go home for dinner around five thirty, watch a video or read books until bedtime. During all that, I'm on conference calls for the show. Sometimes I'm doing research over the phone. I warn people—there will be a *lot* of background noise. So far, no one has minded."

And while her shows have been based in New York, she has covered breaking stories all over the world. "I've reported live from Moscow and Paris and Thailand and Cuba, and covered breaking news in every state. It's a busy life, but I love it."

Before *Weekend Today*, O'Brien anchored MSNBC's award-winning technology program *The Site* as well as the cable network's weekend morning show. For someone so young, she seems to have been a newscaster forever. But she did have a previous life, including a childhood with a big family (five brothers and sisters) and lots of animals in the Long Island suburbs. "My dad used to take me to Belmont to see the horses race and I loved it. As a young girl I dreamed I'd become a hot walker at a race track. I figured that was a good way of working around horses if I couldn't be a jockey."

When this photo was taken her children were four and a half and three years old, the twins nine months. Just writing that makes me tired, but Soledad has a very different take on it: "The boys are just learning to sit up, and falling over makes them belly laugh with glee. They're the perfect balance to a busy and stressful career, because at this stage they make *me* laugh all the time."

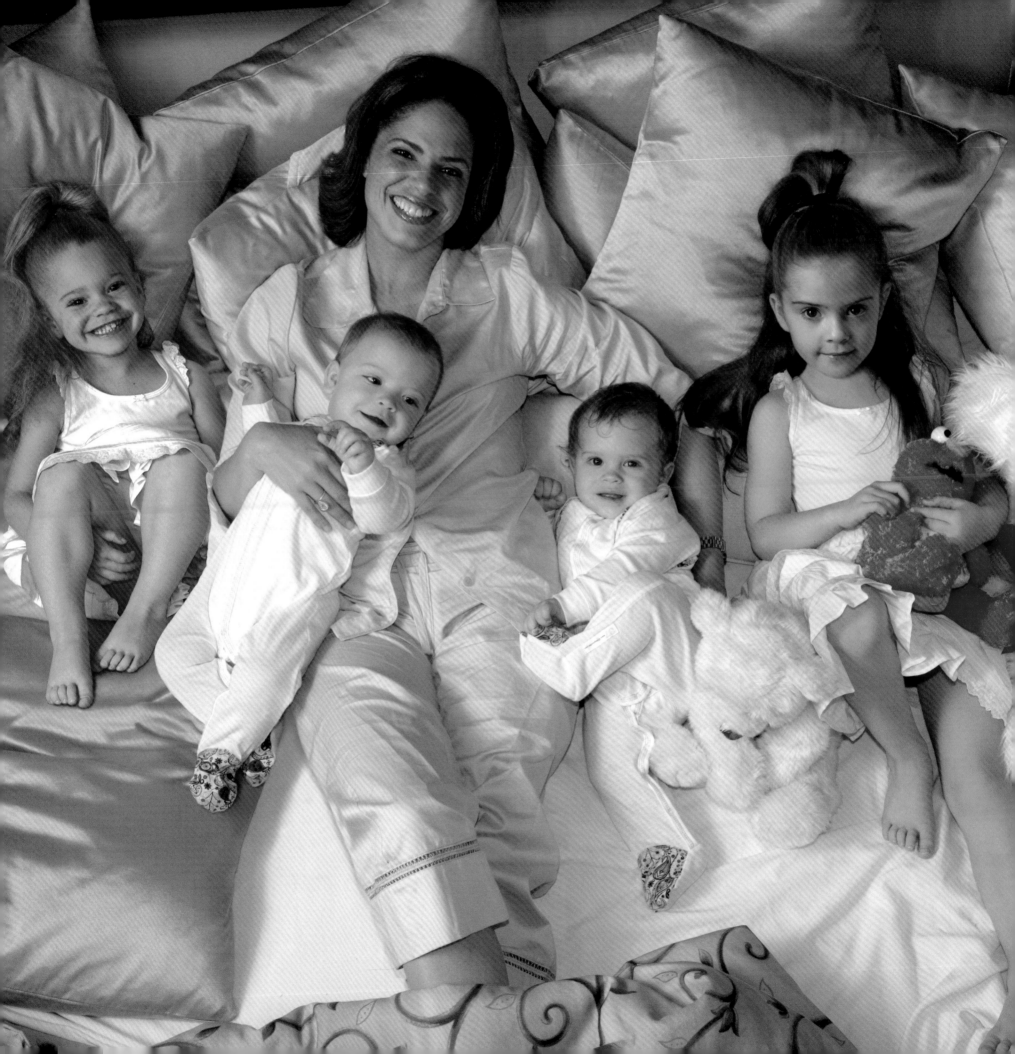

Madeleine Albright · *Worldwide Democracy*

*Many people dream of great
and grave responsibilities as they
play chess. After all, the names
of the pieces in this game of
long-term strategy speak of
power and history—king,
queen, knight, bishop, castle.
But Madeleine Albright knows
firsthand the awesome responsi-
bilities of leading nations—no
woman has held higher office in
the United States government.*

In 1997, the honorable Dr. Madeleine Albright became the first woman secretary of state. On her watch, NATO expanded, peace took hold in the Balkans, democracy spread worldwide, and our relationship with China deepened on several fronts. Previously, from 1993 to 1997, she was the U.S. permanent representative to the United Nations, a cabinet-level post in the Clinton administration. In that role she led this country's delegation to the UN's Fourth World Conference on Women in Beijing, China.

Dr. Albright's path to success is atypical enough to qualify as typically American: She was born in Prague, Czechoslovakia, and came to America when her family fled that country after the Communists took control in 1948. Is it any wonder that she draws strength from the words of Bobby Kennedy: "If there's nobody in your way, it's probably because you're not going anywhere."

Today she runs the global strategy firm, the Albright Group LLC.

She is also the first Michael and Virginia Mortara Endowed Distinguished Professor in the Practice of Diplomacy at the Georgetown School of Foreign Service and the first Visiting Saltzman Fellow at Columbia University's Saltzman Institute of War and Peace Studies. She is chair of the National Democratic Institute for International Affairs, chair of the Pew Global Attitudes Project, president of the Truman Scholarship Foundation and a member of the Board of Directors of the New York Stock Exchange.

Her fantasy is not about herself. She wants to "see global peace in the future and a more understanding world, a world where countries are able to choose democracy." She has already shown she has the means to draw that fantasy closer to reality. We await your next move, Dr. Albright.

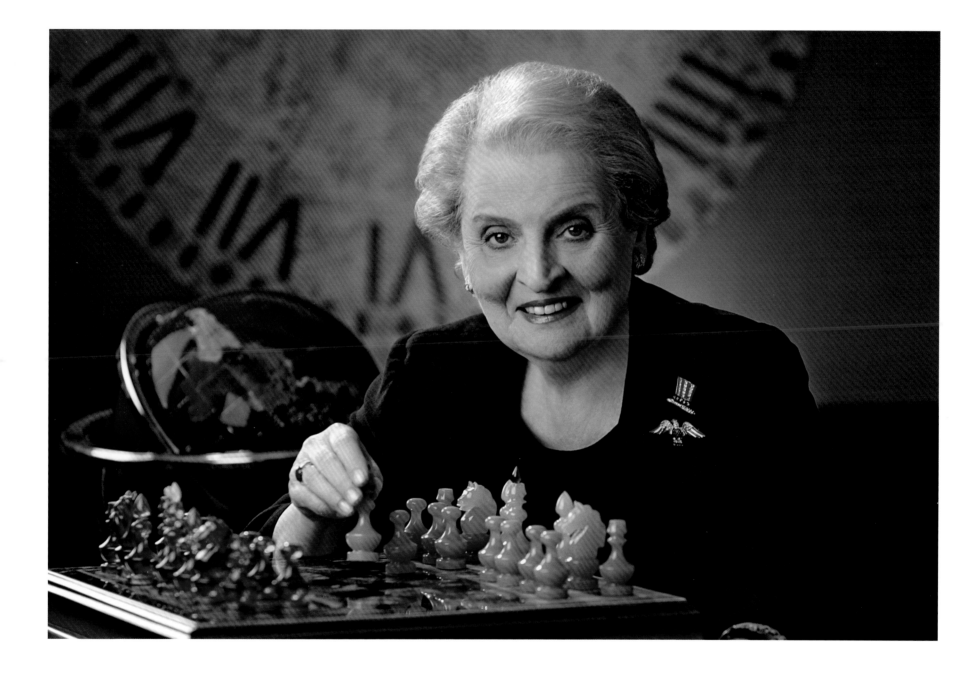

Ellen Sigal · *Prima Ballerina*

"Dance takes me into another world, makes me completely happy and peaceful." Dr. Sigal's journey from real estate mogul to cancer crusader has unfolded much like a classical ballet: passionate steps woven into one fluid performance. "One does not always choose the path they go down in life. I certainly would never have predicted where I am today. But I would not change a thing."

Ellen Sigal, PhD, was a successful real estate developer. Then, around twenty years ago, her forty-year-old sister developed a tragic case of breast cancer. Dr. Sigal turned her energies to accelerating progress against the disease that claimed her sister. She became involved with the Duke University Comprehensive Cancer Center and rose to chair of its board. In 1992, she was a presidential appointee to the National Cancer Advisory Board and served as chair of the Budget and Planning Committee, which had oversight of the federal cancer budget.

In 1996, the Director of the National Cancer Advisory Board wanted to mark the twenty-fifth anniversary of the National Cancer Act with heightened public awareness. Still in real estate and still on the board, Ellen responded by forming a non-profit organization, Friends of Cancer Research, dedicated to mobilizing public support for cancer research funding and providing education on key public policy issues.

Realizing she couldn't continue in real estate and effectively run this new organization, Ellen chose to dedicate 100 percent of her time to cancer research and is today the chair of Friends of Cancer Research. In addition, Dr. Sigal serves on many boards, including the National Cancer Institute Board of Scientific Advisors, the National Institutes of Health prestigious Director's Council of Public Representatives, and the American Association for Cancer Research Foundation Board. She also has been instrumental in harnessing the energies of Hollywood on behalf of cancer research, serving as president of the Creative Community Task Force for Cancer Research.

In 2004 alone, Dr. Sigal received special acknowledgment from Research!America, *Washingtonian* magazine, the George Washington University Cancer Institute, and the Association of American Cancer Institutes for advancing the fight against cancer. Dancing dreams aside, Dr. Sigal has achieved true "prima" status in real life.

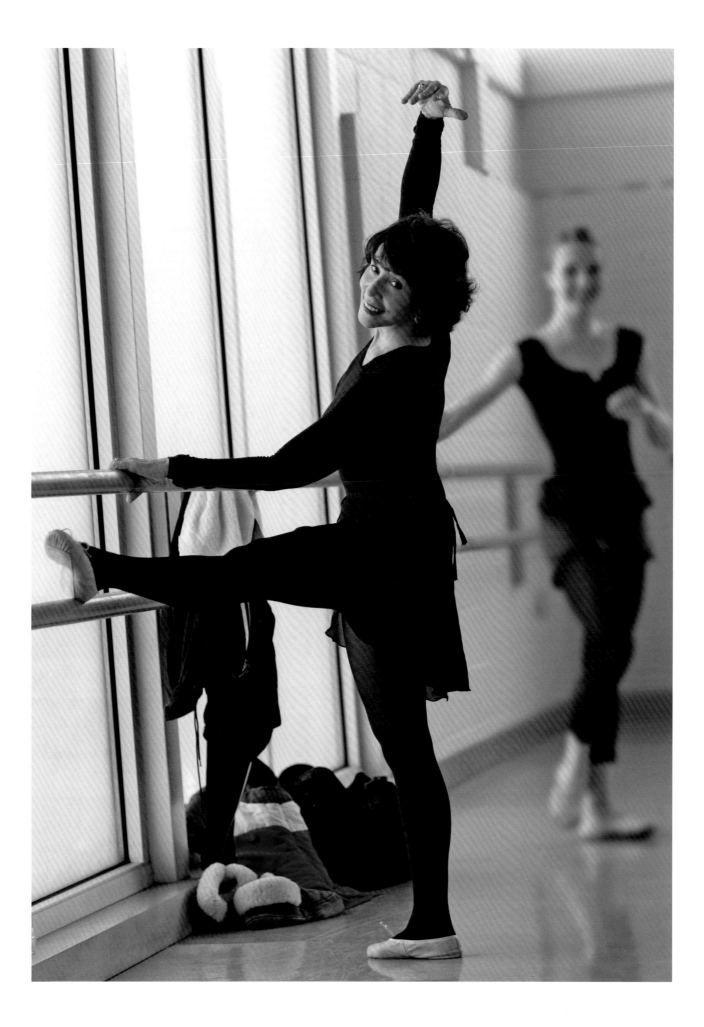

Cathy Hughes · *Gone Fishing*

"There was one bathroom in our household of six (sometimes seven), yet I spent countless hours before the mirror, pretending my hairbrush was a microphone, the bathroom a soundproof studio. I would read commercials, deliver the news, and, of course, announce the latest hits."

Even in her childhood dreams there was a need to give back, to inform, to be of service. Cathy Hughes dreamed she would grow up to be a full-time housewife, mother of six sons, *and* have a radio station in her home, broadcasting information on child rearing and domestic bliss—"a cross between Dr. Spock and Martha Stewart." In a strange twist of fate, instead of having a station in her home, she once had to give up her house and move into the station she then owned. But we get ahead of the story.

Cathy was a very successful radio GM (in her tenure at WHUR, she increased their sales revenue more than ten-fold) who wanted her own station. She and her husband were denied a loan to buy the tiny AM station WOL by thirty-two banks. The thirty-third time was the charm, and Radio One was born. Her marriage ended shortly thereafter, and Cathy and son Alfred later lived in the station. It was the success of her own talk show that helped this single mother turn one station into sixty-nine, including every major market. Today, Radio One is the largest black-owned radio corporation in the world.

But it is TV One, a joint venture with Comcast, that is her current passion. She calls it the first *adult-oriented* cable network for African Americans. "I have an awesome responsibility to African American adult viewers who will not be content watching music videos all day," she says. And in the same breath: "I love the opportunity to learn a new medium."

She doesn't just want to make TV One a success—she has a personal goal of providing more managerial and broadcast opportunities for African-Americans and women than all her competitors combined.

With so much on her plate, one can see why her fantasy would be to simply go fishing. Somehow we suspect that will remain a fantasy for a while longer.

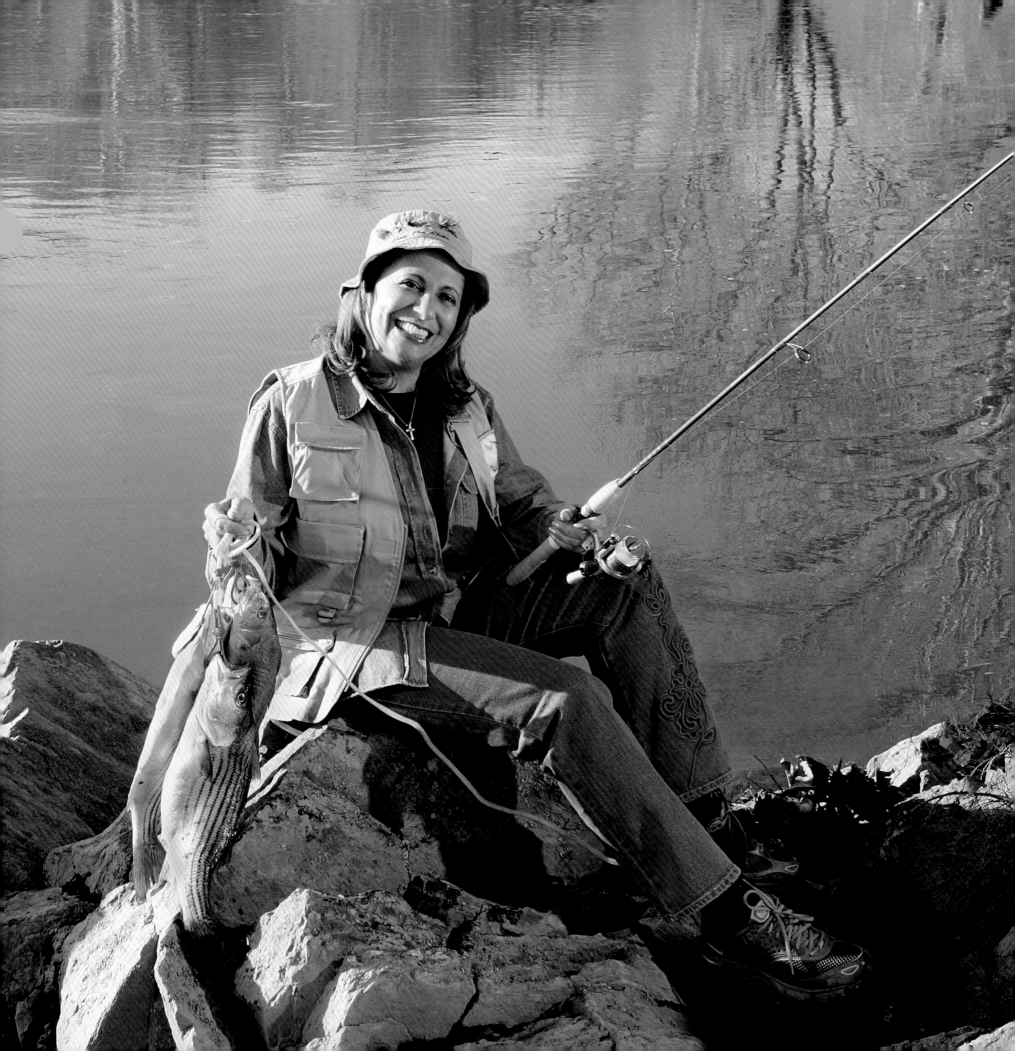

Denyce Graves · *Lottery Winner*

Art can inform in a way that penetrates deeper than mere facts—and that's not always easy on the artist. But after rehearsals and performances, Denyce Graves can return to her daughter, Ella (named, of course, for Ella Fitzgerald).

If you were mastering the title role of *Margaret Garner*, you might want some relief, too. Here's why. In 1856, Margaret Garner sacrificed her children rather than see them enslaved again, for which she was tried on charges of "theft and destruction of property." *Margaret Garner*, the opera, was written by Richard Danielpour to remind us of our shared humanity. He also wrote it expressly for Denyce Graves to sing. If the plot is familiar, that's because Toni Morrison based her novel *Beloved* on it; she also wrote the libretto for *Margaret Garner*.

Pretty heady company, but Ms. Graves has been at the top of her craft for many years. She made her Metropolitan Opera debut as Carmen and became well known for several subsequent performances of *Carmen* with Placido Domingo. While this success means a life spent mostly on the road, daughter Ella is "a great little traveler, friendly with everyone, and great to take lunch breaks with and come home to. She's right there—all love. Even though we're away more than eleven months of the year, it's important to me to create a real home environment wherever we are."

Her appointment as a cultural ambassador for the United States hasn't lessened the travel load, what with master classes, performances, and lectures all over the world, but it's some of the more rewarding and important work she does.

And the lottery? "I wouldn't stop working, but I'd scale down the performances. There's so much I want to experience, I'd need several lifetimes. I'd spend more time reading music history, taking ear training and language study. Just more time to learn. Of course, I feel I've already hit the lottery with Ella."

Abbe Lane · *Matador*

Many people thought, and still think, Abbe Lane was born in South America. Easy mistake to make. She speaks three languages fluently. And most people first really took notice of her as the singer in the Xavier Cugat Orchestra. But Abbe Lane was born in Brooklyn. And born, apparently, to perform.

We asked all the women in this book to complete this sentence: "As a girl, I dreamed I would become…" The most popular answers are along the lines of "a star" (actress, ballerina), followed not surprisingly by dreams close to the eventual achievements of our subjects. But there was no eventually with Abbe Lane. She, too, finished the sentence with the words "a star." But at the age of four she was already on the radio show *Children's Hour*. She then went on to two shows on Broadway and was fronting a professional orchestra at fifteen (her age at the time of her Cugat debut). One year later, she married the popular bandleader. They lived in Italy and Spain and it was there that she was drawn to bullfights, and especially to the courage demonstrated by the matadors. "They would dedicate their bullfights to me. I was very impressionable."

Who isn't impressionable at sixteen? But then, she had already been in show business a dozen years. She attended the New York Professional School, appearing on Broadway while still a student. She has had a truly international career, with her own shows in England, Switzerland, Spain, Holland, Argentina, Italy, Chile, and Mexico.

Today she lives in Los Angeles with her husband, Perry Leff. She is a gourmet cook, a talented interior decorator (their homes—the other is in Aspen—are decorated with antiques acquired all over the world), and is involved with several charities. She has even written a roman à clef, *But Where Is Love?*, in development as a Broadway musical.

With all those accomplishments, we wouldn't take any fantasy of hers lightly. In fact, she did learn a few moves from the masters, actually in the ring with young bulls. "I loved it both for the pageantry and the artistry." Just another skill set for Miss Lane.

Jackie Bong-Wright · *Butterfly*

Jackie Bong-Wright believes she has been blessed to be a real butterfly in life. She has been all over the world, sampling the best that countries and cultures have to offer, and done her part to cross-pollinate beauty and ideas (for ideas know no borders)—but not without cost. Her blessed life has also seen real hardship.

She fled Vietnam and came to the United States in 1975, with nothing but her three children, all under twelve years of age. It was just four years earlier that her husband, Nguyen Van Bong, was assassinated the day after he accepted the position of Prime Minister of South Vietnam. Educated in France and a teacher by trade, he could have stayed safely away from his homeland. Instead he returned to Vietnam, trained its future leaders and founded a political party with a platform for reconstructing the country, running against corruption and Communism.

Jackie's homeland had known mostly emperors and dictators over its long history; she knows firsthand that free governments don't just happen. So she does her part here in America—she is president and CEO of the Vietnamese American Voters Association, a nonprofit organization providing civic, social, cultural, and health services to Vietnamese Americans, with a special emphasis on voter registration and education. For her work in resettling boat people, the U.S.-Asia Institute gave her national recognition as one of ten outstanding Asian Americans in the United States.

Jackie Bong-Wright has been a teacher, an administrator, a counselor, a reporter, and a TV producer and host. She holds a bachelor of arts from the Universities of Bordeaux (France) and Saigon, Vietnam, and a master of science in international relations from the School of Foreign Service at Georgetown University. Remarried to a U.S. diplomat, she has continued to be a citizen of the world, traveling to Europe, the Caribbean, Central and South America, and Asia. Her autobiography, *Autumn Cloud*, is now out in paperback.

One more aspect of her butterfly fantasy: after her transformation she will use her wings to "bring harmony wherever I go."

Lynda Johnson Robb · *To Read to Every Child*

Some fantasies are unattainable and represent an ideal version of what the fantasist does. Such is the case with Lynda Robb. Her fantasy is to read aloud, to children, every children's book published. She has already read aloud to countless children at Reading is Fundamental(RIF) programs, and continues to do so.

Should we be surprised? Her father —President Lyndon Baines Johnson—had a vision of this country as "The Great Society," free from want and hunger and prejudice. Her mother told her "Do something that makes your heart sing."

Her love of books and reading showed the way to making her heart sing: she got involved in RIF as a founding director and is today a *chair emeritus* of the organization. For its fortieth anniversary she will be active in a yearlong celebration of RIF's role in children's literacy.

"With RIF, children choose a book they get to keep forever. One they want, not one that's been assigned, that's 'good for you.' Children get to be in charge. And they'll often choose books beyond their grade level and find a way to climb up to that level and read it."

RIF programs operate in all fifty states, the District of Columbia, Puerto Rico, the U.S. Virgin Islands, and Guam. RIF is also affiliated with programs in Argentina and the United Kingdom.

"I met someone recently who got a book from one of our first programs. He's a PhD living in Paris. He still has his RIF book."

"When my youngest daughter first went off to college, I called and asked how she was doing and she said 'you wouldn't believe the stress. But you would approve of how I'm handling my exams. I went to the library and re-read Babar, George and Martha, and *Alexander and the Terrible, Horrible, No Good, Very Bad Day*.' We all have days like Alexander's. Reading a beloved book is always comforting."

Ann Curry · *Humanitarian*

The dream of the little girl who would grow up to become the news anchor for NBC's *Today* show and coanchor of its *Dateline NBC* prime-time news program was to do something to help people.

As a news reporter she made her dream come true. From Baghdad to the Balkans, from Sri Lanka to Africa, she has covered stories of enormous import. She focuses her skills on what she calls "humanitarian reporting" because she has discovered through experience that "the heart of America is too big not to act when there is a chance to alleviate suffering." Her reporting from the Gulf of Mexico after Hurricane Katrina is a shining example of this principle in action.

Growing up in turbulent times—Vietnam, Watergate, the struggle for equal rights and racial equality—she saw that if people are given knowledge about the world, they have the power to change it. "I understood that when I saw something happening on TV in another country, even as far away as Southeast Asia, it mattered here at home to my small town, to my family."

She and her father were the first in her family to go to college, and graduated the same year. With a degree from the University of Oregon School of Journalism, she started as an intern at a TV station near her hometown of Ashland, Oregon, rising to become the station's first female news reporter. She reported in Portland and Los Angeles before joining NBC News as a correspondent. NBC made her an anchor first at *NBC News at Sunrise* and later to help launch MSNBC, and then, to her delight, news anchor of *Today*. Along the way, she has earned two Emmys, four Golden Mikes, several Associated Press Certificates of Excellence, a Gracie, and an award for Excellence in Reporting from the NAACP.

Married, with a son and daughter, she works to make a difference, so that she will know at the end of her days, as her father suggested, that it mattered she was here.

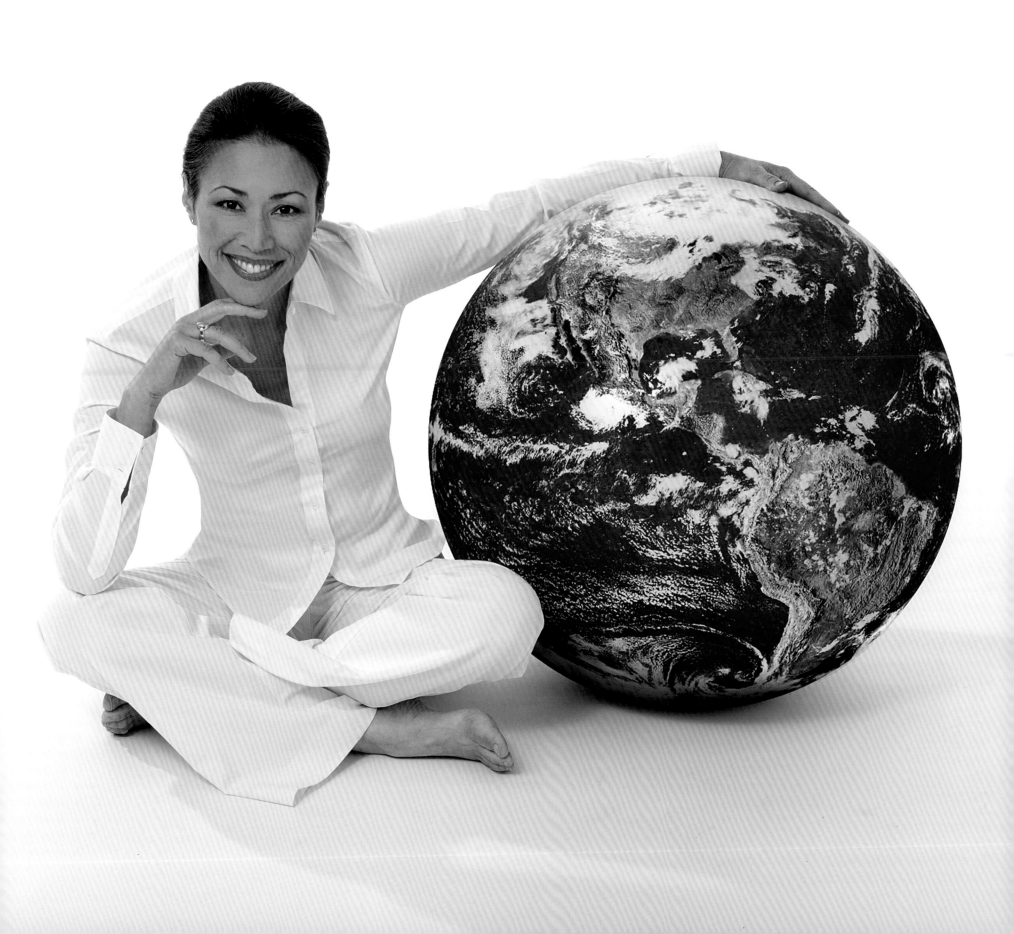

Lynda Carter · *Olympic Gold Medalist*

"I love athletics. I've known several elite athletes, and the dedication it takes to get to that elite level is really amazing to me. And after all that, often it comes down to a mental toughness, to the way they approach their event. When the differences are measured in milliseconds, what makes you the one to run faster that day?"

Her childhood dream was to become an actress and entertainer. By the time she was twenty-five, one couldn't be much better known than this Wonder Woman. She began her career singing in bands as a teen, and along the way she won the 1972 Miss World USA pageant, representing her home state of Arizona. So what does Lynda, who was also once voted the most beautiful woman in the world by the International Academy of Beauty, want to do today?

Her current passions are her guitar lessons (a return to those teen years fronting bands?) and opening herself "to other opportunities." Having done everything from star turns in dozens of movies and television shows to being the "face" of Maybelline for more than a decade, she continues to keep her famously blue eyes peeled for out-of-the-box acting roles that run counter to her *Wonder Woman* fame. Those roles have come—on stage in two productions of Eve Ensler's *The Vagina Monologues* and in light-hearted fare such as *The Dukes of Hazzard*, re-teaming her with *Super Troopers* director Jay Chandrasekhar and costarring withWillie Nelson, Jessica Simpson, Sean William Scott, Johnny Knoxville and Burt Reynolds.

Since her marriage to lawyer Robert Altman in 1984, however, her family has come first—the couple has two teenage children. High on her list of things to do is to travel more with her husband. "If you've been around for any time you get it—the real substance is your family and friends and the work. And by the work, I mean the craft of it. The only thing fame gets you is a greater choice of projects." As always, Lynda somehow makes the time for her favored charities, focusing her energies on issues affecting women's health and children.

The fantasy of a woman who once played Wonder Woman is to run faster and jump higher than anyone else in the world—to win an Olympic gold medal in track and field.

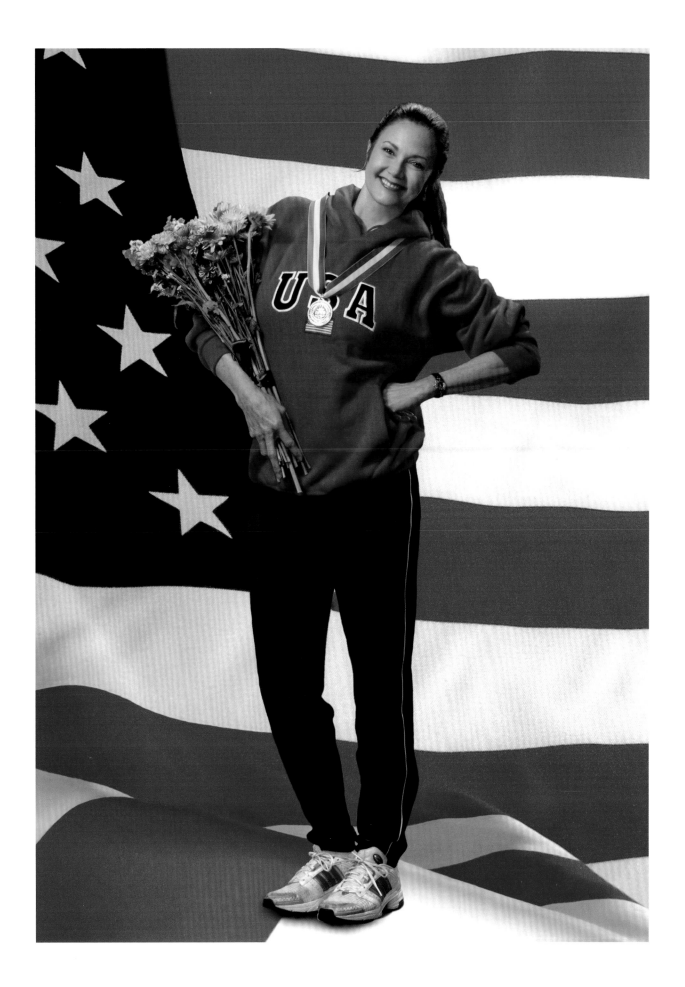

Debbie Allen · *Native American Princess*

"We're all connected to the indigenous people of this land. When I reflect on the greatness of this continent, I think of it as it was thousands and thousands of years ago, with some of the greatest civilizations just now finally becoming known to us."

Actress. Director. Producer. Choreographer. Singer. Dancer. Author. What drove her to found a dance studio? First look at the course list of the Debbie Allen Dance Academy she founded in 2001. The curriculum for boys and girls ages four to eighteen includes classical ballet, modern, African, jazz, and hip-hop. Plus there are special workshops in the Peking opera, martial arts dance techniques, flamenco, salsa, and tap. Next look at the words of Debbie Allen: "My current passion is for the thousands of kids I can now inspire to dance." She hopes to one day endow the academy and see it branded around the globe.

She comes from a family that doesn't really think about obstacles—she turns to her own mother for words to live by: "Be true, be beautiful, be free." But then, Vivian Ayers is a Pulitzer Prize–nominated writer. Today, Debbie, her mother, and her sister Phylicia Rashad are involved in restoring and memorializing the Brainerd Institute in South Carolina. It was started in 1866 for newly liberated African Americans; Debbie's mother was one of its last graduates in 1939 (and its youngest at fifteen years old). When complete, it will be known as the Brainerd Memorial, and will be open to the general public.

Just as she and her mother and sister are bringing back to life a significant part of our recent history ("the modern word nerd is derived from the Brainerd students; they were always the smartest"), Debbie believes today's technology, and today's unbiased scholars, will bring forth the story of what was once referred to as the "pre-history" of this continent. "History and scholarship will one day catch up with the real truth. There is still so much being discovered and uncovered, layers and layers and layers to explore. My fantasy of being a Native American Indian princess is in honor of the true ancestors of America, an acknowledgment of the DNA that is a part of every American."

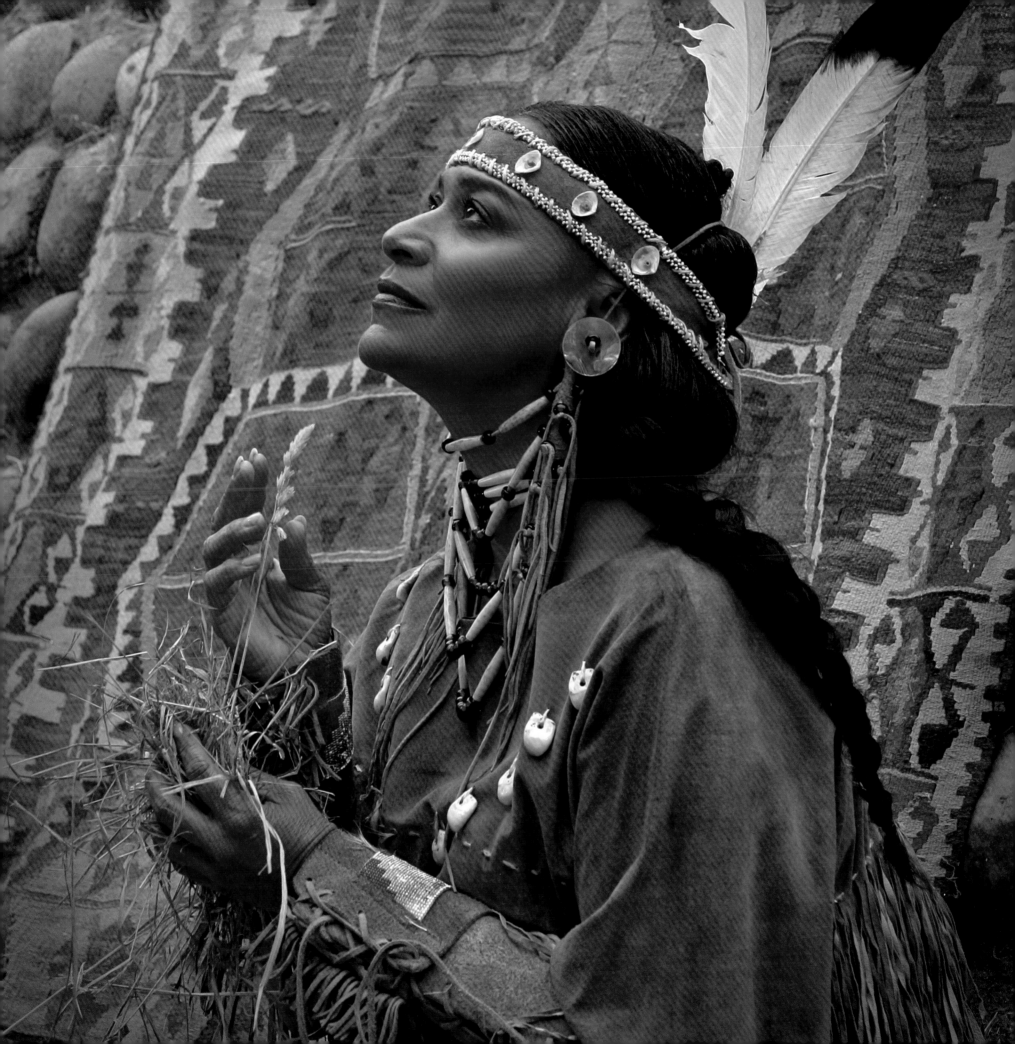

Pat Schroeder · *To Have Super Powers*

Super hero powers are usually reserved for fighting flamboyant villains. Pat Schroeder wants super powers to change a place she knows very well—Congress. "There's an awful lot of cleaning out I'd do to get the government focused on real issues for real people once again."

She mastered one of the more common super hero powers at an early age. At fifteen, Patricia Scott Schroeder learned to fly and got her pilot's license. Today she is the president and chief executive officer of the Association of American Publishers (AAP), the national trade organization of the U.S. book publishing industry, a post she has held since June of 1997. In between, she served twelve terms in the United States House of Representatives.

When first elected to Congress in 1972, her two children were very young; her legislative career reflects her commitment to women's and family issues. During her tenure she became the dean of congressional women, co-chaired the Congressional Caucus on Women's Issues for ten years, served on the House Judiciary Committee and was the first woman to serve on the House Armed Services Committee. As chair of the House Select Committee on Children, Youth and Families from 1991 to 1993, Mrs. Schroeder guided to enactment the Family and Medical Leave Act and the National Institutes of Health Revitalization Act. She was also active on many military issues, expediting the National Security Committee's 1991 vote to allow women to fly combat missions, and working to improve the situation of military families through passage of her Military Family Act in 1985.

To support herself while at the University of Minnesota, Mrs. Schroeder worked as an insurance claims adjuster. After graduating *magna cum laude*, she went on to Harvard Law School, one of only fifteen women in a class of more than five hundred men. She'd like to see more and more doors opening for young women, and feels mentoring is key. "More women who've made it should be out front and talking to today's young women."

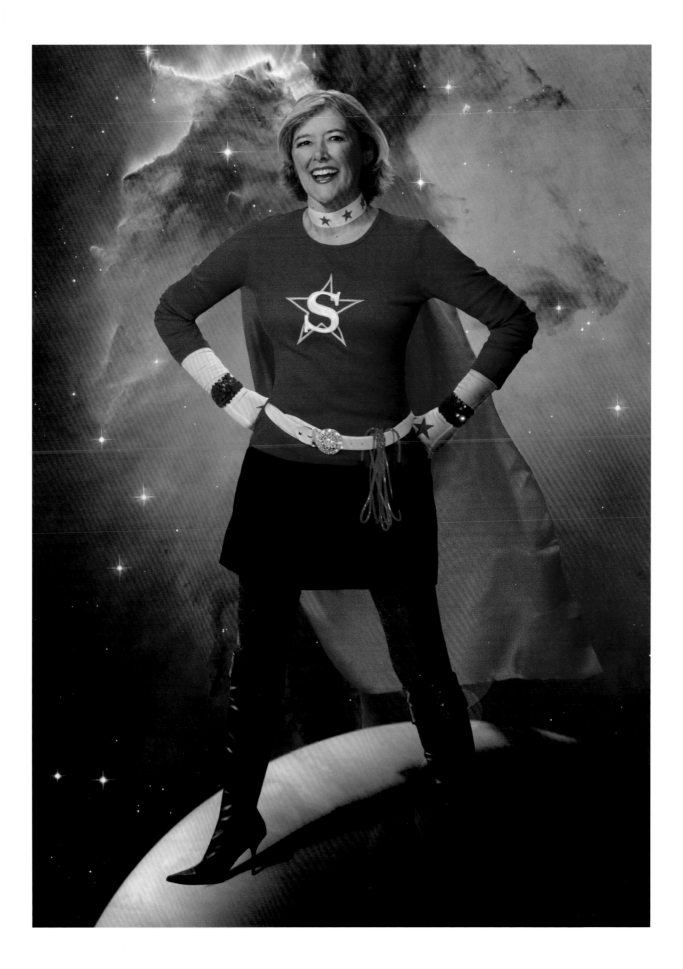

Dominique Dawes · *Supreme Court Justice*

Dominique Dawes has always been interested in justice and the law. In fact, she can easily picture herself having pursued a career with the FBI. Shy in the classroom as a girl, she blossomed in the gym, where to this day she remains most outgoing with her fellow gymnasts. As for performing gymnastics in a full-length robe: "What a difference wearing that and the nearly nothing of a leotard."

When someone lives by the words "If you think you can, you can. If you think you can't, you're right" she obviously believes she can. Dominique was the first African American gymnast to compete in an Olympic Games, as well as the first to win an individual medal. She participated in three Olympics altogether, earning one gold and two bronze medals. She has four World Championship medals and more National Championship medals than any other athlete, male or female.

All these accomplishments, and not yet thirty years old. She started when she was six, began competing at ten, and had one coach her entire gymnastic career.

Her childhood dreams were to be an Olympian and a role model—exactly what she has become. During the peak of her athletic career she found the time to be the *Girl Power* national spokeswoman. For this program promoting self-esteem and healthy lifestyles to young girls, she spoke alongside both President Clinton and then-First Lady, now Senator, Hillary Clinton. In a similar vein, she is now heading *uniquely ME!*, a self-esteem program co-sponsored by the Girl Scouts of the USA and Unilever. Dedicated to empowering girls to feel good about themselves and fulfill their dreams, *uniquely ME!* addresses the effects of low self-esteem among girls eight to fourteen years of age, focusing specifically on underrepresented communities. Dominique will draw on her own experiences and successes to provide a positive role model.

So what does this talented woman do for an encore? An increasingly popular spokesperson on youth and women's lifestyle issues, she is also covering events for CBS Sports, Fox Sports Net, CNN, and others. And, in keeping with her youth focus, she is coaching gymnastics at the very gym where she began.

Her fantasy is to be a Supreme Court Justice. We think she has just the balanced view to deliver sound opinions.

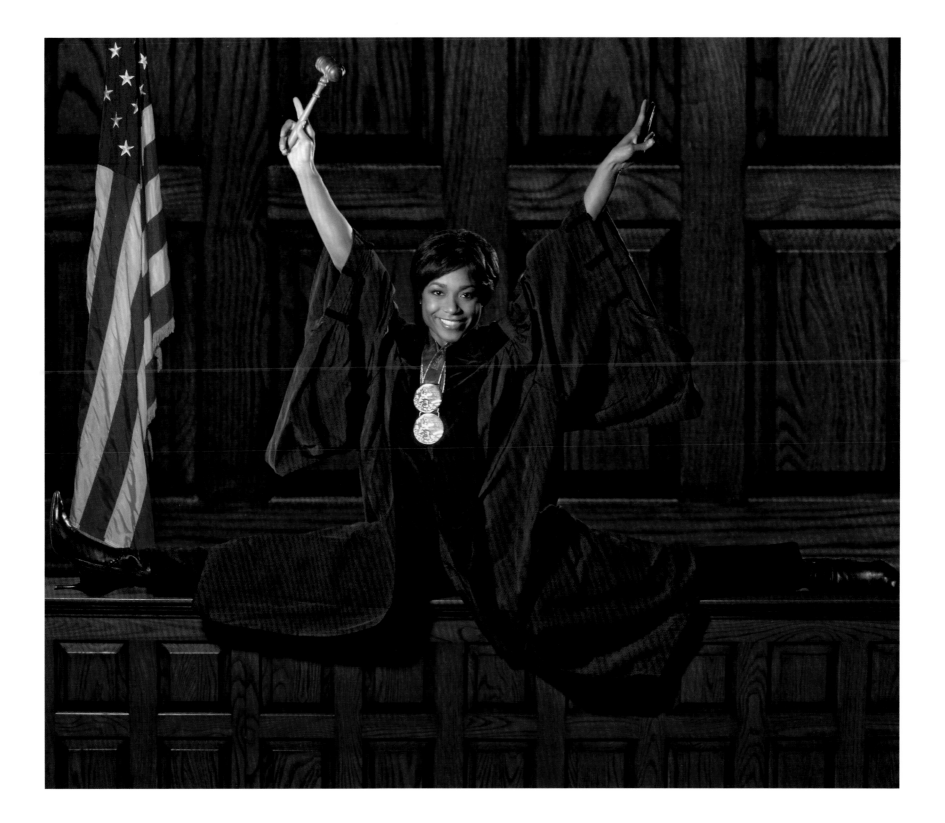

Jo Carole Lauder · *To Dine with Picasso, Pollack and Calder*

When you have been as active as Jo Carole Lauder has in The Museum of Modern Art for the past thirty-five years, you must pick your art fantasy carefully. She chose three of her favorite artists, whom she knew would provide lively dinner conversation.

Jo Carole Lauder's association with The Museum of Modern Art in New York is long-standing and deep. She is the President of the International Council, has been a member of The Contemporary Arts Council since 1970, served as its Chairman and is now Honorary Chairman. She has been Chairman, for several years, of the Museum's annual major fundraising event, *The Party in the Garden*, and is Co-Chairman of the Trustee Committee for Special Programming and Events. She is a member of the Trustee Committees on Architecture and Design; Education; Film and Video; Marketing and Communications; and Photography. She is also a member of the Chairman's Council.

While living in Vienna as the wife of the Ambassador to Austria, Mrs. Lauder promoted American cultural interests. She was instrumental in bringing two major exhibitions of American artists to Vienna, a Jasper Johns print retrospective from The Museum of Modern Art, and the works of Sol LeWitt, and she became active in the Vienna Secession, a building that her husband helped to restore. She furnished a wing of the Embassy Residence with American Folk Art and, upon leaving Vienna, donated the collection to the State Department. That ties in directly with her role as Chairman of the Board of Directors of The Foundation for Art and Preservation in Embassies, an organization that assists the U.S. Department of State in acquiring the finest examples of art by American artists for placement in our embassies around the world.

Her fantasy may be an attempt to bring this world one more work from one of her favorite artists because, when Alexander Calder was once asked when he decided a piece he was creating was finished, his answer was: "When it is time for dinner."

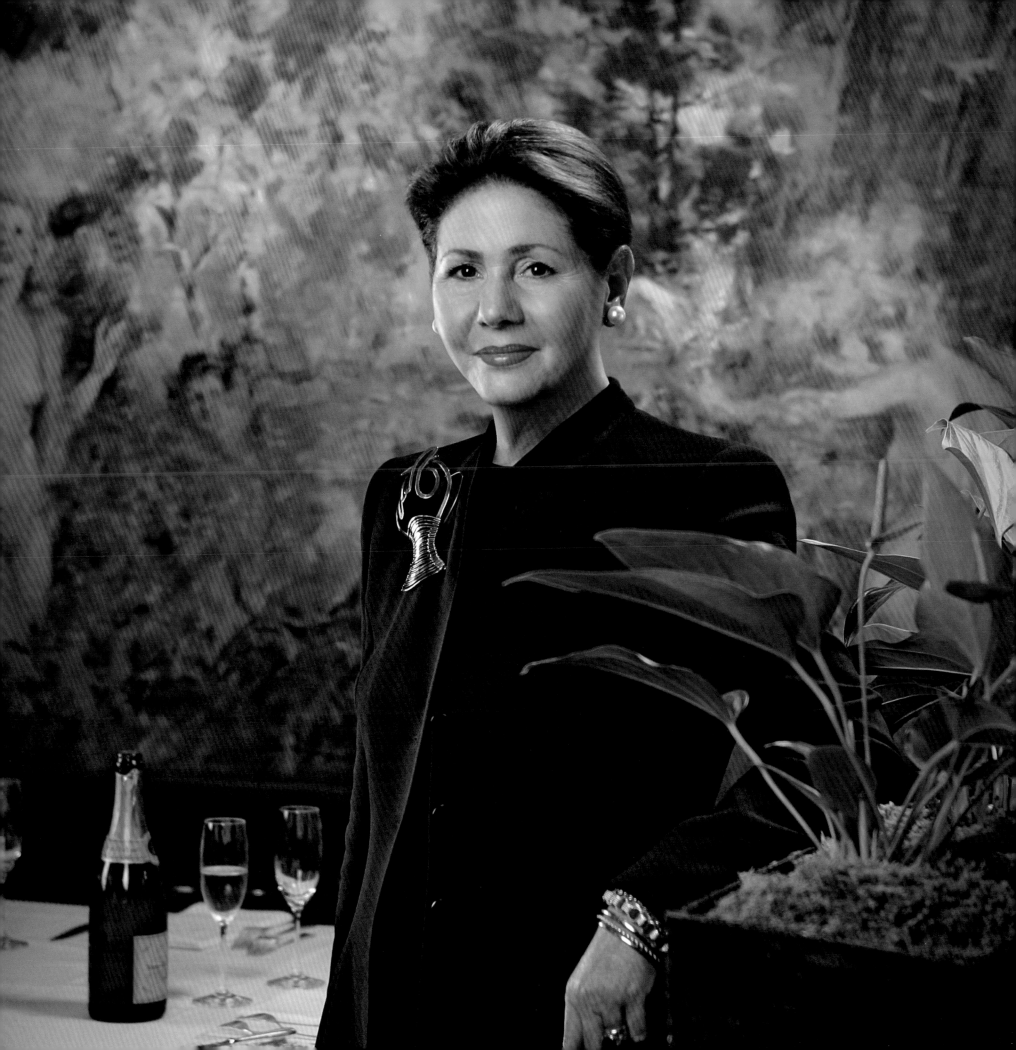

Phyllis Greenberger · *Artist*

"Art has already been a large part of my life, from lessons when I was young to the ways I realize it manifests itself now—through my gardening and elaborate dinner parties, gourmet cooking and decorating. Color and creativity and design can come out in so many ways other than making traditional works of art."

Phyllis Greenberger is the president and CEO of the Society for Women's Health Research, an advocacy organization based in Washington DC. It was formed in 1990 to improve the health of women through research, with Ms. Greenberger as its first, and only, executive director.

"There are significant biological differences between men and women and those differences affect all aspects of health and disease. For too long, women were not routinely included in clinical trials. This, of course, affects treatment and diagnosis."

She was the driving force behind the Institute of Medicine report "Exploring the Biological Contributions to Human Health: Does Sex Matter?" which called on researchers to investigate the implications of basic biological sex differences for the betterment of human health.

"Our goal is to improve the health of women and men by focusing on sex differences. We are bringing our message to researchers, healthcare professionals and all women—when it comes to health, sex matters."

Selected as one of the twenty most influential women in medicine today by the *Medical Herald*, Ms. Greenberger is frequently called upon to speak on topics such as the importance of the inclusion and retention of women in clinical trials as well as to testify before Congress as an advocate for additional research and funding for women's health. Ms. Greenberger also serves on many boards of directors, advisory and editorial boards, and was a member of the Presidential HIV/AIDS Advisory Council and the National Institutes of Health's National Advisory Environmental Health Sciences Council.

When away from running the organization, she finds a little time to paint, usually at her house on Cape Cod. She'd like to be a part of the baby-boomer trend of moving into more personal and creative second careers. "I minored in art history and took my junior year of college abroad in Florence, Italy. I still can't pass a painting without examining it."

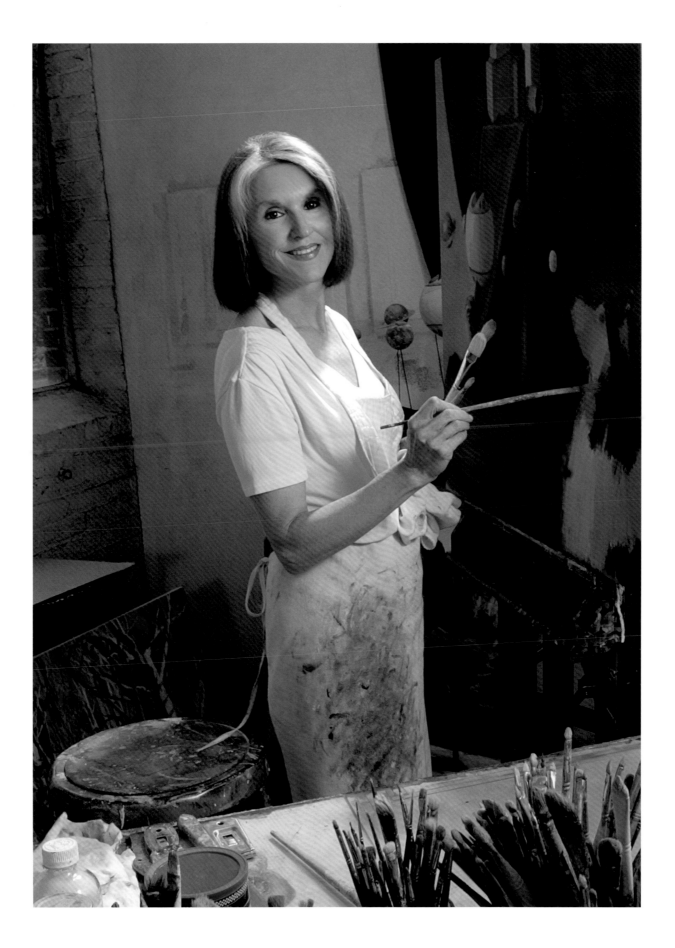

Wendy Rieger · *Surfer*

"My mother was a reading teacher and believed the ability to read was a basic right." Through Children & the Arts, Wendy takes that idea one step further, helping children from kindergarten through high school read books on the arts. "It's one of the easiest way to help them escape the hardships of their world—singing and dancing, painting, and photography can be a way out of poverty."

Fantasies don't have to be worlds away from your own experience. In fact, they are often more powerful as a simple wish fulfillment for something you once came very, very close to doing. Indeed, they can be more desirable precisely because of their familiarity.

Wendy Rieger grew up near the beach in Norfolk, Virginia, watching her brothers and their friends surf whenever they could. She always wanted to do it, too, but somehow "it simply eluded" her.

No wonder. She came to DC, got her journalism degree from American University, and was already covering the Washington market for WAMU radio more than twenty years ago. From writer to reporter to local host for *Morning Edition*, she later did NPR newscasts and was an anchor and reporter at WTOP radio before switching to television by joining CNN's Washington Bureau. In 1988 she joined WRC TV, where she now co-anchors *NEWS4 at 5* while still doing general assignment reporting. As its honorary spokeswoman, she raises money for Children & the Arts, a charity that has been able to donate thousands of art books to local schools, youth clubs, and scouting groups in the nation's capitol. With her support, the program has tripled in size in the last five years. She is a regular in the DC AIDS Ride, serves on the Advisory Board of the Smithsonian Environmental Research Center, and still greets us with the news nearly every afternoon.

Through her work she hopes she has caused some viewers who may be prejudiced and shortsighted to stop for a moment and reconsider. We hope she gets to stop and catch an ocean wave sometime soon herself.

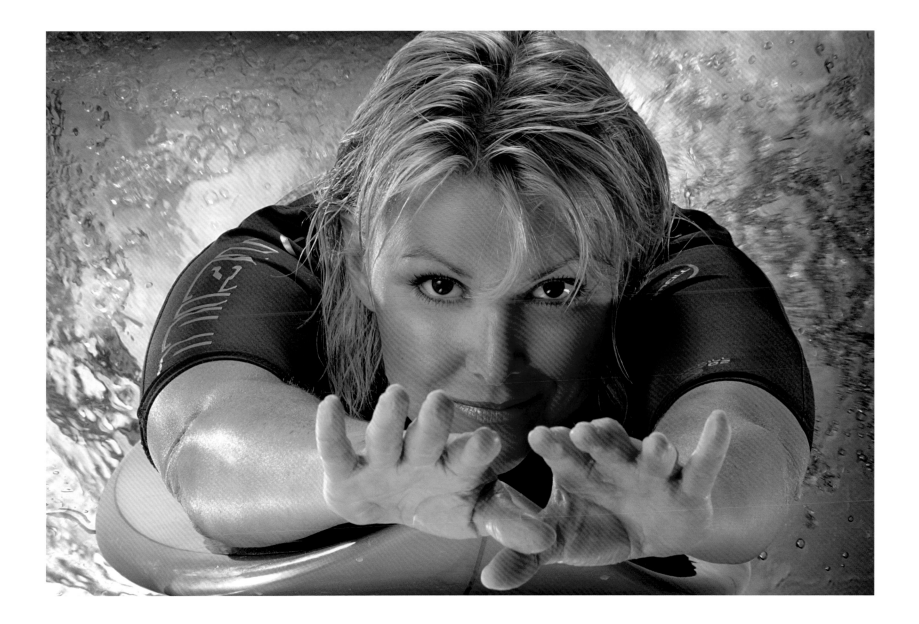

Sarah Brady · *Private Eye*

"Every book I ever really loved was a detective or spy novel, beginning with Nancy Drew, the Hardy Boys—even the Bobbsey Twins had little mysteries. In high school I read all the Agatha Christies (and have now read them all at least three times). To this day all I ever read are mysteries. My Dad was an FBI agent; I wanted to be one, but in my day they didn't take women."

She will tell you that the Brady Bill, signed into law by President Clinton on November 30th, 1993, is named for her husband Jim Brady, grievously injured in the assassination attempt on Ronald Reagan in 1981. And so it should be. But there's also little doubt that the bill, requiring a five-day waiting period and background check on all handgun purchases through licensed dealers, would never had made it into law without her efforts.

Jim and Sarah had been married not even eight years when the shooting occurred. Shortly thereafter, with a husband in rehabilitation and a young son to raise, Sarah became active in the gun control movement.

By 1989 she was chair of Handgun Control, Inc. Two years later she became chair of its sister organization, the Center to Prevent Handgun Violence, a 501(c)(3) organization working to reduce gun violence through education, research, and legal advocacy. Today, to honor Jim and Sarah's contributions, the groups have been renamed the Brady Campaign to Prevent Gun Violence and The Brady Center to Prevent Gun Violence. In 1996, Sarah addressed the National Democratic Convention on behalf of the gun control movement.

Of course, she already knew how to get things done. She had spent ten years working actively for the Republican Party. She was assistant to the campaign director at the National Republican Congressional Committee, an aide to two congressmen, and for four years director of administration and coordinator of field services for the Republican National Committee. During that time she also chaired the Building Committee for the Republican National Committee Annex, served as a delegate to five Virginia Republican State Conventions, and as an honorary regent of the National Federation of Republican Women.

Mrs. Brady also serves as the honorary chairperson of the National Head Injury Foundation. Among the many, many honors she has been awarded is the Angel of Peace Award from the Violence Prevention Coalition.

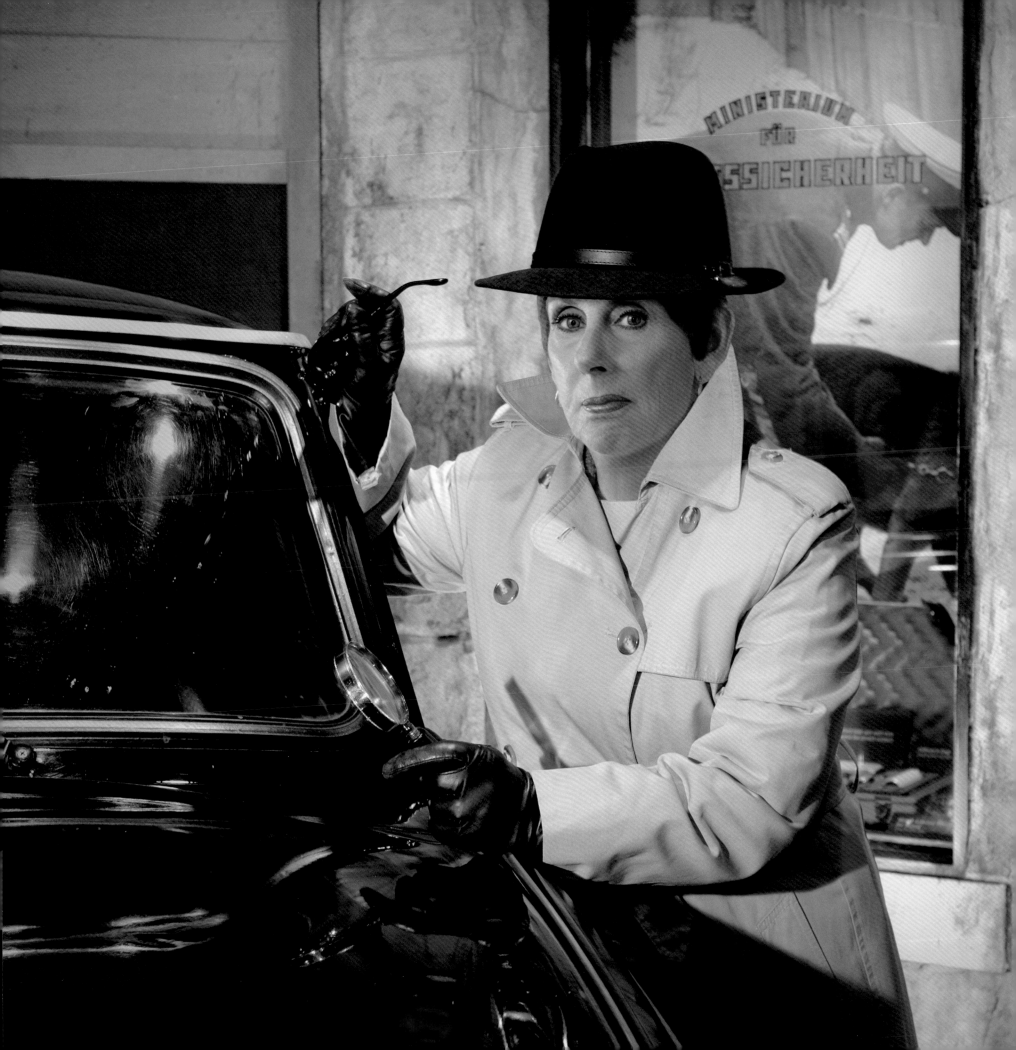

Diane Rehm · *Oscar-winning Actress*

It is the stuff of melodrama really—painter loses her eyesight, musician loses his hearing. We reject it as implausible in fiction. But in real life, it actually happens sometimes. Think of Beethoven. Or ask Diane Rehm.

Diane Rehm is a living, breathing symbol of radio in Washington, on the air continuously since 1979. Her two-hour daily talk show has been broadcast around the country by National Public Radio since 1996, across the globe via NPR Satellite and Armed Forces Radio Network, and is now on Sirius Satellite Radio as well. Quite an achievement for anyone, but especially rewarding for someone who, as a young girl, dreamed of becoming a cast member of the award-winning children's program *Let's Pretend*.

But in 1998, this woman who makes her living with her voice was diagnosed with a rare neurological disorder, spasmodic dysphonia, that makes it difficult, if not impossible, to speak. She took a five-month sabbatical to find treatment, then returned to host her program, write articles about her vocal problems, and finally an autobiography, *Finding My Voice*. Ted Koppel, a long-time listener of her show, devoted an entire episode of *Nightline* to a conversation with Diane. For bringing this affliction to the attention of the nation, Diane was recognized by the National Council on Communicative Disorders and the Maryland Speech-Hearing-Language Association.

Diane and her husband, John, went on to write another book, *Toward Commitment: A Dialogue about Marriage*.

Diane is a member of the Board of Trustees at McDaniel College and is a fellow in the Society of Professional Journalists.

Having begun her acting career in kindergarten as the Wicked Witch in *Hansel and Gretel*, Diane's fantasy is to star on the big screen as an Oscar-winning actress.

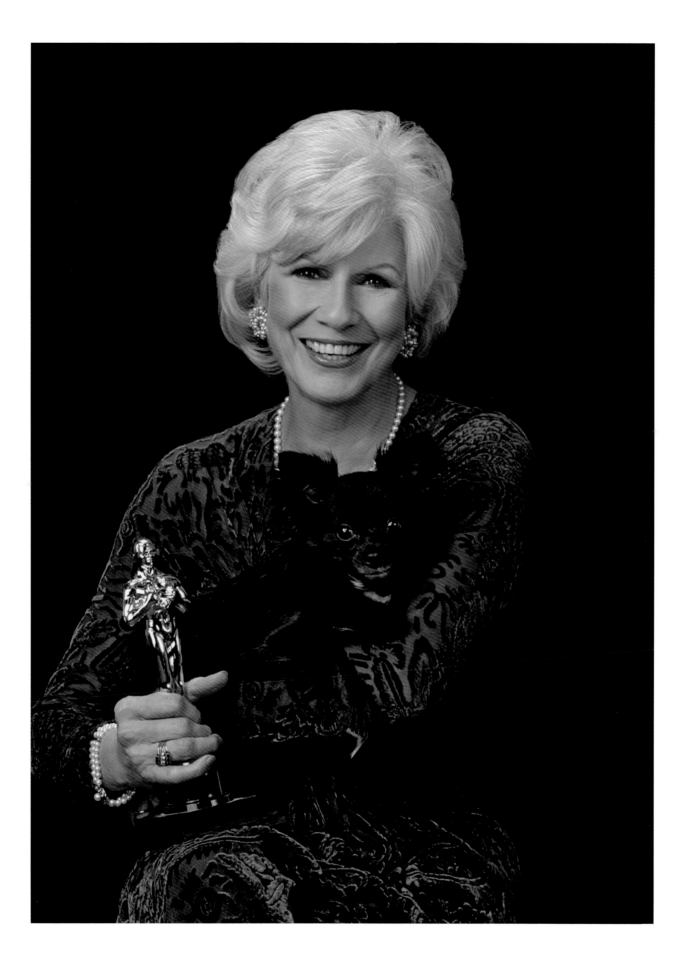

Dorothy Height · *Medical Doctor*

While best known for her efforts in the United States, Dorothy Height continues to work for human rights, especially for women, in nearly every corner of the globe. She has been true to the vision of her mentor, Mary McLeod Bethune, to leave no one behind.

A heroine of what we call "mass movements," Dorothy Height is a powerful personal presence. Eleanor Roosevelt, Dwight D. Eisenhower and Lyndon Johnson listened to her strong, consistent voice in support of human rights, civil rights, and equal rights under the law. She pushed President Eisenhower to desegregate schools, and President Johnson to appoint more African American women to positions of responsibility.

Yet she was also an accomplished executive, fighting for the rights of African Americans and all women through leadership positions with the National YWCA and the National Council of Negro Women, serving as the latter's president for forty years.

During the height of the civil rights movement in the 1960s, she organized "Wednesdays in Mississippi," bringing together black women and white women from the North and South to create a dialogue of understanding. In 1986, she organized the Black Family Reunion Celebrations. So far, more than 14 million people have participated in these events which reinforce the historic strengths and traditional values of the African American family.

Recipient of the Presidential Medal of Freedom, the Franklin Delano Roosevelt Freedom from Want Award, the NAACP Spingarn Medal, and the Congressional Gold Medal, she is also in the National Women's Hall of Fame.

Dr. Height has seen the world change in her ninety-three years—driven a lot of that change herself. And with all her achievements, we have the nerve to ask her to have a fantasy. Persistent, calming, imbued with moral clarity, this leader of national organizations returns to the gratification of helping another person, one-on-one, as a psychiatrist.

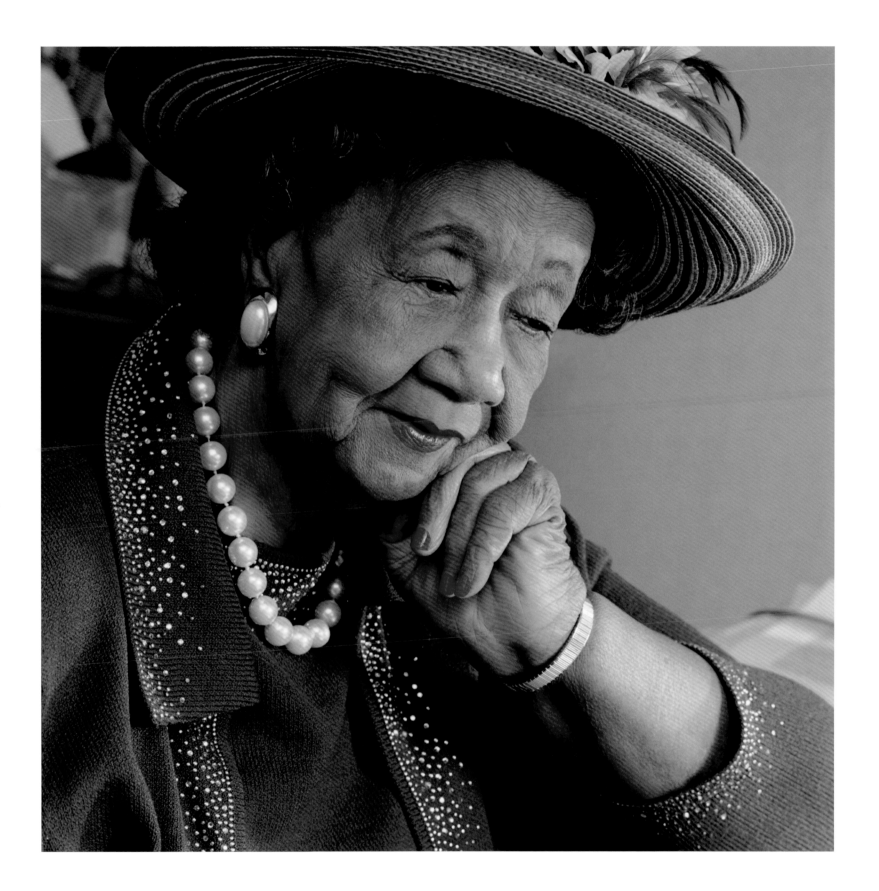

Kitty Kelley · *To Lock Her Troubles in a Trunk*

Kitty Kelley is a gunslinger of a writer. Her aim is true, but everyone still runs for cover when they see her coming. Should we be surprised that her favorite saying is an old cowboy adage? "Speak the truth, but ride a fast horse."

There are plenty of ways to be an artist. You can paint Indian miniatures or be a Louis Sullivan and build proto-skyscrapers. But whether it's the final product or the subject matter, scale is always a part of the equation. Kitty Kelley works big. Her subjects: Jacqueline Kennedy Onassis, Elizabeth Taylor, Frank Sinatra, Nancy Reagan, the British Royal Family, and the entire Bush family.

Nancy Reagan: The Unauthorized Biography sold faster than any biography in publishing history. *His Way: An Unauthorized Biography of Frank Sinatra* (the publication of which he tried to block) set a record as the biggest-selling biography. *Jackie Oh!* and *Elizabeth Taylor: The Last Star* were also international bestsellers. *The Family: The Real Story of the Bush Dynasty* was published two months before the 2004 presidential election and, like most of her books, debuted on the *New York Times* best-seller list at number one.

Kitty Kelley was educated in a private Catholic girls' school, so, as she jokes, she was focused on "not becoming a nun." This, however, did not stop her from dreaming of becoming a cardinal (she liked the clothes).

Kelley received the Outstanding Authors Award from the American Society of Journalists for her "courageous writing on popular culture", the Philip M. Stern Award for "her outstanding service to writers and the writing profession," and the Lotos Club of New York presented her with its Medal of Merit.

Her fantasy is the only one in this book that is completely conceptual: "to pack all my troubles in a trunk (preferably Louis Vuitton), lock them away forever, and laugh!" From the outside looking in, it doesn't seem she would need a very big trunk. On the other hand, we can't help but think that some of the people she's profiled may have the same wish for her as she does for her troubles.

Sally Smith · *Isadora Duncan*

"I have always admired innovation. Isadora Duncan dared develop her own style of dance; originators, like Isadora, helped me dare to design a new style of teaching children with special needs. Besides, I love free-flowing, colorful scarves with the wind blowing on my cheek as I ride in a sleek car!"

She started as an artist. "In high school I was passionate about modern dance, drama, music, and art. I chose the university I went to for its arts program, but was absolutely enchanted by the work of Piaget, psychoanalyst Erich Fromm, cultural anthropologist Dr. Edward T. Hall, and sociologist Dr. Arnold Rose." With advanced degrees in psychology and cultural anthropology, Sally L. Smith added her love of the arts to the mix, and the Lab School of Washington was born in 1967, joined in 2000 by a Baltimore campus.

"Influenced by all my passions, the Lab School's unique programs help students with severe learning disabilities, ADHD, and language problems to achieve." And achieve they do. More than 90 percent of Lab School students go to college.

But what drove her to design her unique methods? "My number three son had severe learning disabilities—ADHD, coordination problems, language fluency problems—and his prognosis was poor." Today a computer specialist, assistant teacher, and businessman, her son states, "I gave her a career!" The spark for this unique teaching method was her three sons' themed birthday parties. The children would imagine themselves as secret agents, pirates, medieval knights, cavemen. "My youngest, who couldn't learn anything traditionally, remembered everything from these parties where all his senses were employed." Taking this as her cue, she designed her Academic Club Program, a hands-on, experiential education with a theme. For one hour a day the youngest Lab School students are, for example, in the Cave Club learning about hominids while the older children are artists in the Renaissance Club taught by "Lorenzo de' Medici."

Since 1976, Sally Smith has been professor in charge of the graduate program in Special Education: Learning Disabilities at American University, training teachers her way. The Academic Club methodology has been a primary teaching tool at the Lab School. Sally would like to spread the arts-based methods of the Lab Schools to the entire country, and today other schools are learning how to use it through the Academic Club Teaching Service (ACTS).

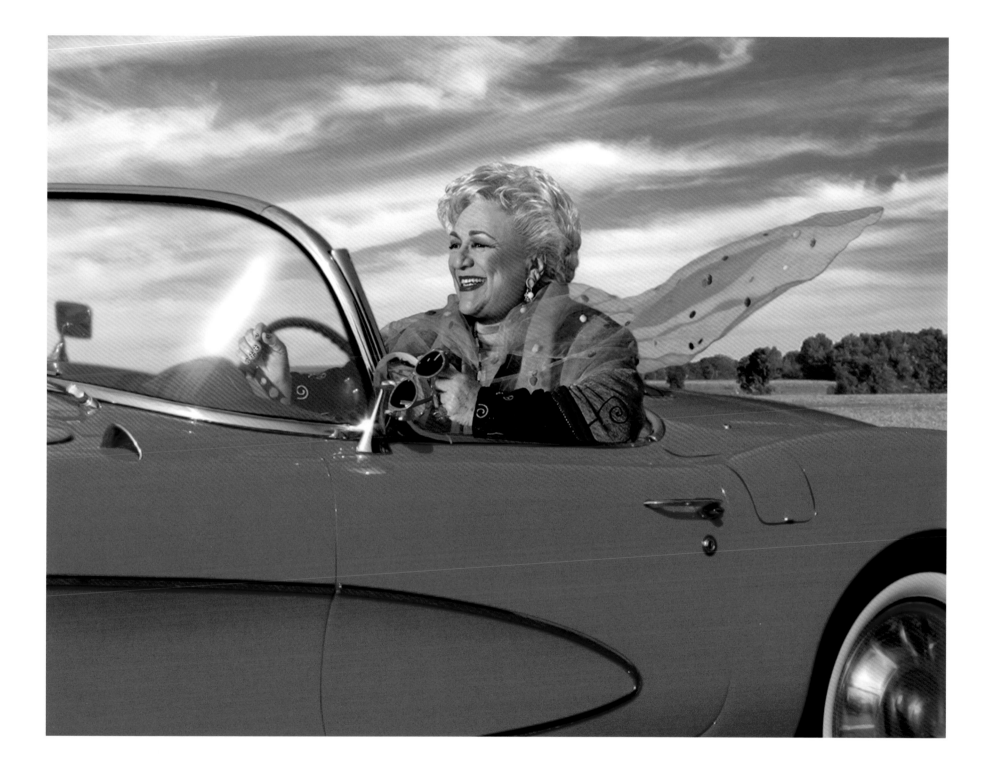

Catherine Reynolds · *Queen of Country Music*

"Growing up in my household it was Frank Sinatra, Elvis, and The Beatles. But I had family out in the country, and what they listened to seemed to sing to my soul. I like the storytellers: Reba McIntyre, Martina McBride, Wynona— that great voice that can tell a story with authenticity."

College may have increased Catherine Reynolds' love of country music—she attended Vanderbilt University in Nashville, the city that also houses the Grand Ole Opry—but it's the role of higher education in America that spawned her success, and ultimately led to her being one of the foremost philanthropists in the country.

"College tuitions increased 268 percent in fifteen years. At the same time the Federal student loan limit hasn't increased since 1992. The truly needy, 10 to 15 percent of our population, could get funding to attend college and another ten to fifteen percent, the wealthy, could attend. But that left 70 to 80 percent of the population in the middle with very few options. No one was addressing that gap."

Reynolds created a whole new product, the first twenty-year unsecured student loan—and a new industry. It was not easy to get the funding. After all, banks weren't used to making unsecured loans to people without jobs. Defying the expectations of the bankers who thought the loans too risky, the program has an extremely low default rate. "Education allows people to live the American dream. That's the simple premise at the heart of the program— people value their education." Her creative approach to private educational financing revolutionized student lending and spawned a multibillion-dollar industry of more than sixty-five lenders offering more than 200 financial products. Hundreds of thousands of Americans have been able to attend the college of their choice.

Mrs. Reynolds then turned to philanthropy with the same entrepreneurial spirit, chairing the Catherine B. Reynolds Foundation, one of the largest in the nation. In 2004, she was selected by *Business Week* as one of the 50 most philanthropic living Americans and the first self-made woman ever to make their list. As she likes to say, "If you can do well and do good at the same time, you've won the game of life."

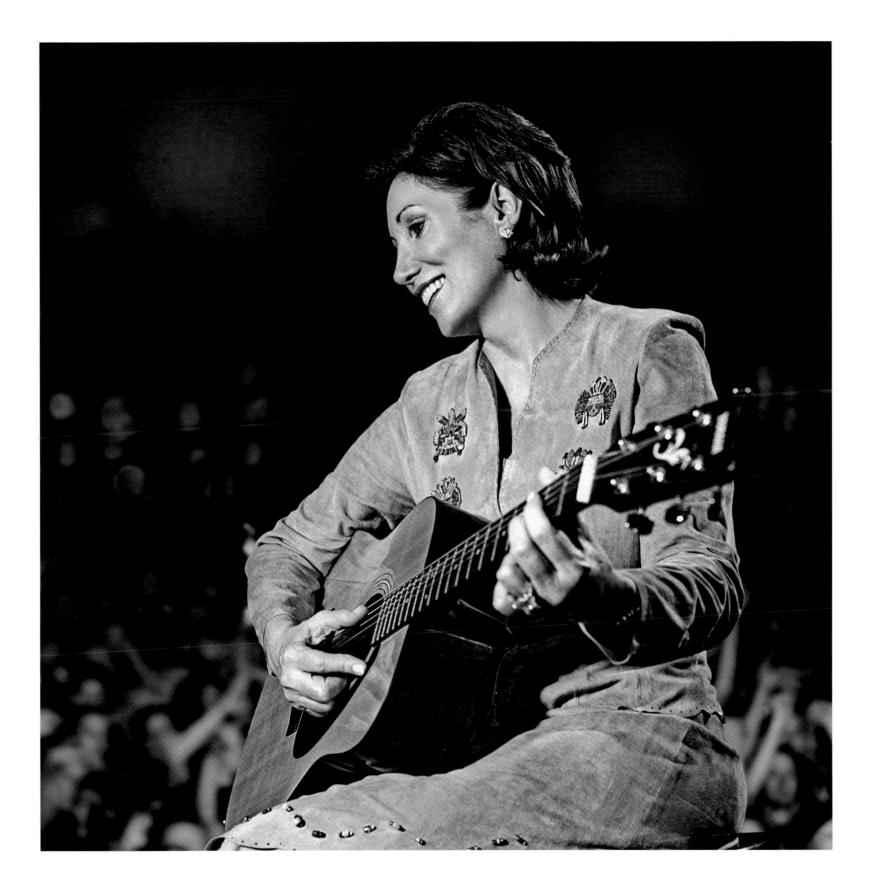

Joan Rivers · *Archaeologist*

Joan Rivers has a passion for digging things up. "That's how I got my last date."

Miss Rivers was the first sole permanent guest hostess of *The Tonight Show*, the first woman to host a nighttime talk show for Fox, and went on to win an Emmy for her daytime show, which ran for seven years. Currently, her red carpet coverage of all the major televised award shows—with her daughter Melissa—can be seen on the TV Guide Channel. She is also the hostess of *The Joan Rivers Position*, a weekly advice show on Channel 5 in the United Kingdom. "It's Judge Judy meets Jerry Springer meets Dr. Ruth. I solve everyone's problems, whether they want them solved or not."

Sometimes her professional and fantasy worlds cross. "The last time I was at Versailles, one of the curators was a fan, and she let me go into the unopened, unrenovated parts of the palace. Suddenly, I was really back in the eighteeth century.

"I go insane in medieval cities—the paintings and tapestries. I'd love to go back in time and find out what life was really like in England when they were painting themselves blue. How they solved the problems of living that we're still trying to solve today—(plus, I'm shallow—I think archaeologists have the best outfits—short shorts and little tank tops, big pith helmets and dark glasses). I love Howard Carter's first words when asked what he saw as he opened King Tut's tomb—'I see wondrous things.' I'm looking forward to the King Tut show returning. I took Melissa in the '70s. Back then I thought 'my Aunt Rita has better stuff.' I'm a little more mature this time."

So while her fantasy is worlds away from what she does every day, the qualities that have made her so successful in the entertainment industry would carry over into archaeological success. "I work hard at everything. I leave nothing to chance; I don't ever want to regret that I didn't take that last extra step to get it right. I would be a great one to comb through sand."

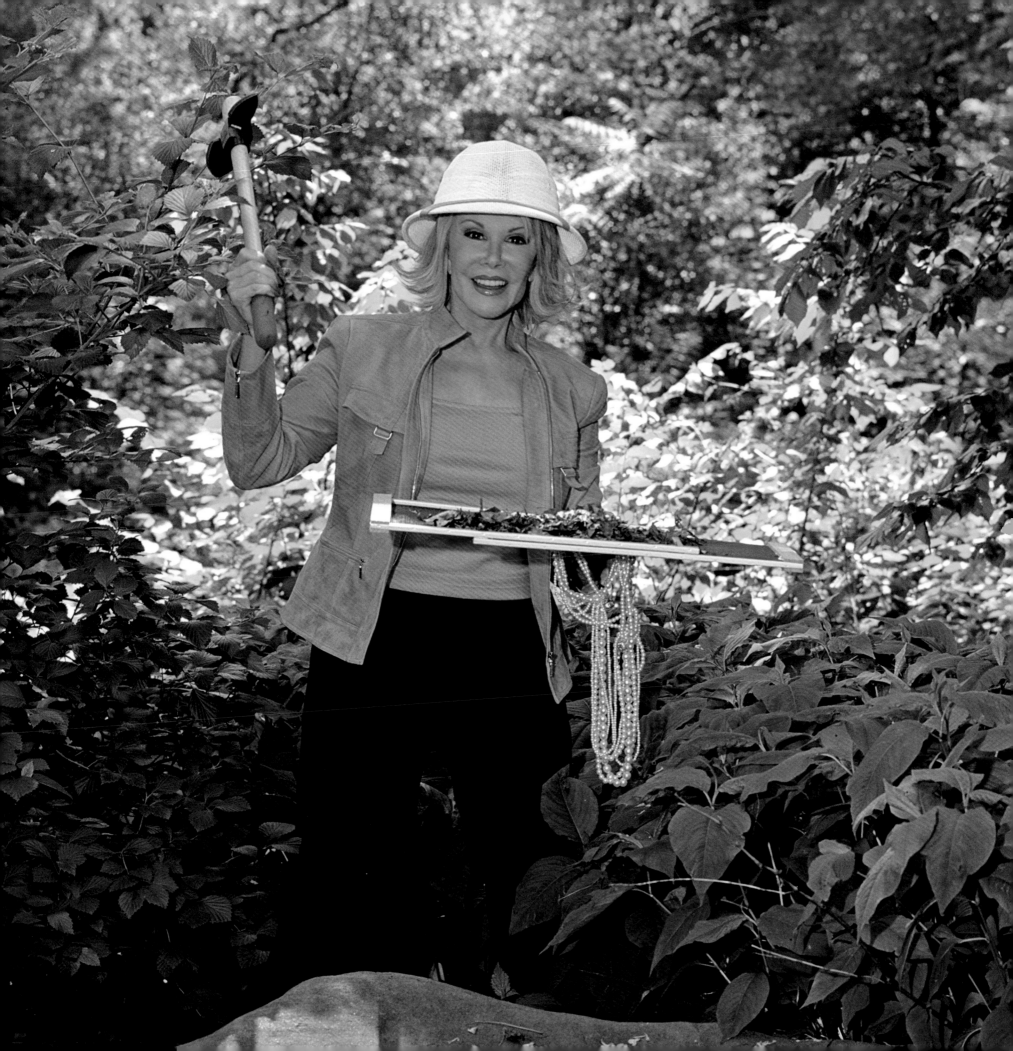

Letitia Baldrige · *Make-up Expert*

Manners and ice hockey are so rarely mentioned in the same breath. However, our society's foremost expert on manners did have two equal passions as a child—to become an opera singer and to play on her brother's ice hockey team.

Letitia Baldrige burst into our consciousness as social secretary to the Kennedy White House and chief of staff for Jacqueline Kennedy.

In other words, she kept the calendar for Camelot, and did so in a way that invited the entire country into that elegant world. Since then she has spent a lifetime promoting civility and good manners, as advisor to four other First Ladies and as head of Letitia Baldrige Enterprises, which she founded in 1964.

As a child, she dreamed of being Deanna Durbin and a congressional page. And though she never sang on the silver screen, she made more of her time in Washington than any page. She continues today to lecture on behavior and hold seminars on the subject of manners. Her twenty books, including *Letitia Baldrige's Complete Guide to the New Manners*, have sold by the hundreds of thousands and been translated into six languages.

In her books and lectures, she promotes a society "where people think of one another, not only of themselves." Her fantasy is to make that happen directly, hands-on, as a make-up expert.

In this way she would "help women who feel down on themselves feel up again; help disfigured women attain the glow of real beauty from their inner selves; help young girls highlight their natural beauty; and help older women realize that those lines are not proof of aging to be despised, but proof of a woman who has really lived, and has the fascinating stories to prove it."

She is living proof that good manners are not about rules, but about making others feel welcome and special.

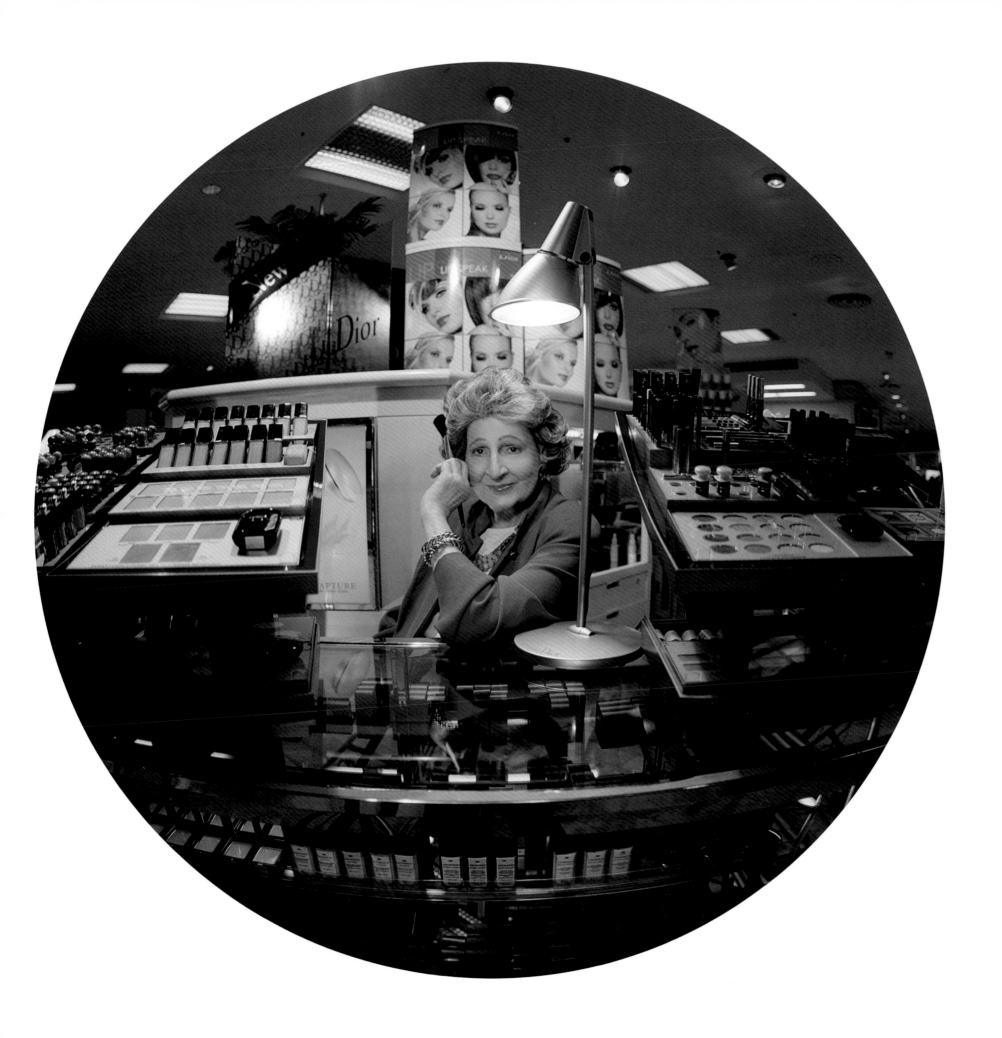

Judy Woodruff · *Detective*

"Journalism was not on my radar screen until I was out of college. I always knew I wanted a career, but I didn't really know what I wanted to do except that it should be something different. There were few women role models other than secretaries, nurses, and teachers, and the mothers I did know who worked you could count on one hand."

Judy Woodruff has covered politics and breaking news for more than three decades at NBC, PBS and CNN. In the spring of 2005 she left her full-time CNN position to pursue longer-form journalism and become a senior fellow at Harvard University's Shorenstein Center for the Press, Politics and Public Policy. For twelve years she anchored CNN's *Inside Politics*, as well as being a CNN senior correspondent. Before joining CNN in 1993, Woodruff was the chief Washington correspondent for the *MacNeil/Lehrer NewsHour* on PBS. From 1984 to 1990, she anchored public television's award-winning weekly documentary series *Frontline with Judy Woodruff*.

She is the founding co-chair of the International Women's Media Foundation (IWMF), an organization devoted to promoting opportunities for women in the news media around the world, particularly in countries where a free press is new or struggling. To date, IWMF programs have been held in twenty-two countries and on the Internet and have reached more than 3,500 women in the media worldwide, providing the information, skills, and connections they need to succeed. Each year, IWMF honors women journalists with their Courage in Journalism Award. One Iranian and one Bangladeshi reporter, as well as a German photo-journalist, were honored in 2005. The name of the award is not to be taken lightly—death threats, assaults and stabbings, war zones, censorship trials—these women have shown great courage in practicing their craft.

But courage doesn't need a world stage to manifest itself. Ms. Woodruff is also a strong advocate for people with disabilities, and has been for many years. In 1994, she and her husband, Al Hunt, were named "Washingtonians of the Year" by *Washingtonian* magazine for their fundraising work to fight spina bifida, a condition their oldest son was born with.

Being a detective is not too far afield from the profession in which she has excelled. "Well, that's what reporting is, having curiosity about something and wanting to get to the bottom of it."

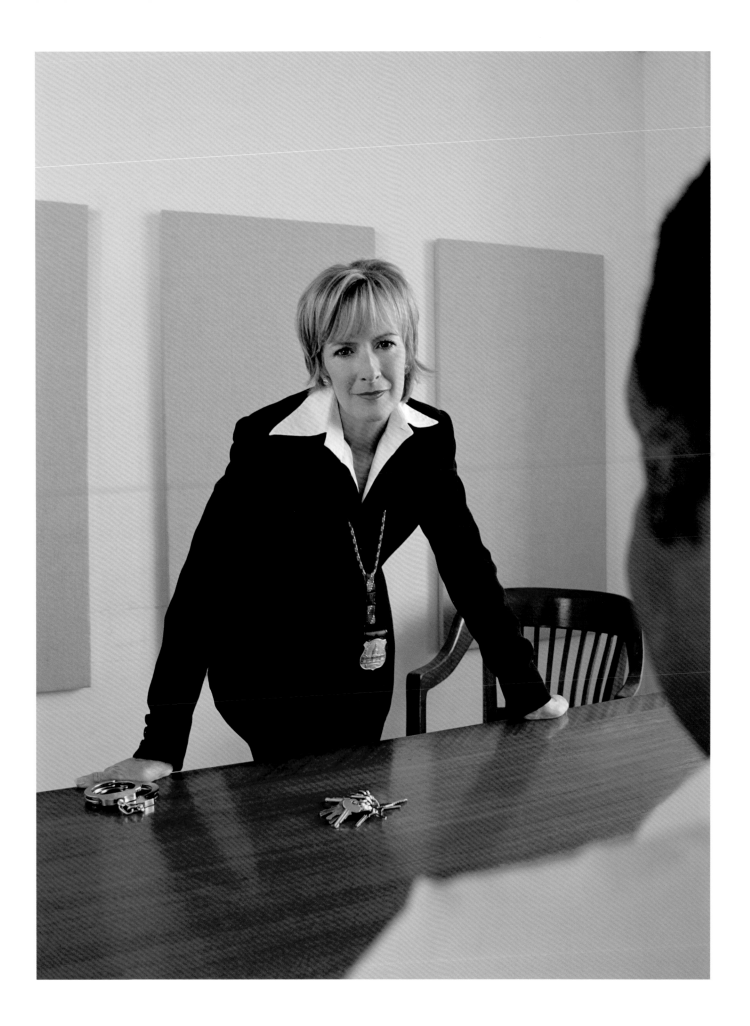

Phyllis Richman · *To Write a Classic Food Novel*

Graduate work in city planning and sociology are terrific preparation for a life of writing about food. After all, restaurants involve social behavior. "Relationships," says Phyllis Richman, "always serve as the background to what I write and how I think about food."

How do you make a sensory experience come alive? How do you make readers hear and see and taste? Writing well about food is a lot like writing well about music and art—it's very, very hard.

Yet Phyllis Richman has done it for thirty years. Food critic for the *Washington Post* for more than twenty-three years, its food editor for eight years, she has written food features for nearly every section of that paper, from the Style section to the financial pages. There have also been freelance articles, a dining column, annual dining guides and three novels: *The Butter Did It*, *Murder on the Gravy Train* and *Who's Afraid of Virginia Ham*. And it is here that this member of "Who's Who in American Cooking", this James Beard–, Penney-Missouri, and Bert Greene–award winner, reveals herself to be not only a tough food critic, but a critic of her own achievements: her fantasy is to write a "great food novel—the *Jane Eyre, Madame Bovary, Crime* and *Punishment*—of kitchen literature. Food would be as memorable as the characters and provide the setting, the action and the drama."

This fan of nineteenth century novels knows what she's up against. "The hardest thing about writing is launching it, getting started each day." She employs a simple technique to jump-start her back into the flow of her work—"I leave off writing each day in the middle of a sentence."

Just as two people can follow the same recipe with wildly different results, there's no guarantee that you can reveal the human soul through words about food. But she's going to try again. Note her favorite quote: "Painters love to paint, writers love having written."

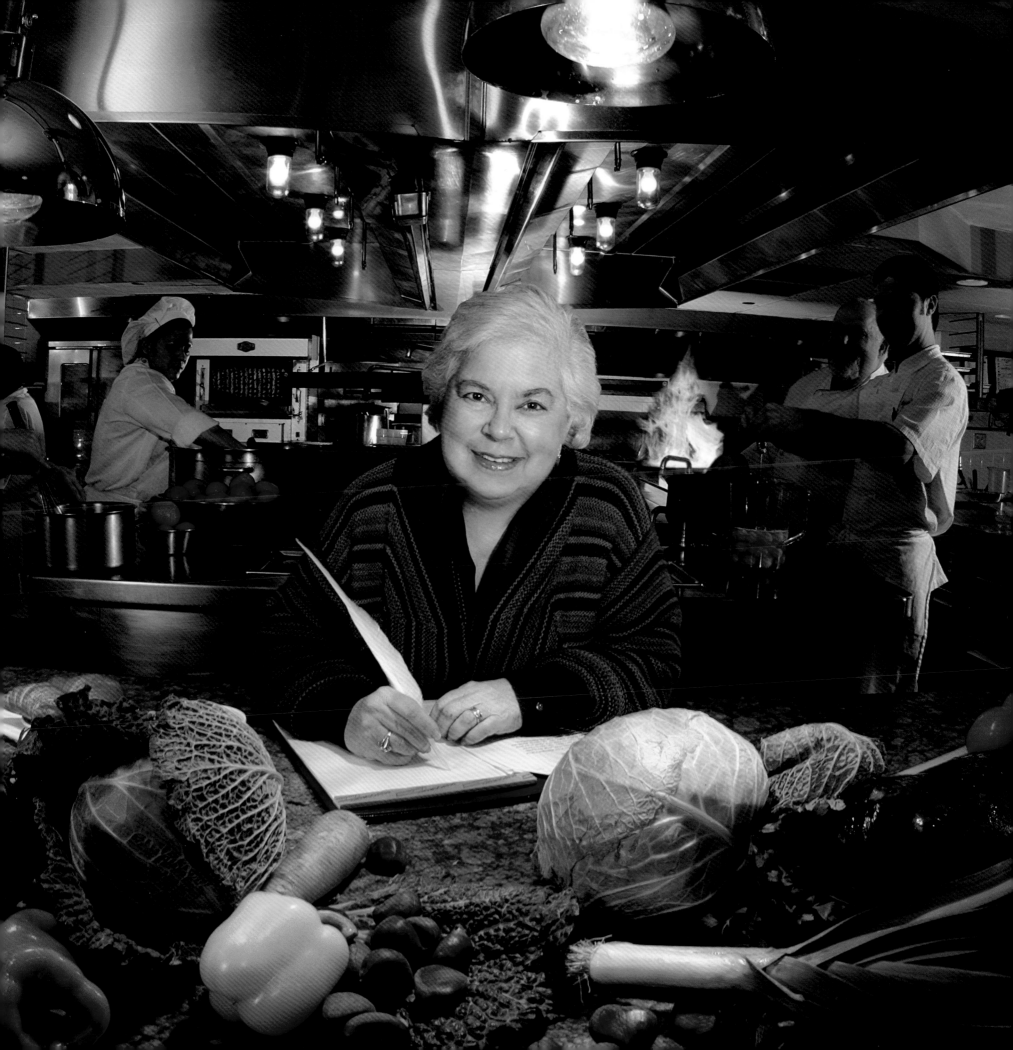

Suzanne Farrell · *Pilot*

"I love being on my island in the country. When I was still performing with Mr. Balanchine, my final weekend performance typically ended around 9:00 P.M. I would race from the theater, make-up still on, and catch the last commuter plane to Utica. That way I could stay upstate until early Tuesday morning. I would think, 'I've memorized all these ballets, I could learn to fly a plane—then I wouldn't have to rush.'"

To say that Suzanne Farrell *is* ballet would be going too far. But not by much. She did what all good ballerinas do, acting as a vessel for the work, almost disappearing into it while at the same time being the only thing an audience can see. But Farrell did so much more, transcending her vehicle to become its muse with skills that literally changed the art form.

Of her repertory of more than one hundred ballets, nearly a third were created expressly for her by George Balanchine and other choreographers such as Jerome Robbins and Maurice Béjart. Through her, they expanded the limits of ballet technique to a degree not seen before. She practiced a form of alchemy, taking form and theory and what's in a choreographer's mind and giving them a corporeal reality. The tangible accomplishments are many: she joined Balanchine's New York City Ballet in the fall of 1961 and danced there for twenty-eight years.

Dedicated to the preservation of the work of the twentieth century's greatest choreographers and to the artistic development of a world-class dance ensemble, The Suzanne Farrell Ballet grew out of a unique partnership between The John F. Kennedy Center for the Performing Arts and Miss Farrell beginning in the fall of 2000. Miss Farrell holds the Frances Eppes Chair in the Arts at Florida State University and holds honorary degrees from Harvard, Yale, Notre Dame, Georgetown University, and others. In November of 2003 she was awarded the National Medal of the Arts. But for all the honors, understanding her achievement requires a mystical view. Suzanne Farrell was a tomboy—climbing trees, in love with games—when she wandered onto the stage of an empty theater. She felt the spirit of the performers who had been there. "I bent down and picked up a splinter from the stage—I still have it—and thought 'this is the world I want to be in.'"

Her intense physicality as a dancer challenged gravity. Her fantasy is to conquer it permanently, viewing the world from eight miles high, where the turbulence of our world seems serene.

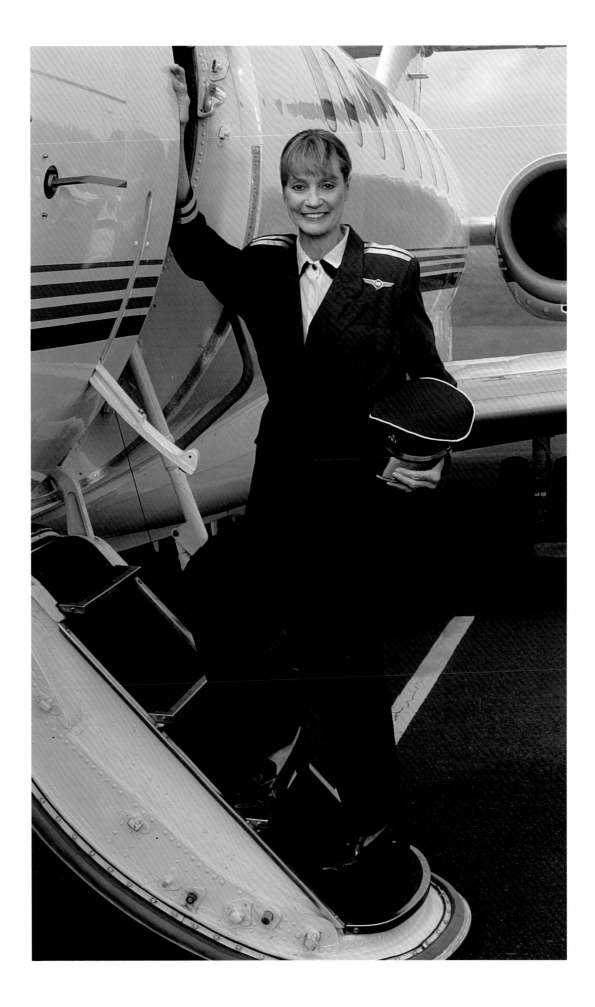

Nora Pouillon · *Shaman*

"I like to imagine myself as a modern-day medicine woman, sharing my vision to help people live better lives." That vision includes changing the country's eating habits with an organic fast-food chain. "Imagine being handed something affordable, appetizing, and nutritious at the drive-through window. We could start a revolution!"

If you were to own a restaurant in Washington, you just might want it known that it's the favorite of the president and first lady. That was certainly the case with Restaurant Nora throughout the 1990s. But what's less well known, and ultimately more important, is that Restaurant Nora became America's first certified organic restaurant in 1999. Ninety-five percent or more of everything served there is produced by certified organic growers who share Nora Pouillon's commitment to sustainable agriculture.

Surprised? Thought that distinction would belong to a restaurant in northern California? You shouldn't be. *Zagat's Restaurant Survey* says that chef/owner Nora Pouillon, "practically invented market-driven menus featuring natural ingredients." Asia Nora, Ms. Pouillon's second DC restaurant, follows the same organic and seasonal ethos. Nora does believe that "you are what you eat" and that foods grown and raised without the use of chemical additives or hormones are not only better for you, they taste better, too.

By promoting a sustainable healthy-living sensibility, she is practicing a type of communal medicine, approaching the shaman of her fantasy. It's all about what you take, and what you give back. "I think when you become a parent, you start to see the world through the eyes of your children. You begin to imagine what it might be like for them after you're gone. What we leave behind for future generations becomes more and more of a priority. To educate people on how to live sustainably, to reach their full potential but in ways that are responsible and respectful, is something I care about deeply."

Of course, this doesn't mean that everything she serves is always good for you: her dessert wine and single-malt scotch selections are extraordinary—we suggest moderation in all things.

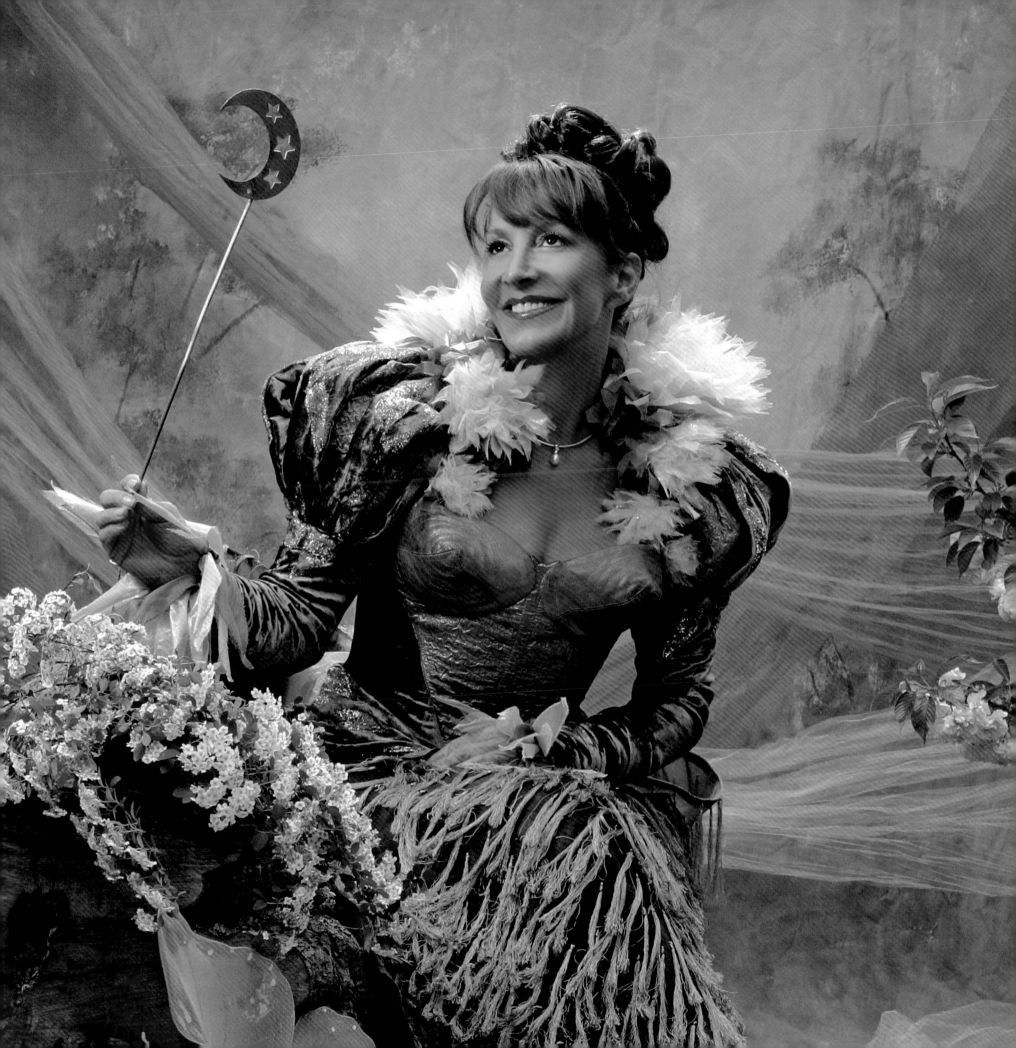

Betty Friedan · *Mystery Writer*

*"I have accomplished what
I wanted to do."*

From H.G. Wells to *The Terminator*, the idea of traveling through time to change something, and the ripple effects of that change—intentional or not—has been a hoary staple of science fiction plotting. Why bring this up when speaking of Betty Friedan? Not because her fantasy is to genre-travel in her writing from non-fiction to mysteries, which it is, but because it's hard to imagine modern America without *The Feminine Mystique*. It's hard to imagine this very book you're reading without *The Feminine Mystique*. Everyone may not be pleased with the results, but almost all will tell you that its publication in 1963 changed the world in profound ways. The sea change may have occurred without it—surely feminism was not born from a single work—but this book was its midwife.

There is no denying the arc of the women's movement in the 1960s nor its affects on our culture since then, unleashing intellectual and material resources that had been, to a large extent, previously untapped. And there's no denying Betty Friedan's role in that movement. A founder of NOW (National Organization for Women), National Women's Political Caucus, and NARAL (National Abortion and Reproductive Rights Action League), she has traveled and lectured all over the world and has written for such diverse publications as *McCall's*, *Harper's*, the *New York Times*, the *New Republic*, and *The New Yorker*. She is also the author of the books *The Second Stage, It Changed My Life*, and *The Fountain of Age*.

In recent years, she has been a visiting distinguished professor at the University of Southern California, New York University, and George Mason University. Her fantasy is to write a mystery novel, a "whodunit?" When it comes to women's rights, we already know who done it.

Connie Morella · *Shakespeare's Portia*

"I was always interested in engaging with people (I still am), whether through sports or tap dancing or drama and class activities. My mother once told the press that as a child I would even shake hands with a fire hydrant."

As a young girl, Ambassador Constance Morella built model airplanes and wanted to be a test pilot. She thinks the attraction was that being a test pilot was something women just didn't do.

In 1987, Connie Morella became the first woman member of the Maryland General Assembly to win election to the United States House of Representatives. As an advocate for women, children, and families, she was practicing compassionate conservatism long before it was a slogan. She won re-election seven times, serving sixteen years as congresswoman from Maryland's Eighth Congressional District—a Republican from a district thought to be a Democratic stronghold. She also went against gender stereotypes to promote economic growth through science and technology. It's no coincidence that Maryland's tech corridor runs through her backyard. She has truly followed the advice of Admiral Grace Hopper, America's first woman admiral: "A ship in port is safe, but that's not what ships are for. Sail on!"

Women do things no man has ever done before, too. When Connie became permanent representative to the Organization for Economic Cooperation and Development in 2003, she was the first former member of the House to be named such—man or woman.

Her fantasy seems a natural—portray the strong, wise Portia from *The Merchant of Venice*, who states, "The quality of mercy is not strain'd,/ It droppeth as the gentle rain from heaven"

After all, Constance Morella was a professor of English before she chose the life of a public servant, and points out that "the bard was prophetic in creating a compelling and compassionate woman in the law." Her example makes him seem all the more prescient.

Cokie Roberts · *Symphony Conductor*

When we asked what she still hoped to accomplish, Cokie Roberts answered "Do I still have to accomplish something? I just want to give back now." That kind of directness and clarity has served her well for the past fifteen years as a political commentator for ABC News.

Cokie Roberts is a political commentator for ABC News and Senior News Analyst for National Public Radio. She was a regular on the Sunday interview program *This Week*, ultimately becoming the co-anchor, from 1996 through 2002, of *This Week with Sam Donaldson and Cokie Roberts*.

Her appointment to the newly formed President's Commission on Service and Civic Participation is one obvious opportunity to give back, as are the non-profit boards on which she serves, including her role as vice-chair of Save the Children. Six grandchildren present many opportunities as well, both for her and her husband, Steven V. Roberts. They collaborate on several projects, including a weekly syndicated newspaper column. The Roberts are also contributing editors to *USA Weekend* magazine. Together they wrote *From this Day Forward*, an account of their own more than thirty-five year marriage, along with many other marriages in American history. It immediately made the *New York Times* bestseller list, her second but not final appearance there.

Cokie's previous book, *We Are Our Mothers' Daughters*, is an account of women's roles and relationships throughout American history. It was a number one bestseller, residing on the list for six months. Her most recent bestseller is *Founding Mothers: The Women Who Raised Our Nation*. It relates the stories of the women who, from the early 1700s through George Washington's presidency, influenced the Founding Fathers. Often through their own letters, she reveals these women's much larger role than has been generally acknowledged.

A member of the Broadcasting and Cable Hall of Fame, Cokie Roberts was cited by the American Women in Radio and Television as one of the fifty greatest women in the history of broadcasting. Her choice of symphony conductor, while grounded in an appreciation of music, has a strong element of control in it. "When you're a conductor, you tell people what to do and they have to do it—as opposed to your colleagues and children."

Barbara Mikulski · *Madame Curie*

"When just a girl I saw a movie about Marie Curie. I was inspired. She was the first woman to win the Nobel Prize and she was of Polish heritage, just like me. I decided right then I wanted to be a scientist and made my parents buy me a chemistry set."

Her dreams of being a scientist fortuitously went awry when she went to college. "I got a C in chemistry, and an A in social sciences. I decided to go with my strengths, and work to help others. That's why I become a social worker."

That middling grade was good news for the citizens of Baltimore, of Maryland and of all the United States, for it was how the Honorable Barbara Mikulski became a U.S. senator. Currently serving her fourth term, she is the third-highest-ranking member of the Senate Democratic leadership and the dean of the Senate women. But how did she get from social worker to senator? "A sixteen-lane highway that would have torn Baltimore apart and destroyed many neighborhoods was planned. We needed to organize." She built coalitions across the city, helping the people of Baltimore to save their neighborhoods, which today are thriving.

"The road fight was my turning point—that's when I knew I would rather be opening doors for others from the inside, than knocking on doors from the outside." Not long after, she won a seat on the Baltimore City Council, serving for five years. In 1976 she ran for Congress and won, representing Maryland's Third District for ten years.

From community activist to U.S. senator, she has never changed her view that all politics and policy is local and that her job includes serving the people in their day-to-day needs. Maybe it came from seeing her father open the family grocery store early so local steelworkers could buy lunch before the morning shift. Attending local Catholic school, Mikulski was inspired by the Christopher social movement. Their motto—"It's better to light one candle, than to curse the darkness"—became one her guiding principles.

And her scientist dream? "I'm on the Commerce, Justice, Science Appropriations subcommittee. We put money in the federal checkbook for NASA, the National Science Foundation, and the National Oceanic and Atmospheric Administration."

Bernadine Healy · *Football Coach*

Her childhood interests—science, philosophy, religion, and Jane Austen—have served her well. She is an accomplished cardiologist, writer and administrator, and in each role has tackled difficult moral and ethical issues head-on. But it is her ability to synthesize her skills, and those of others, into something even greater that is even more remarkable.

Bernadine Healy, M.D. was the first woman to head the National Institutes of Health. Today a senior writer for *U.S. News and World Report*, she covers medicine and science and writes the regular *On Health* column. Prior to this, Dr. Healy was president of the American Red Cross where she instilled a new medical and teamwork motto: "Together we can save a life." Unlike many scientists, Healy views administrative posts as important because of their broader policy implications. For example, she used her positions to fundamentally change medical and research policy pertaining to women, undermining the subtle but pervasive bias against women in medical research.

When Healy was appointed director of the National Institutes of Health in 1991, with its 16,000 employees and $9 billion budget, it had been without a director for twenty months, and drifting. "We needed a moon walk for women." That would be her Women's Health Initiative, designed to close the huge gap in clinical knowledge. She assured that NIH would fund only clinical trials that included both men and women when the condition being studied affected both genders. Her own research and practice in cardiology led to a deeper understanding of the pathology and treatment of heart attacks, including their distinctive nature in women.

Yet even as she held various administrative posts, Healy always reminded those around her to "imagine you're the patient." As a child, her parents operated a small perfume business from a cement block building behind their house. At Vassar College she majored in chemistry and minored in philosophy, graduating *summa cum laude*. "When I was growing up, it was unusual for a woman to pursue a career in medicine." She was one of ten women in a class of 120 at Harvard Medical School when she received her M.D. *cum laude*. Perfume leads to chemistry; philosophy to football. Why a football coach? "Football demands the leadership to build the best talent, demand teamwork, generate enthusiasms and never give up. And to play the sport well, you have to imagine you're a fan and share their passion to win." Sounds exactly like the leadership she has already shown.

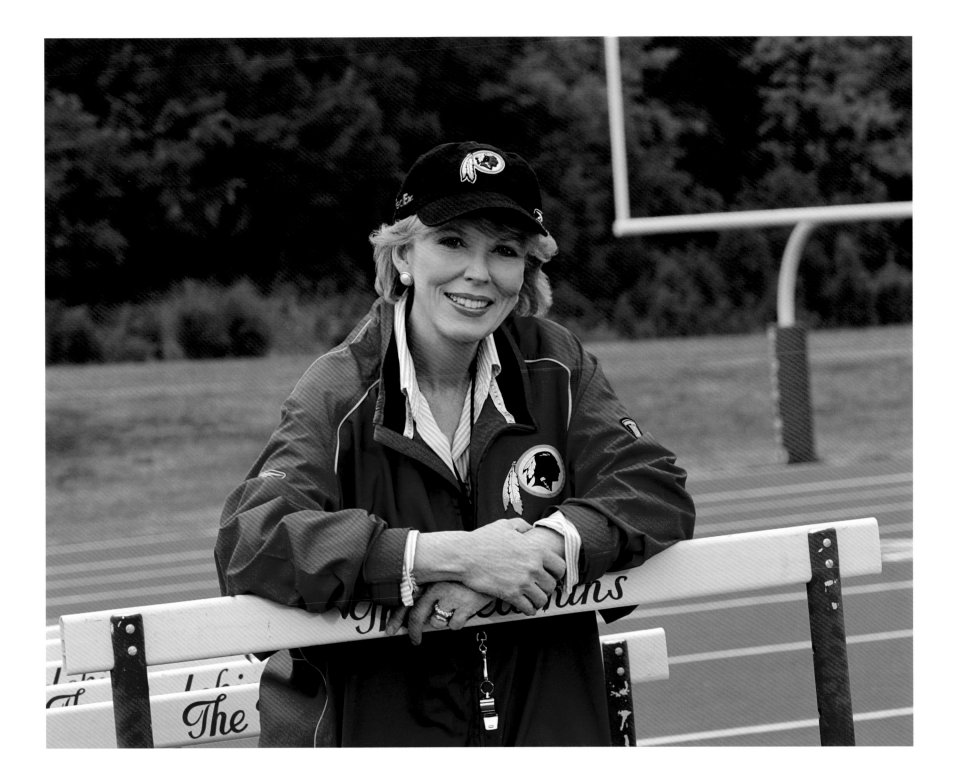

Dina Merrill · *Interior Decorator*

Dina Merrill's childhood enthusiasms were gymnastics and animals, especially tortoises. Why tortoises? "Jumbo. He was a giant land tortoise from the Galápagos Islands. We were visiting the islands and eventually took him to the Honolulu Zoo on our boat. I would ride him around the deck. He was very intelligent, and figured out how to get into everything."

Maybe it was Jumbo who taught the young Dina Merrill to stick her neck out. While her parents were less than enthusiastic when she enrolled at the American Academy of Dramatic Arts, she was soon an established and well-respected professional. Yet she took the risky move of walking away from it all to marry and raise her children.

She still starred in more than thirty films (and counting), on Broadway and on television. Today she not only acts in films, but produces them as a vice-chairman of RKO Pictures. Raising a family and having such a full career are just two of her accomplishments. When one of her children was diagnosed with diabetes, Dina became a founder of the Juvenile Diabetes Foundation.

She is a director of Project Orbis, a flying eye hospital that teaches advanced eye care and surgical techniques all over the developing world. "It's a DC–10 that's both a surgical hospital and a teaching facility. Our volunteers will perform an operation as chief surgeon, with a local doctor attending. Then they will assist as a local doctor performs the same operation on another patient. In this way, our influence is felt long after we leave."

Much of her time is devoted to working for the disadvantaged, principally for the New York City Mission Society. She also works for the election of Republican pro-choice candidates. In support of the arts, she was a presidential appointee to the Board of Trustees of the John F. Kennedy Center for the Performing Arts and is currently a trustee of the Eugene O'Neill Theater Center and a director of the Museum of Broadcasting.

Her interior decorator fantasy isn't only about herself either. "My husband and I want our homes to reflect what we like. And when you decorate for someone else, you want to create something that is art, that is beautiful, but must also capture the essence of what a person wants around them to be comfortable."

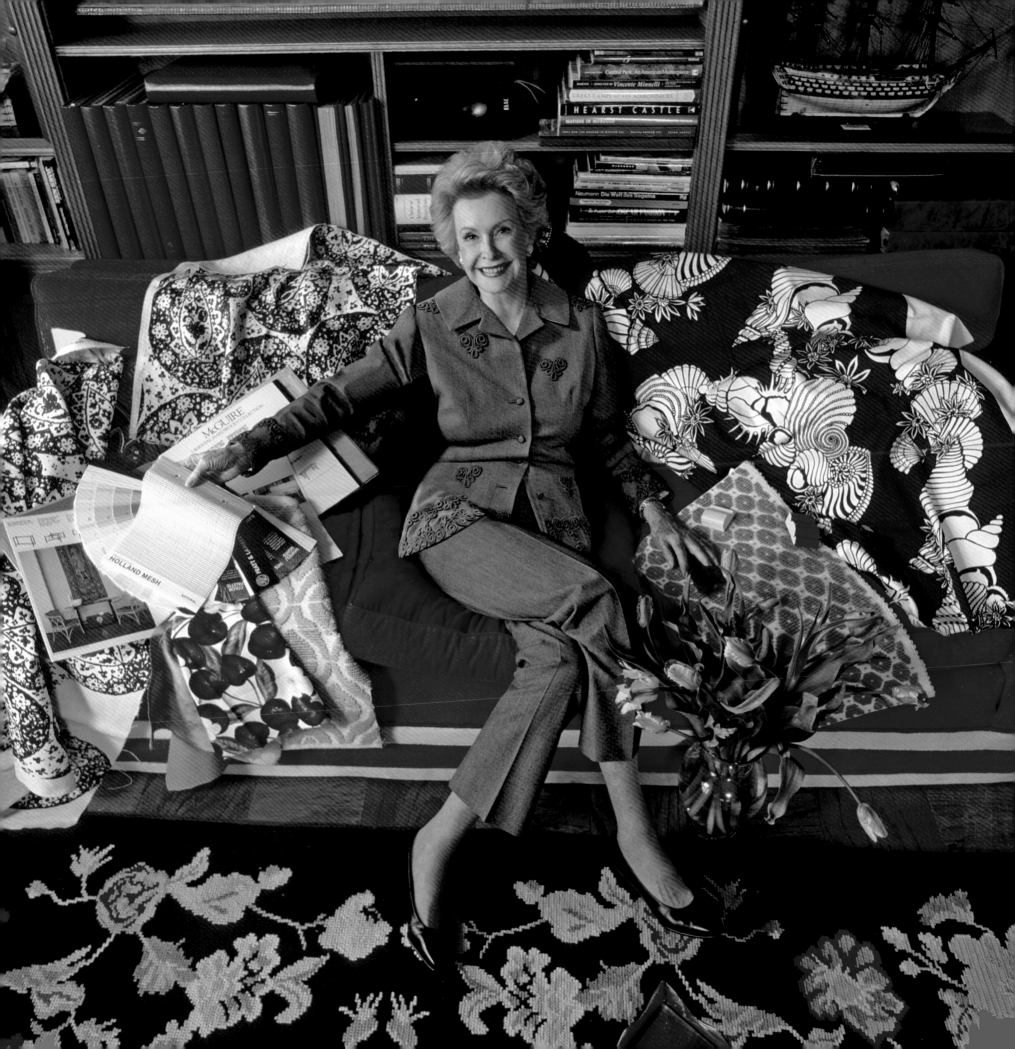

Helen Thomas · *Torch Singer*

As a young girl, Helen Thomas dreamed of being a journalist or a torch singer. "All children are performers," she states, and she was no different when her family would gather round a piano. She imagined herself as Helen Morgan, famously draped on a piano singing *My Bill*. Glamorous, yes, but knowing what we now know, the pull of a good lyric must have also been at work.

By high school she knew she would become a journalist, but that hardly describes her accomplishments in the field. As United Press International White House bureau chief, president of the White House Correspondents Association and president of the Gridiron Club, she was the heart, soul and conscience of the White House press corps. Covering every president since John F. Kennedy to George W. Bush, she wrote three books on the subject, and was the first woman to open and close a presidential news conference. She vividly remembers bringing the proceedings to an end by saying to JFK, "Thank you, Mr. President."

In short, she became Helen Thomas, *sui generis*.

Along the way, she picked up forty honorary degrees, and now, freed from the constraints of objective reporting, regularly gives us her opinions as a Hearst Newspapers' columnist. Her favorite quote is "Ask not for whom the bell tolls. It tolls for you." A very old aphorism about facing the truth, rendered with the modern "you" rather than "thee." How like Helen Thomas.

What's left to do? Plenty, as her columns clearly show, but in terms of fantasy and dreams the torch singer inside remains. It's not hard to understand the appeal of the intimacy of a small room, a piano, and timeless lyrics to a writer who made the whole world her stage.

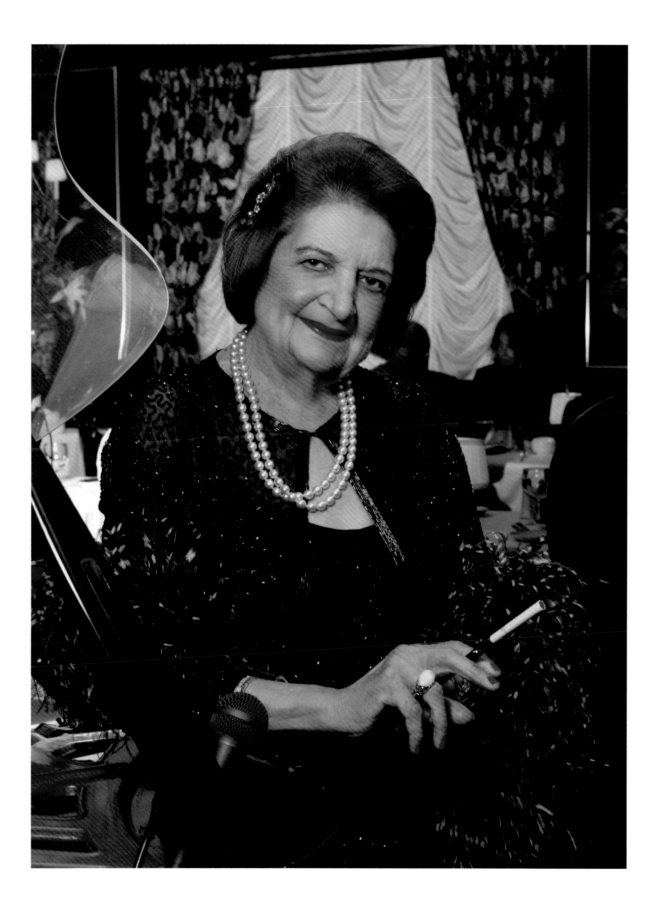

Laney Oxman · *To Have Her Sweet Sixteen Party*

"I was four years old and drawing on the walls with crayons, starting in my bedroom, continuing down the hallway, into the foyer and out to the lobby of the apartment building we lived in. It's such a vivid memory; I was so excited I couldn't stop—I even drew on the mailboxes. "Then we moved into our own home and my father gave me a wonderful gift: the entire basement was coated in a chalkboard paint. I could draw all I wanted to, even giant murals."

You can see Laney K. Oxman's work in the permanent collections of the Corning Museum, the Virginia Museum of Art, the White House Collection of American Art and many other venues. Layered and complex, her ceramic and glass pieces combine several techniques to comment on the varied and changing roles of women through time, from the real to the iconic.

"I am a woman and an artist. These elements cannot be separated. My work is who I am and what I am. Through it, I am fulfilled."

Married two weeks after her eighteenth birthday, Laney put off formal schooling because she wanted to have children (which she did at ages nineteen and twenty-one). Her husband, Michael, was studying to be an architect at Pratt Institute in New York. One day, he brought home some clay from a ceramics class he was taking and showed Laney how to hand build. That was it. "Putting my hands to clay and modeling it was so natural that I knew right then I would become a ceramic artist."

Laney finds giving to another generation very rewarding. She recently received her MFA from Temple University so she could teach at the university level as well as create.

Her piece in the White House Collection is entitled *Feminine Nostalgia*, which leads directly to her fantasy—to be sixteen again for one night, and attend the sweet sixteen party she never had.

But following her desire to give to the next generation, her fantasy has spurred another piece. In this case, not a work in ceramic and glass for public display, but a quiet and private act. Each year she helps another graduating senior, someone who otherwise couldn't afford to attend her senior prom, to enjoy her own real life-fantasy evening.

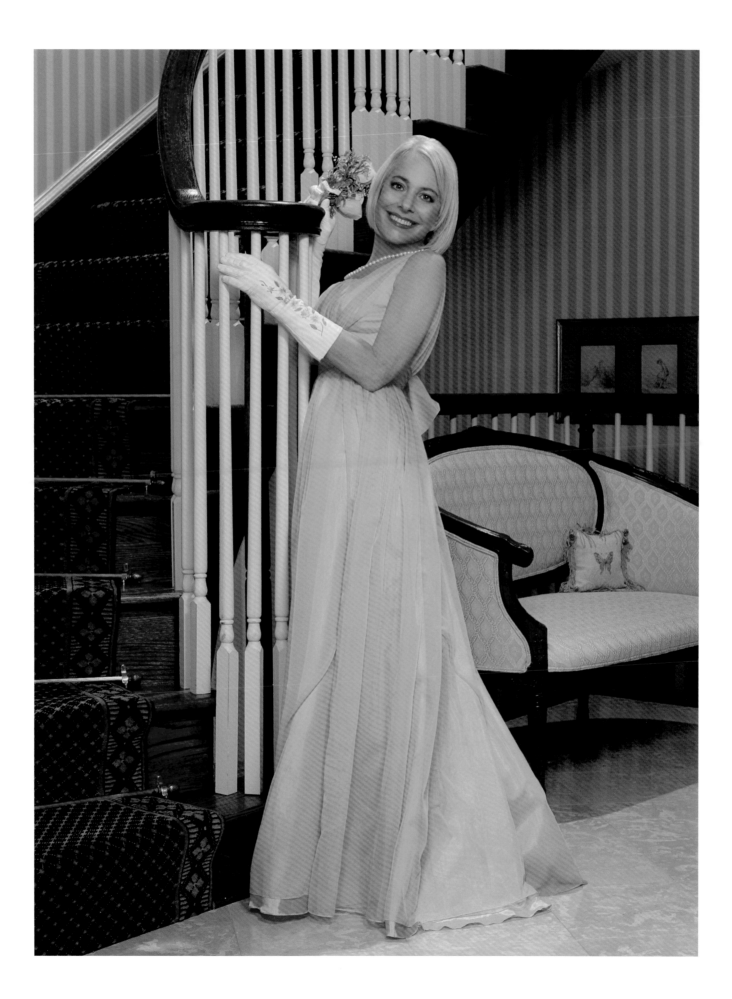

Gail Berendzen · *Firefighter*

Gail Berendzen's first experience with organized women was a softball team: "When Christ the King Lassies—a girls' softball team—came to town I was ten and one of the first to sign up. I wasn't very good. I spent the summer dodging runners in the position created just for me as a shortstop between home plate and first base. But I still loved the game."

That same young girl figured out early that there were limitations and possibilities, accepted roles and other paths for those who dared. "I planned to become a teacher. It was that, nurse, or mother. Nurse was never going to work as long as people had blood, and, unlike mothers, teachers got summers off to travel."

As an adult she would found an organization that provides women insight on critical issues from prominent speakers, all in an atmosphere conducive to networking and support. That is W.O.M.E.N. Inc., otherwise known as Women Organized for Mentoring, Education and Networking. It began with Women of Washington (DC) in 1991, followed by Women of Los Angeles and Women of Pasadena, and has put on more than three hundred events. W.O.M.E.N. Inc. fosters bi-coastal networking between all its dynamic and diverse members—men can be members, too. Members' professions include business, finance, law, medicine, education, government, arts and sciences, television, and media.

So why a firefighter fantasy? "Even before 9/11, I had great admiration for firefighters. They have a bond you don't see in many professions. Unlike 'emergencies' that come up in offices, these people put out real fires—a dangerous, multi-skilled job I could never do. Underpaid and underappreciated (until needed), they put their lives on the line every day. I would love to be a part of such a team, maybe steering the back of a hook and ladder and feeling the satisfaction of putting out a fire or two."

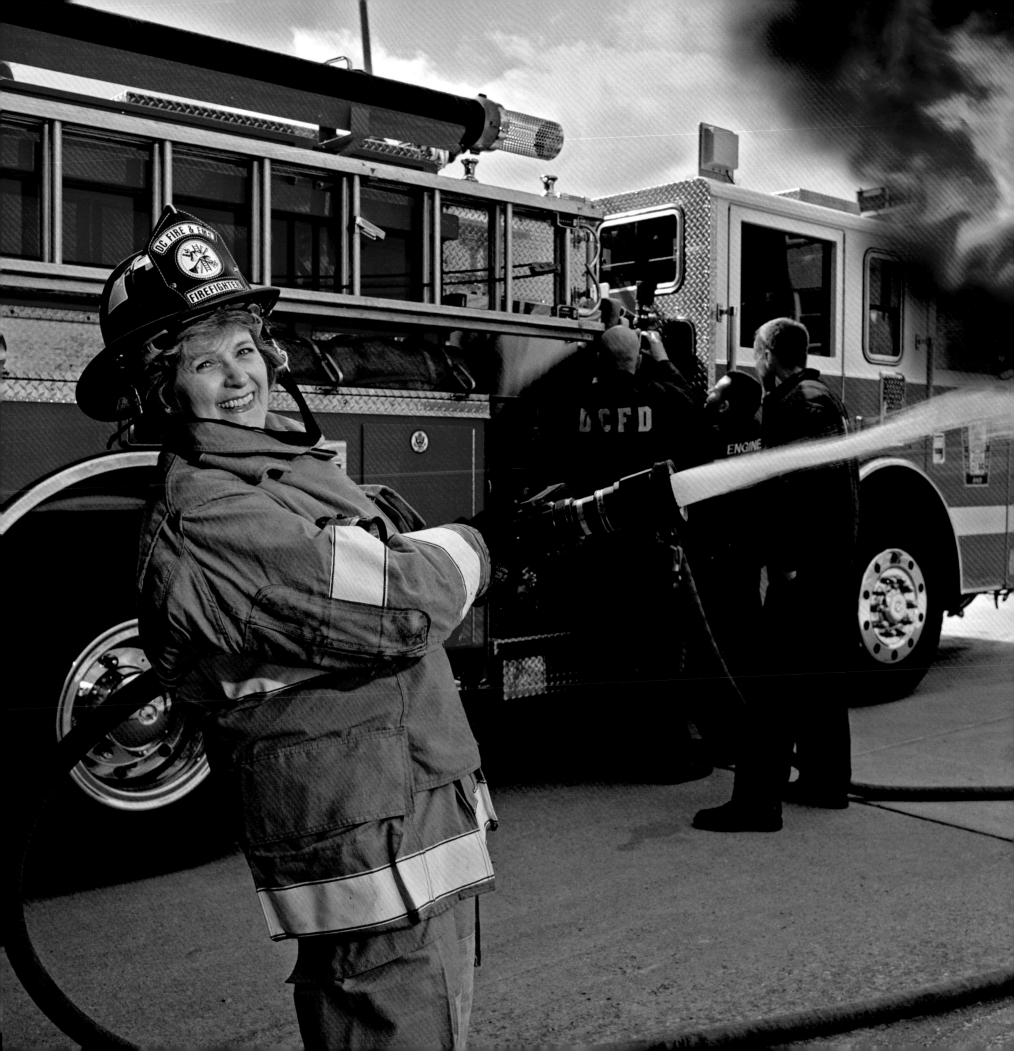

Eleanor Clift · *To Rescue Abandoned Animals*

The cats she knew as a child were workers, prowling around her father's delicatessen in Queens, New York, earning their keep by catching mice. "My whole life strays found me," she said, until two years ago she went to a shelter for the first time. "I thought it would be depressing. Instead, we took the first two cats we saw, and I was so impressed with the job they do on a shoestring budget that I've been helping ever since."

On the way to winning an essay contest on "What the United Nations Means to Me", a thirteen-year-old girl was singled out by one of the judges. "We have similar names" said the woman who had recently headed the drafting of the Declaration of Universal Human Rights for the UN. This well-known humanitarian, Eleanor Roosevelt, became a role model for the young woman who would grow up to be a well-known political journalist, one of the most respected of the rather recent vintage of reporters we call pundits. Eleanor Clift is regularly seen on the air covering Washington as a political analyst for Fox News Network and as a panelist on the nationally syndicated *The McLaughlin Group*. Formerly *Newsweek's* White House correspondent, she currently is a contributing editor for the magazine and writes the weekly *Capitol Letter* for Newsweek.com and MSNBC.com.

Eleanor is also the author of *Founding Sisters and the 19th Amendment* and the co-author, with her late husband Tom Brazaitis, of *Madam President: Shattering the Last Glass Ceiling*—which tracks the rise of women in politics—and *War Without Bloodshed: The Art of Politics.*

Is there a bit of the humanitarian in her reporter's role? When she's on the job, many of the most powerful people in the world know that someone who truly understands the system is watching—and reporting back to the rest of us. After all, her favorite quote is "Feel the fear and do it anyway."

But after spending the day keeping accountable people whom some might call "fat cats," she returns home to her own real cats, rescued from shelters. Her fantasy is to rescue countless more cats and other animals: a feline-itarian!

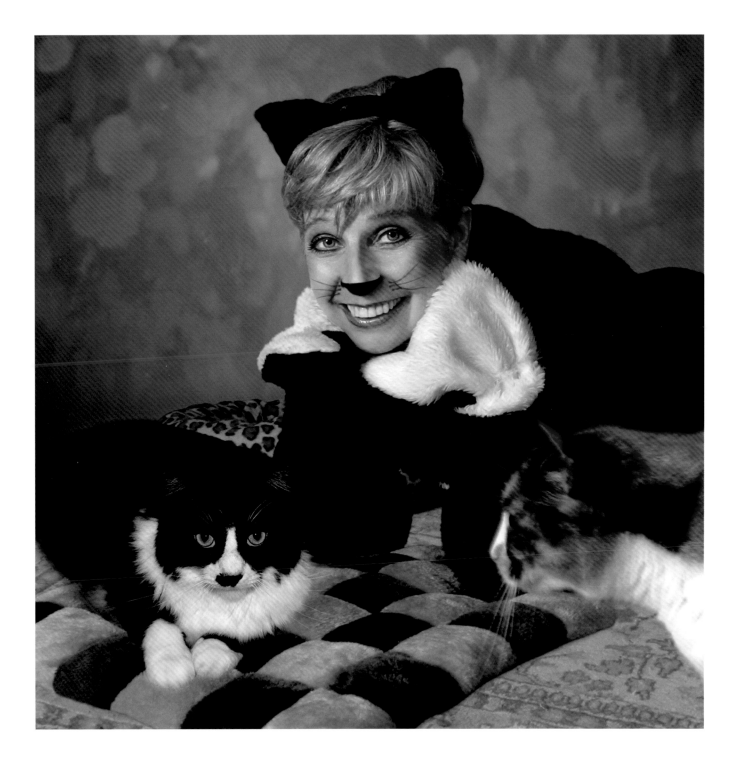

Nesse Godin · *To Build an Airplane*

"As a little girl, I idolized my oldest brother and wanted to be just like him. He was going to college to be an engineer. I asked him what that meant, and he would say 'I'm going to build airplanes.' 'How?' I asked, at which point he would make a paper airplane and fly it across the room. 'Like that.'"

For Nesse Godin, "Love your neighbor like yourself" are words to live by. She spends a lot of her time convincing others of the value of those words as well. Had I walked in Nesse Godin's shoes, a walk that included a death march, could I find the strength within me to think that way? We must repeat it: love your neighbor like yourself.

She was born in Shauliai, Lithuania, where she lived with her parents and two brothers. It was a place where neighbors had lived together in peace for many years. Suddenly, it was all about hatred. The writing literally was on the wall—slurs painted on the sides of buildings. Then one day she was no longer free; the Jews of Shauliai were rounded up and forced into a ghetto. She was thirteen. At sixteen she was loaded into a cattle car. Unknown to her, the destination was the Stutthof concentration camp. She survived four labor camps and a dead of winter death march. (The Nazis didn't want the Allies to find witnesses to what they had done.)

Nesse has dedicated her life to telling her story, personally teaching young people and adults what hatred can do. She was one of the first survivors to speak out, and is co-president of Jewish Holocaust Survivors and Friends of Greater Washington and a founding member of several survivor groups. Nesse volunteers regularly at the United States Holocaust Memorial Museum, has told her story in many documentary films and even spoke recently at the United Nations. She has numerous awards and recognitions from both military and civic organizations, including the Elie Wiesel Holocaust Remembrance Medal.

She and her husband Jack, also a survivor, settled in Washington, DC and are proud parents of two daughters and one son, and grandparents of seven. Remarkably, one brother escaped the ghetto before deportation, and both her oldest brother and her mother survived the camps as well.

Her fantasy is to build an airplane, just as her brother said he would. Maybe to make it easier for her to spread her story across the globe.

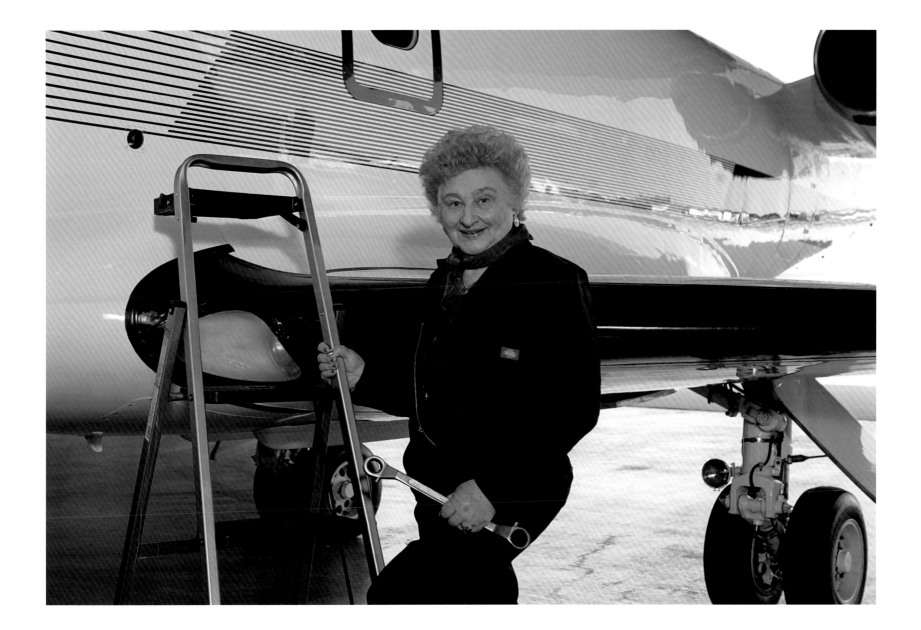

Debbie Dingell · *Four-star Hotelier*

As a child, Debbie Dingell was interested in meeting all kinds of people. As an adult, she has done just that, but with the added satisfaction of not just meeting but also helping people in countless ways. In between, as a young girl, she dreamed of becoming a nun.

Could it be that today's Debbie Dingell arose from the cross-pollination of a child who delighted in interpersonal connections, and a young girl who imagined dedicating her life to something higher? Did these words of Mark Twain have something to do with it? "Kindness is the language which the deaf can hear and the blind can see."

Whatever the influences, Debbie Dingell spearheads the philanthropy of one of the world's biggest corporations as vice-chair of the General Motors Foundation and executive director of Global Community Relations and Government Relations at GM. But she also directs many other charitable and civic efforts as a private citizen, concentrating on women's issues, a focus that grew twenty years ago from the shocking discovery that there were virtually no major studies on women's health issues. Rather, studies on men *inferred* the same results to women. She also found that funding for breast cancer research and other women-related illnesses was practically nonexistent, and that insurance companies were forcing women out of hospital beds almost immediately after childbirth.

She set about founding the National Women's Health Resource Center, which she chaired, and became a member of the National Institute of Health's Advisory Panel for Women's Research. On the Advisory Board of the Susan G. Komen Breast Cancer Foundation and the Michigan Women's Foundation, she also served as vice chair of the Barbara Karmanos Cancer Center in Detroit and co-founded the Children's Inn at NIH, a private, nonprofit residence for pediatric outpatients at NIH. The Children's Inn keeps children with their families during serious illness, facilitating their healing.

Her fantasy life—to meet plenty of people and help them—is not far from her reality. Only in this case all the occasions are of the happiest kind—weddings, anniversaries, big celebrations. She wants to run a four-star hotel.

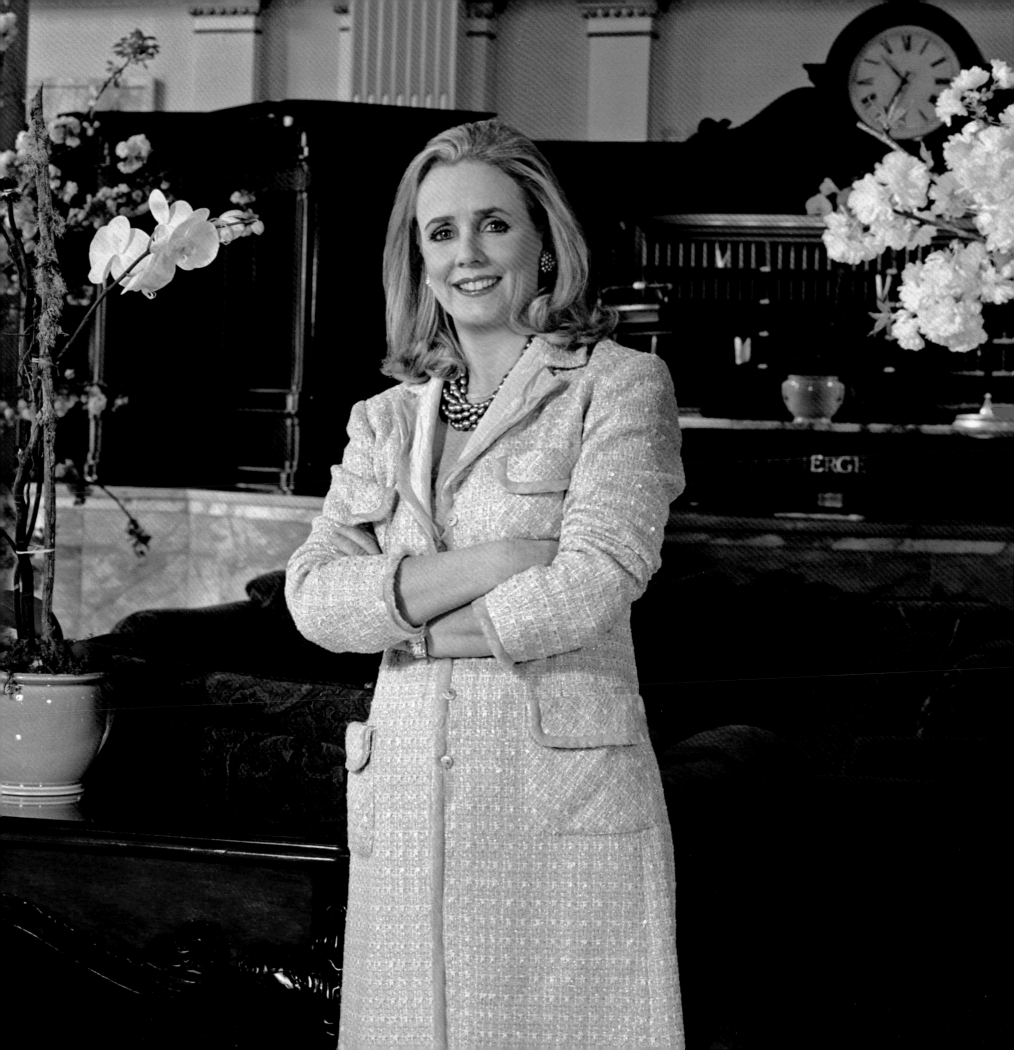

Marie Johns · *Bistro Owner*

Marie C. Johns recently retired as president of Verizon Washington, DC. "I was so fortunate to have a great career in telecommunications for over twenty years." But in addition to being responsible for Verizon's nearly $700 million operations in the District of Columbia, she was at one and the same time an engaged business leader in the Washington Metropolitan region, and remains so.

Today, she continues to provide leadership to a wide range of professional, civic, and cultural organizations, working to improve the District of Columbia's viability on several fronts, particularly in efforts related to strengthening education, health care, and economic development systems. These organizations, past and present, include the DC Chamber of Commerce, the Greater Washington Board of Trade, the Federal City Council, Howard University, the Washington Performing Arts Society, and the YMCA. She is the founding chair of the Washington DC Technology Council and serves on the boards of directors of HarVest Bank of Maryland and the Mid-Atlantic Permanente Medical Group.

Marie is an active member of the Metropolitan African Methodist Episcopal Church. She cites Philippians 4:13: "I can do everything through Him who gives me strength" and a line from a beautiful old spiritual "If I can just help somebody, then my living will not be in vain," saying they continue to inspire and guide her as she looks forward to her next career. "I am not sure just what it will be, but I am excited about the possibilities, and want to leave a legacy of service."

As a child, she had a desire to travel to different places. "I always wanted to explore new areas and meet new people. In my imagination, that was the essence of adventure." With a bistro like *Chez Marie*, she could meet all those new people, and the adventures would come to her.

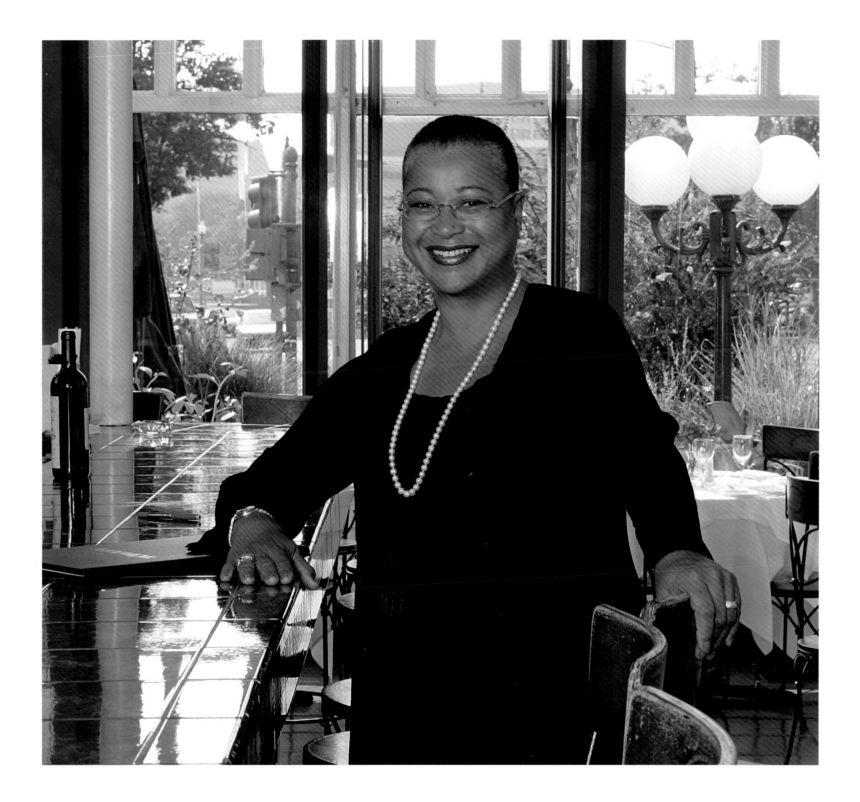

Joy Zinoman · *To Live in a Dacha*

"We recently did an entire season of Russian plays, seven of them. So we went to Russia and were the guests of an actress and playwright couple. They took us to their dacha. Incredibly beautiful, it was your bohemian fantasy of the artist's life – lots of food, people singing and playing instruments."

Imagine taking fictional characters whom we know and love, removing them from the works in which they appear, and having them meet in a brand new work. That is a supreme act of imagination. As part of The Studio Theatre's 2005 all-Russian season, Joy Zinoman directed *Afterplay*, in which two of Chekhov's characters, each from a different play, meet twenty years later in a new setting. But Joy Zinoman doesn't just direct plays. She directs entire theater companies. Founds them. Builds them into local institutions with national reputations. And that is imagination made concrete. She founded Washington DC's The Studio Theatre almost thirty years ago and has been its artistic director ever since. Three years earlier she founded The Studio Theatre Acting Conservatory. A decade later The Studio Theatre Secondstage for emerging artists was born.

The Studio Theatre not only serves artists and audiences—it has led the revitalization of an area that was economically in ruin since the 1968 riots. Today, Washington's Greater Fourteenth Street Historic District is thriving, and nothing says more about the area than the award-winning renovation and expansion of the Studio Theatre complex.

Joy Zinoman did all this after living in Thailand, Laos, Taiwan and Malaysia and becoming an expert in Asian theater, She taught in both Taiwan and Malaysia and is fluent in Asian languages, including Mandarin Chinese. "I lived in Asia for almost fifteen years, returned, got a degree in Peking opera, gaining extraordinary experience in Asia in the theater that I wouldn't have had as a woman in this country."

So with all that international experience and non-stop work, who could blame her for wanting to get away to the traditional summer retreat of the Muscovite, the Russian dacha? "I have a romantic attachment to that setting as I love Chekhov and most Chekhov plays take place on estates." Maybe that is how she accomplishes so much—her work and fantasy intertwine. Away at her dacha, which Chekhov characters will be joining her?

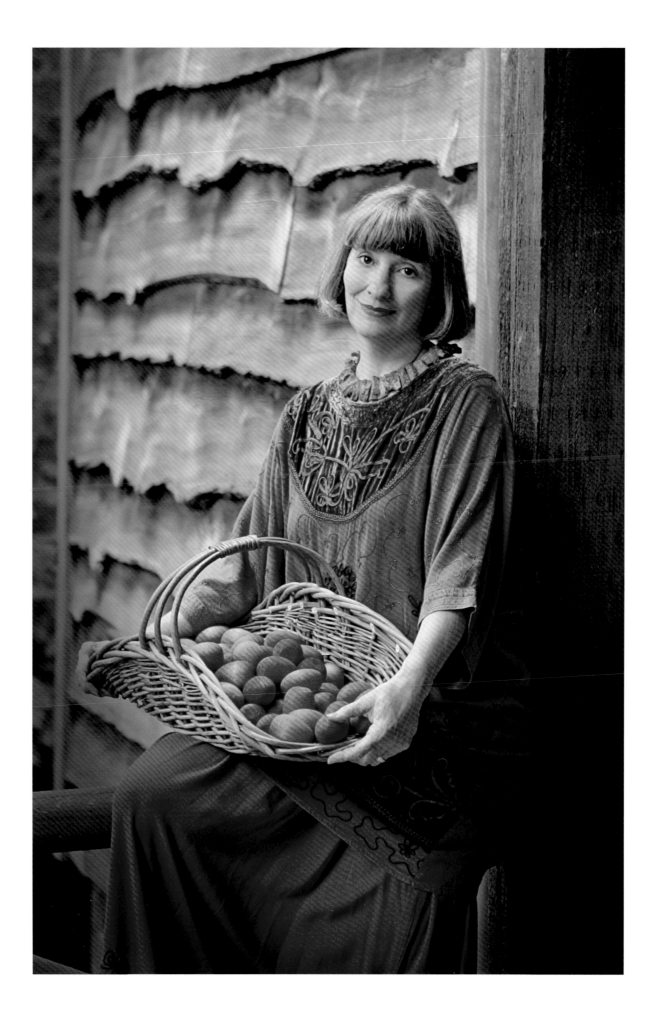

Charito Kruvant · *Lion Tamer*

M. Charito Kruvant is founder and president of Creative Associates International, Inc., a professional and technical services firm that helps communities in transition. Simply listing some of the countries where they are active—Afghanistan, Liberia, Ecuador, Zambia, Ghana. Sudan, El Salvador, the Philippines and even Iraq—gives us insight into the kind of turmoil she often faces, and works to overcome. Maybe because a civil war forced her own family to flee their Bolivian homeland when she was just a girl, she understands what that word transition really covers.

Her firm supplies education; mobilization and communication; and helps communities and societies, especially, those which have been in turmoil and conflict, to master change and engage in transformation. For example, in Guatemala, they established programs to help reintegrate former gang members into the community, and to provide education and job training for at-risk youths. In Ghana, a program to assist 12-to-17 year olds working in the harvesting and processing of cocoa, uses literacy as an entry point. That is at the heart of what the firm does, implementing programs that have real local roots as well as national backing.

M. Charito Kruvant started all this more than 20 years ago with help from the U.S. Small Business Administration and is currently chair of the Advisory Board of its Washington District Office. Recently, Charito was selected to be chair of The Community Foundation for the National Capital Region. The Foundation is a part of a network of more than 650 community foundations across the United States.

This woman who was once lowered out of a helicopter to negotiate with rebels now wants to tame a lion. "I believe there is a lion inside of every one of us, and that once we are able to tame this lion we achieve wisdom." From where we stand, it looks like she's spent a lifetime helping others tame the lions within them.

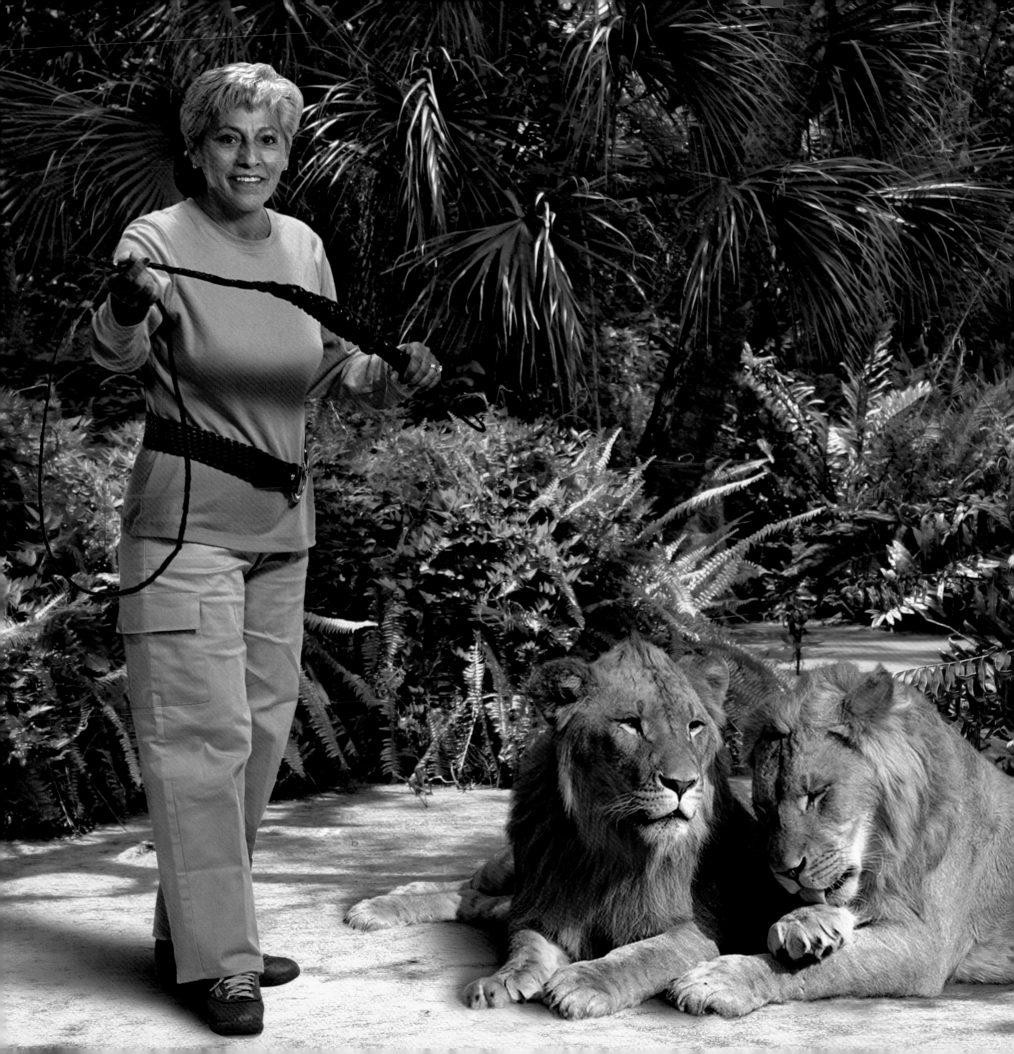

Wilhelmina Cole Holladay · *Concert Pianist*

"Creativity is awesome.
It goes beyond a skill learned.
When something totally new
occurs, it is godlike. I know
I'll never be a concert pianist,
but I do dream about acquiring
a real appreciation of good
classical music, to know it the
way I know art."

Wilhelmina Cole Holladay and Wallace Holladay founded the National Museum of Women in the Arts not to house their own collection—although most of what they've acquired, more than five hundred works, now resides there—but to create a place of scholarship and research. In that way, the museum has an influence far beyond its own walls.

When their museum opened, major exhibitions of women artists were few and far between. Mrs. Holladay doesn't think curators and directors were ignoring women artists on purpose. The paucity of scholarship on women artists contributed to their lack of exhibition.

"Wally and I have been fortunate to travel extensively. Wherever we'd go, we'd ask 'What do you have by a woman?' The immediate answer was always 'nothing.' Then a week later we'd get a call. At one point we set out to research some of our women artists. Nothing. The preeminent Western art book, Janson's *History of Art*, had not one woman artist represented until the year we opened. "When women were left out of the popular writings of art historians, they were forgotten. But if you went back to the primary sources, you could find all sorts of records."

That's why there's a National Museum of Women in the Arts. Today, with nearly three thousand pieces in its permanent collection, it remains the only museum in the world dedicated exclusively to recognizing the contributions of women artists. The Library and Research Center—the largest of its kind—contains more than seventeen thousand artists' files. Anyone may make an appointment to use it.

"To carry out our raison d'être of education, we have committees around the world. Our Paris branch was instrumental in the recent Berthe Morisot exhibit, while our state committees offer opportunities for contemporary American artists to exhibit."

Like their paintings, Elisabeth Vigée Lebrun, Artemisia Gentileschi, Gwen John, and so many other women artists simply needed a spotlight shone on them for the world to see their brilliance.

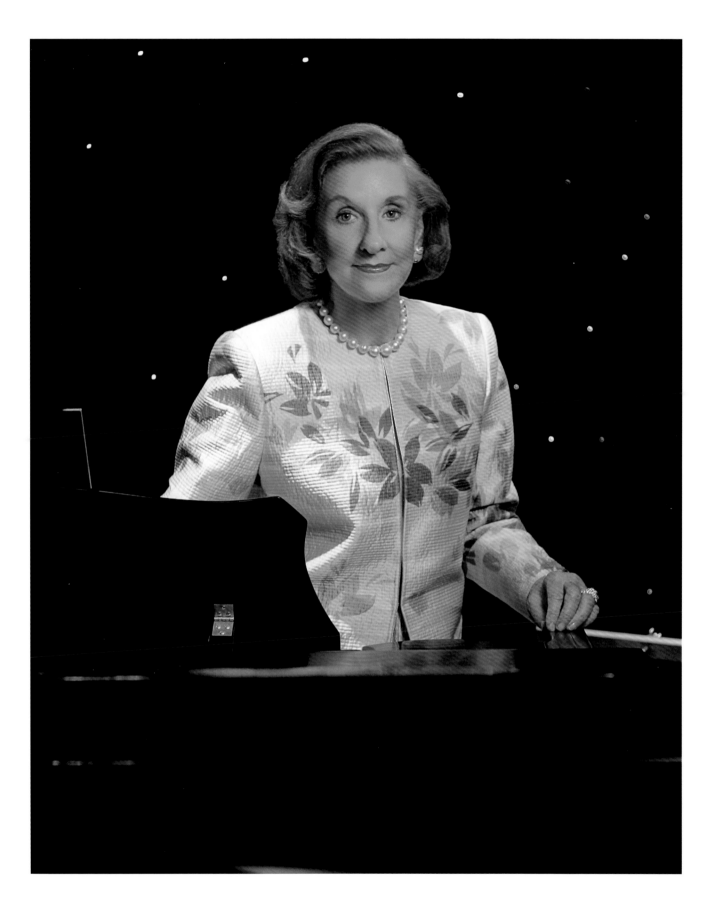

Leslie Milk · *To Have a Play on Broadway*

"There's nothing quite like sitting in an audience and hearing your words and experiencing the audience responding, laughing, actually seeing the joy in their faces. It's the biggest high."

As lifestyle editor of *Washingtonian* magazine and a weekly columnist for the *D.C., Examiner*, Leslie Milk has written about subjects ranging from caring for aging parents to Washington's most powerful women, from climbing Mount Everest to losing weight. Previously, she was a columnist for the *Washington Post* and the *Journal* newspapers. Her book, *It's Her Wedding but I'll Cry If I Want To*, is a guide to surviving a daughter's wedding. She has written two plays. One, *Woman Spends a Year in Labor*, draws on her experiences as a press officer in the U.S. Department of Labor. She is also a popular speaker on women's issues and disability rights. Suffice it to say, her identity is very much aligned with the craft of writing.

"As a child with a disability (my left arm is paralyzed) it was important to discover something I was good at. Once I discovered I could write, I was hooked. I started in sixth grade and I never stopped."

She has written extensively on how the business and governmental landscape of Washington has changed as more and more women gain positions of power and responsibility. "Women are much more collegial, they lead from the middle rather than leading from the top, and that has really changed the business culture." For example, women managers made this new generation of involved young fathers possible. "I think women are much more geared to the personal needs of the people around them. Today fathers as well as mothers are taking time out to attend children's activities. Mothers always did that, fathers didn't. Now they do."

Her favorite words from Hemingway, "The world breaks everyone, and afterward, some are strong at the broken places," are fitting for someone who was once executive director of Mainstream, Inc., a national nonprofit that promotes the rights of people with disabilities.

Having enjoyed the immediacy of an audience reacting to her words, she'd still like to see her in name in lights on Broadway. "You haven't arrived as a playwright until you're on Broadway."

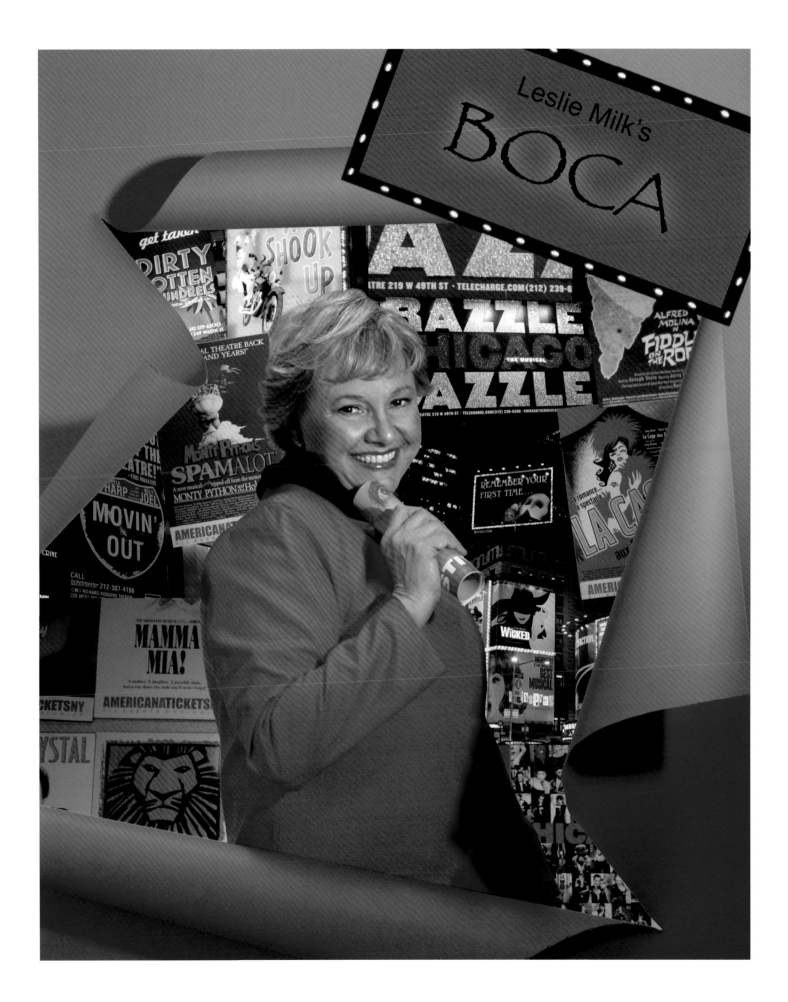

Maxine Isaacs · *President of the United States*

*"I hear so many people say,
'I would never want that job.'
But if you're interested,
as I am, in politics and public
service, in being engaged
and making a difference,
you'd take it in a moment."*

The first major-party presidential ticket with a woman on it also featured the first woman campaign press secretary. The year was 1984. The candidate was Geraldine Ferraro. The press secretary was Maxine Isaacs. There was some resistance to a woman in her position. "It was unusual enough that people would comment. Now no one even thinks about it." She saw first-hand the effect of nominating a woman to be vice president. "The reaction was electric. Wherever we went, people were crying; they would hand her their babies. On a personal level, I was thrilled to be part of an important historical event."

But Ms. Isaacs was also Walter Mondale's Deputy Campaign Manager, so she knows the thinking behind the nomination as well. "Mr. Mondale wanted to use his candidacy to open doors for women and minorities, and the vice presidency was the natural vehicle for that. While he knew that appointing a woman running-mate might help him politically, and he was of course not averse to that, that was not in the end the most important reason for his decision."

Today she is on the faculty of Harvard's John F. Kennedy School of Government, where she has been an adjunct lecturer since 1994, exploring the relationship among policy, politics, the news, and public opinion. Her interest in politics began in high school when her father ran for city council in Shaker Heights, Ohio. He lost the election, but that experience, combined with the civil rights movement, set Ms. Isaacs on the course she has followed ever since, including fifteen years of working in the White House, Senate, and House of Representatives before the 1984 campaign.

"If I were president, I would use the office to create opportunities for people who've had problems gaining access to education, the arts, the workplace. My goal would be to open doors. There's no more powerful platform; I hope to see a woman president in my lifetime, and I am confident that I will."

Barbara Harrison · *Film Director*

At the age of seven she was already distributing, door-to-door, a neighborhood gazette replete with hand-drawn pictures of news events in her hometown of Prairie View, Texas. Her father, a professor of journalism at Prairie View A & M University, encouraged her interest in media, and it was thanks to the copy machine in his office that she published her weekly newspaper.

She loves her job as morning anchor with NBC4 TV in Washington, DC, but Barbara Harrison has always dreamed of becoming a successful film director—one who makes movies with a message.

As a broadcast journalist for 25 years, her assignments have ranged from heartbreaking tragedies to soul-satisfying pieces that leave viewers smiling. The abbreviated form of most news programming poses a challenge to telling many of the more interesting stories. Her dream has been to turn some of these moving moments into longer form documentaries and feature films that would celebrate the human spirit.

Particularly moving are the stories of children featured each week in her "Wednesday's Child" segments. Begun over 20 years ago, it features children who have been abused and abandoned and are currently languishing in temporary care awaiting permanent adoptive homes. "Wednesday's Child" has received local and national awards and is the model for many similar programs across the country. Hundreds of children are now growing up with permanent, loving families thanks to this inspiring weekly segment.

Indeed, right from the beginning, much of her special interest reporting has had a strong family and community focus. She began at WRC TV covering child health issues. To motivate women to seek early prenatal care in order to decrease the extremely high infant mortality rate in Washington, DC, she made a television journal of her own pregnancy.

It is no surprise that the movies she would like to make as a film director would seek to make a difference in the world, to "find a voice for those who would speak out against the hate and prejudice that cause pain. I believe that those who don't speak out against hate are as guilty as those who practice it.

"I want to tell stories that help people find ways to change the world for the better."

Judith Viorst · *Pediatric Surgeon*

She hopes to make life a little better, a little sweeter, for those she loves; to make some small, positive contribution to the wider community and the world in which she lives; and to "finally acquire upper-arm definition." We can state with certainty that she has already achieved two out of three goals.

Fifteen books for children. Ten collections of poetry. A novel. A *Redbook* column for more than twenty-six years. Three musicals adapted from her books. And seven works of non-fiction, including the remarkable *Necessary Losses*, which remained on the *New York Times* bestseller list for nearly two years.

But let's not measure her achievements in numbers, just as we shouldn't measure the importance of *Necessary Losses* in sales. What ties all these works to each other, and the person to the work, is the idea of helping people deal with their lives. Her subjects seem to find her. "Loss is everywhere, but it's not just about death—it's leaving and being left, it's giving up unreal fantasies about marriage, it's letting go of your children. Hard losses, but we grow from them." Control is just as prevalent—good when you're on a diet, not so good when you insist on running others' lives. "Men always tell me 'my wife needs to hear about being less controlling.' Of course, the women say the same about their spouses."

Ms. Viorst graduated from the Washington Psychoanalytic Institute after six years of study. Prior to that she had received a BA in history from Rutgers University.

She has been feeding the minds of grown-ups and children alike for a long, long time. Her fantasy is to move to the other side, so to speak. To heal, not with words and insights, but literally with her hands—to be a pediatric surgeon.

"I have a very dear friend, Peter Altman, who is a pediatric surgeon. There's something so concrete, as compared to writing, about what he does. Get up in the morning, operate on people—change their lives. He's separated conjoined twins; thanks to him two little girls are now living separate lives." Luckily for her readers, she remains a writer, and surgery will remain a fantasy, her "fallback career."

Ann Hand · *To Sing Mimi in* La Bohème *at the Met*

Puccini's heroine bears very little resemblance to Ann Hand—no tragedy here. According to her version of her life story, Ms. Hand seems to have had a dollop of good fortune at every turn. We suspect that Arnold Palmer's take on luck may be at play here—"the harder I work, the luckier I get."

Ann Hand started singing when she was thirteen, and attended college as a voice major. Loving the music of *La Bohème* and *Madame Butterfly*, she thought she'd make a better Mimi than Butterfly, but never found out. Instead, she met and married the man she's been with for fifty-three years. And here's luck once again—Ann Hand feels she began her jewelry business at just the right time.

"Had I started when my children were at home, I don't know how I could have done it. When I'm bogged down in the minutiae of my business, let alone the demands of children, I can't be creative. I need to lock myself away."

What she creates has been worn by all the living First Ladies and by cabinet secretaries, senators, congresswomen, and ambassadors. Many have chosen her signature pin, The Liberty Eagle, but her portfolio of designs is growing. In addition to commissioned pieces made in larger quantities, she has many glamour and career pieces in her stores.

Her first commission was a pin to commemorate the return of the restored statue Freedom to the top of the Capitol dome. "That forced me into finding a way to mass-produce my work." From there came more commissions for everything from branches of the Armed Services to national and international organizations, museums, and major corporations.

In addition to jewelry, Ann now also sells scarves and her own perfume. There's even a men's line, including cufflinks and ties. Ann has managed to have a fulfilling, joyous marriage, a happy family of children and grandchildren, and a very successful business.

"A lot of women—and men, too—think that at forty-five or at fifty, if they're not already locked in a career, there isn't another life out there. I didn't begin what I'm doing today until I was over fifty. There's no secret—persevere and never give up."

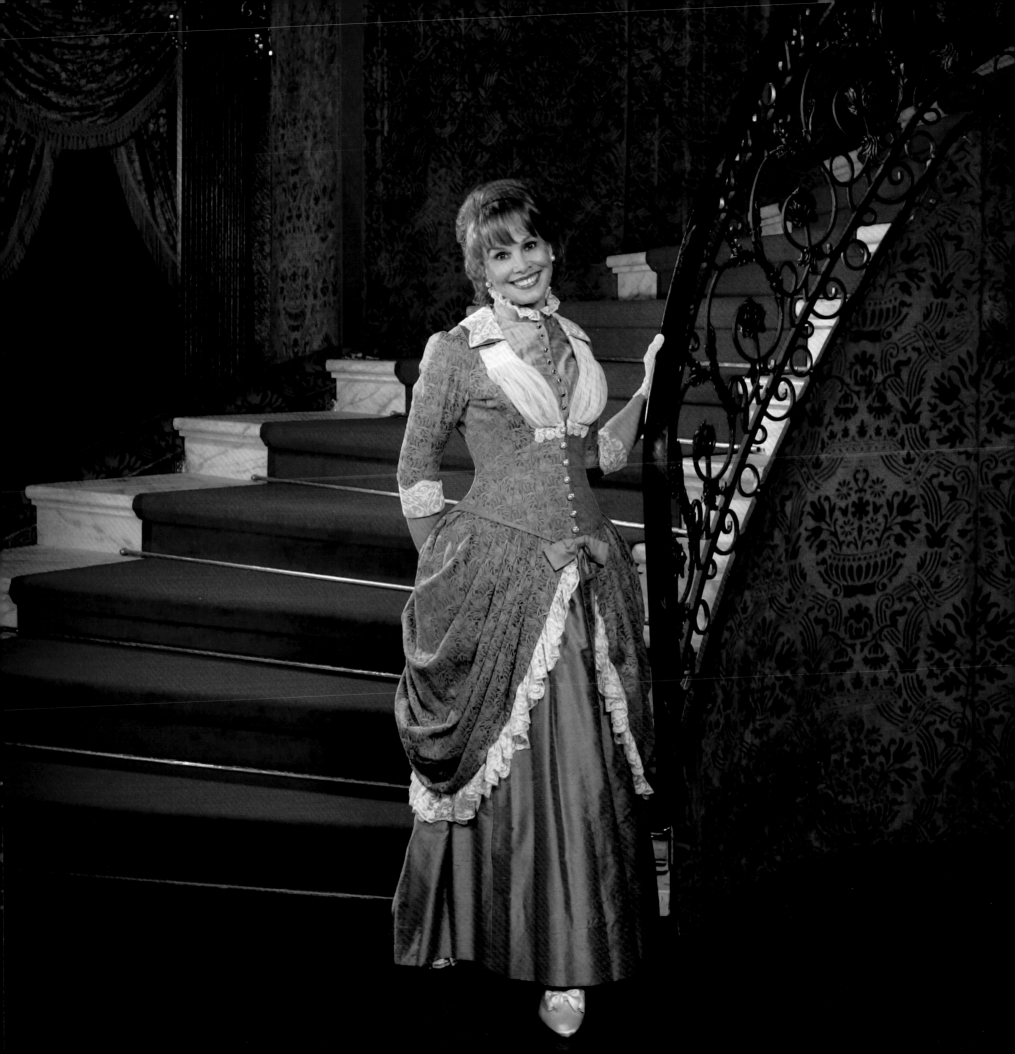

Eleanor Merrill · *Broadway Musical Star*

"In the third grade, the nuns at my parochial school had us tell what we wanted to be. Each little girl stood and said, 'I want to be a nun.' When my turn came I said 'I don't know what I want to be, but I know what I don't *what to be. I don't want to be a nun.' Sister Edwardine was not pleased."*

Be a straight shooter, even if you can't throw straight. That seems to be the lesson that Eleanor Merrill, chairman and publisher of Capital-Gazette Communications, Inc., learned at an early age. She grew up in a tough area, where older boys would throw rocks at the girls. She threw back, not intending to hurt anyone. "My aim was terrible. I came scarily close to being dead-on. They left me alone." It's easy to see why she takes to heart the saying "We cannot direct the wind, but we can adjust the sails."

Her company publishes *Washingtonian* magazine, as well as five Maryland newspapers, including the *Capital* in Annapolis. But her varied and active participation in many civic and arts organizations constitutes a full-time job on its own. Mrs. Merrill is chairman of the Board of Visitors of the University of Maryland School of Journalism. (One of her current goals is to help the University of Maryland be one of the best schools in the nation.) She serves on the Board of Trustees for Dickinson College, her *alma mater*, in Carlisle, Pennsylvania. She served on the Community Board of the John F. Kennedy Center for the Performing Arts as well as on the Board of the National Aquarium, and she is a member of the Board of Trustees of Ford's Theatre and the Shakespeare Theater. Given her experience with the nuns, it is also no surprise that her favorite lines from the bard are: "To thine own self be true,/And it must follow, as the night the day/Thou canst not then be false to any man."

The same bravado that served her so well in childhood shows up in her choice of fantasy—to be a star in a Broadway musical. "Never mind that I can't carry a tune and don't dance that well. Oh, and I also suffer from stage fright."

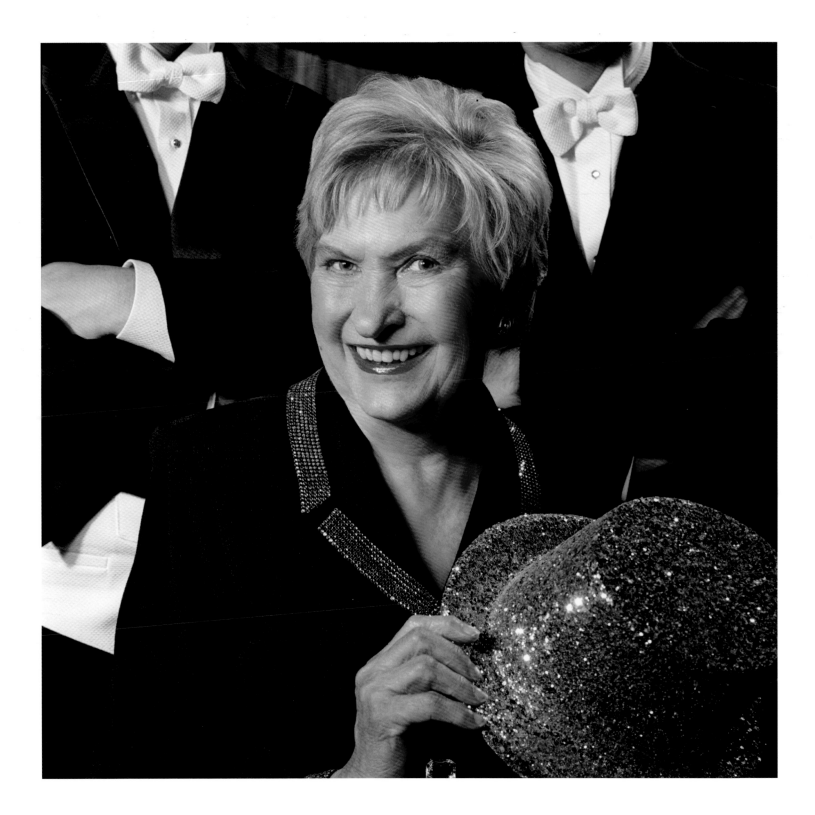

Charlene Drew Jarvis · *Fortune 500 CEO*

Scientist. Public servant. Educator. As president of Southeastern University in Washington, DC, Charlene Drew Jarvis is now on her third career. "I came here for a reason —the experience I had as a legislator overseeing business development convinced me that business-people needed more information to be successful."

With the establishment of its new Center for Entrepreneurship, Dr. Jarvis has brought a new emphasis to Southeastern University. "We're infusing entrepreneurship across the curriculum— students in other disciplines will be introduced to it as a requirement, just as we have infused writing and technology across disciplines." This former research scientist calls it "the applied side of life." Most important, she is creating a pipeline between students and corporations. "We expect our students to have exit competencies that make them sought after in the marketplace."

She began her career as a scientist, working for many years at the National Institute of Mental Health. But what she saw of her hometown during her daily commute brought her to public service. "Every day, I left the District of Columbia to go to my lab in Bethesda. I became very concerned about the failure of the city to recover from the 1968 riots after the assassination of Martin Luther King. I got very involved in the issue of economic revitalization as a volunteer. And the more involved I got the more opportunity I saw to really put some of my skill sets to work to help revitalize the city."

Career number two was born. She ran for DC's city council and won. "As a junior council member, I was fortunate to be named chair of the Housing and Economic Development Committee. It was an extraordinary opportunity to help lay the foundation for our economic recovery." She would remain on the city council for twenty-one years, introducing the legislation that brought in the city's new convention center and the MCI Center.

So with all this success, why is her fantasy to head a Fortune 500 company? For the ego satisfaction, maybe a cover shot on *Fortune* magazine? Far from it. "Because the vision of the CEO with respect to corporate philanthropy is critical. Government cannot be the single supporter of communities; corporate philanthropy is another tool."

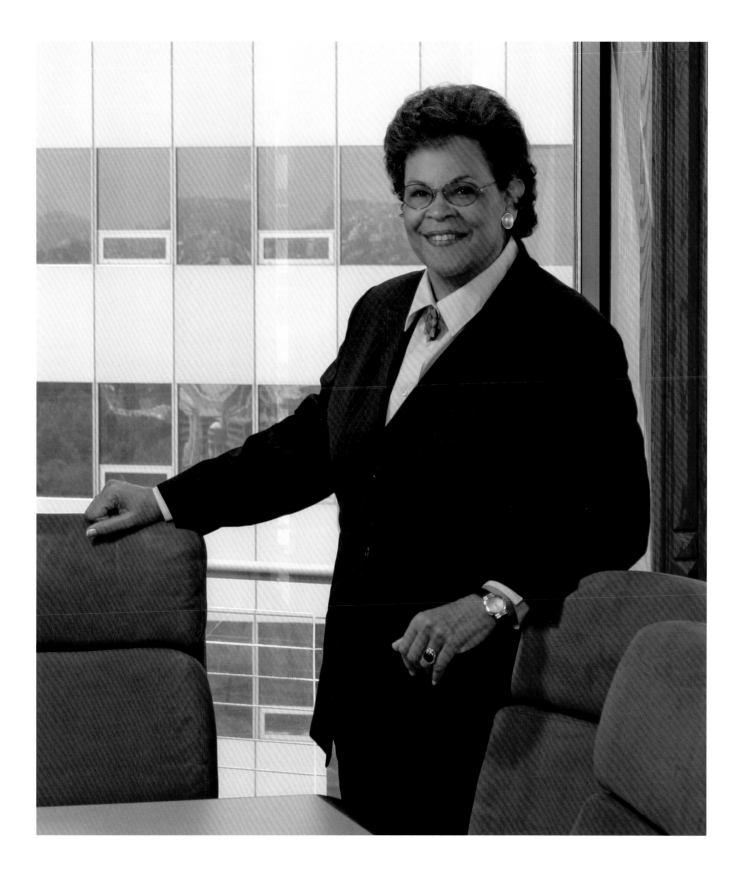

Alma Gildenhorn · *Queen for a Day*

Queen for a Day was a 1950s TV show where women would relate their hardships and the audience would vote a winner (in other words, the one with the worst life). She would be crowned, literally, "Queen for a Day" and given something that would change her life—usually an appliance. However, as a colloquialism, "queen for a day" has grown to mean getting what *you* want for once. But Alma Gildenhorn wants to be "queen for a day," to have the untrammeled power of a monarch, so she can reward *others*, all the people who've worked so hard by her side.

"I believe that as we move on in life, we have an obligation to give back some measure of the goodness that we have received. This involves giving of our time, resources and commitment to causes other than ourselves."

And give of her time and energy she does: to the John F. Kennedy Center for the Performing Arts as an honorary trustee and member of the Executive Committee and to the Aspen Institute as a trustee and member of the Executive Committee. Her largesse is not limited to those two institutions, as she currently serves on the council of the Woodrow Wilson International Center for Scholars and as a trustee of the University of Maryland, where she chaired fund-raising activities for its Clarice Smith Performing Arts Center.

More than thirty-five years of civic and community activism have not gone unnoticed. Mrs. Gildenhorn's service awards include Philanthropist of the Year from the National Society of Fundraising Executives and the Patron of the Arts Award by the Cultural Alliance of Greater Washington. In 1996, she and her husband were named Washingtonians of the Year by *Washingtonian* magazine.

Her favorite quote is "If you will it, it need not be a dream." Given her accomplishments, a powerful will supports her own dreams.

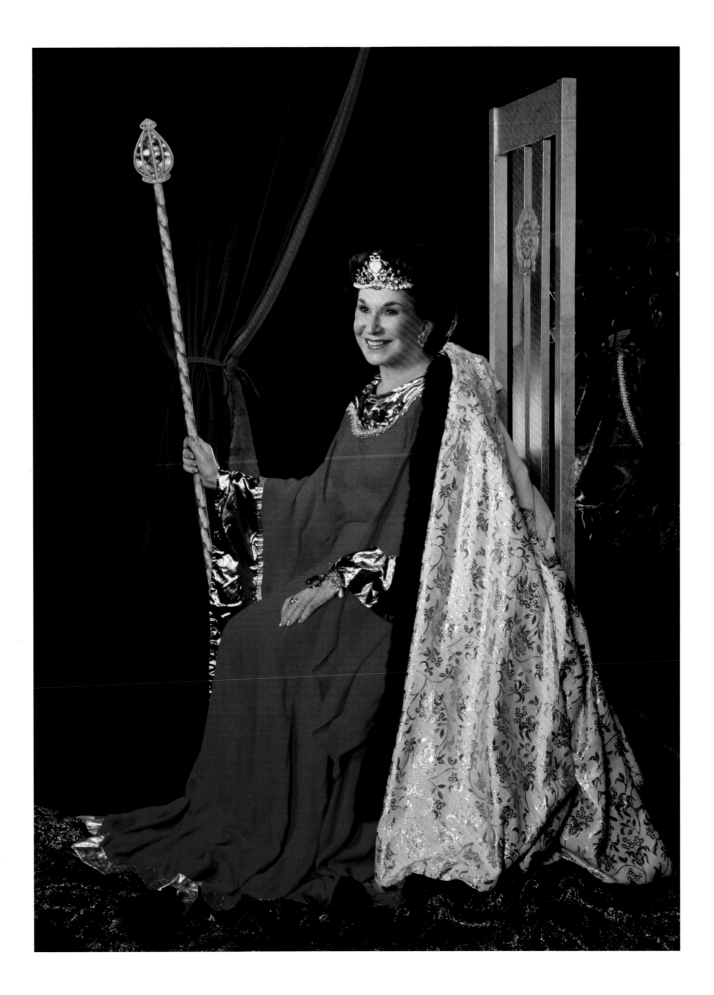

Nancy Chistolini · *NFL Team Owner*

Should Nancy Chistolini ever get to actually live out her fantasy, we may finally get an answer to the question, which is more cut-throat: the world of professional football or the world of fashion and retail sales?

As the senior vice president of fashion and public relations for Hecht's and Strawbridge's, Nancy Chistolini has already conquered the world of fashion and retail sales. Hecht's and Strawbridge's is a division of May Department Stores that operates eighty-two stores in Washington DC, Maryland, Virginia, North Carolina, Pennsylvania, New Jersey, Delaware, and Tennessee. And while her professional responsibilities are great, her seemingly boundless energy for non-profit organizations and volunteer work is what drew us to her.

She is a member of the Women's Leadership Committee for the Boys and Girls Club of Greater Washington; the Executive Committee of the Lombardi Gala, an annual event for the Lombardi Cancer Center and Georgetown University Medical Center; and the Advisory Board of WEAVE (Women Empowered Against Violence), which empowers domestic violence victims to free themselves and their families from the vicious cycle of abuse through a combination of legal representation and case management.

She added secretary of the Board of Directors for the National Italian American Foundation, a non-profit organization dedicated to preserving the heritage of an estimated 25 million Americans of Italian descent, to her extra-curricular activities in March 2004. In 2005 she became a board member of Second Chance Employment Services, a nonprofit organization that seeks to promote financial security for at-risk women and their dependents.

Now Nancy Chistolini wants to own a football team and successfully deal with the challenges of management, marketing, and community relations. Of course, these are very much the same challenges she deals with in her current position. After all, her responsibilities as senior VP of fashion and public relations include working on fashion strategy for each coming season. Which do you think is more difficult, finding a starting linebacker deep in the second round of the draft, or determining what will fly off the racks at a decent margin in six months? We think it's a toss-up.

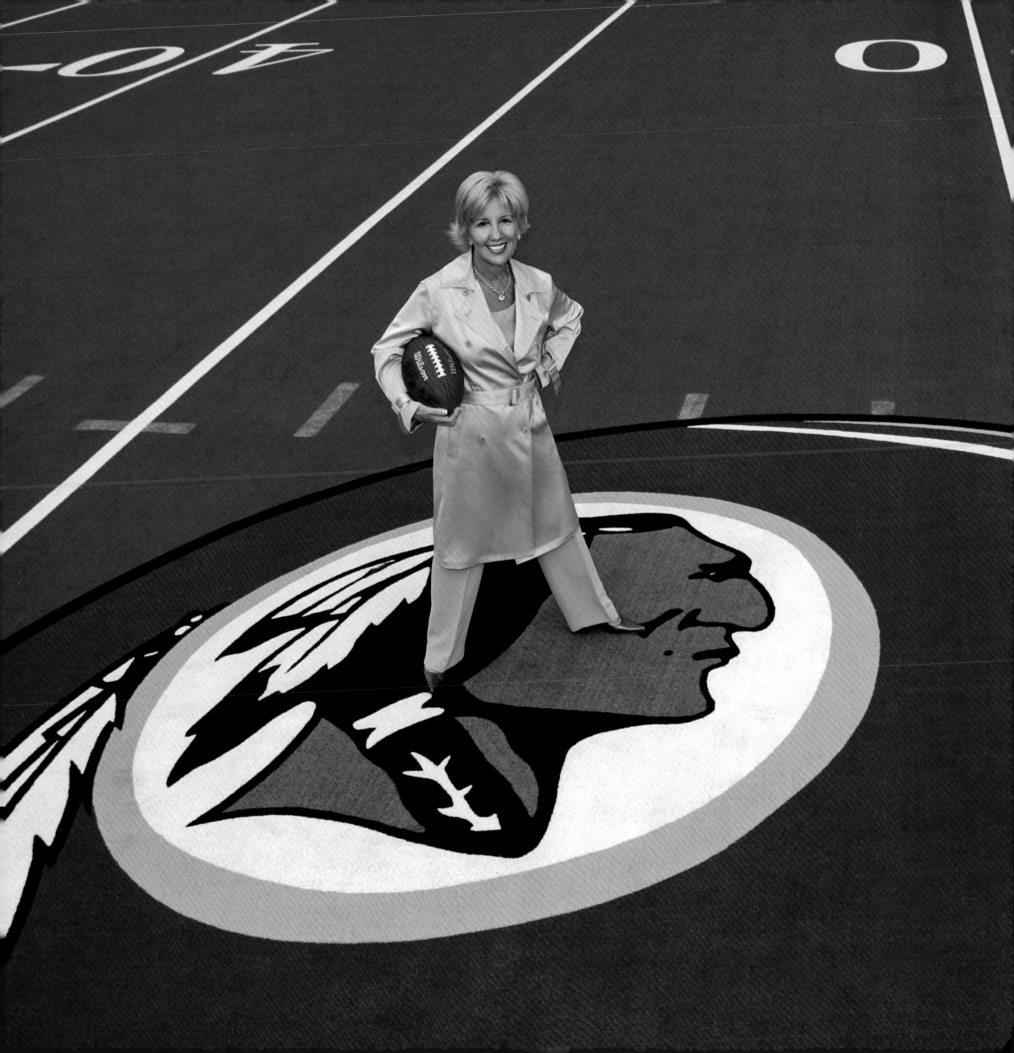

Sally Quinn · *Chanteuse*

The director called: "You've got the lead in We Bombed in New Haven*," he said. But that same afternoon another call came. "My name is Ben Bradlee and you don't know me, but I'd like to hire you as a reporter." The next day Sally Quinn was interviewing with the executive editor of the Washington Post. When she stated that she'd yet to write anything professionally, Bradlee replied: "Nobody's perfect."*

Two days later, Sally Quinn had her first byline. "I never thought about becoming a journalist. I was a theater major at Smith College, was in summer stock productions on Cape Cod, acted in English-speaking theaters in Germany—I wanted to be a movie star." So what happened? "Ben Bradlee. I loved acting, but it wasn't the most intellectually stimulating thing I'd done. When actors talk shop, it's about who won what auditions. When journalists talk shop, it's about everything happening in the world."

She became a fixture in the *Washington Post* Style section throughout the 1970s and 1980s. Her favorite piece may be her profile of Alice Roosevelt Longworth. "She famously would not give interviews. I just persisted and persisted and finally when Longworth was eighty-five I said, 'why not give me an interview when you're ninety. You won't care by then what you say.' And she agreed. Five years later she kept her word, and proved me right—she just unloaded."

At age thirty-two, Quinn left the Post to become coanchor of CBS *Morning News*, a short-lived and frustrating experience she wrote about in her book, *We're Going to Make You a Star*. She has also written two novels, *Regrets Only and Happy Endings*, as well as *The Party: a Guide to Adventurous Entertaining*.

Five and a half years after returning to Washington, she married Bradlee. They have a son who was born with a heart defect. "It was the most important thing that ever happened to me…In the end maybe it will make me a better writer because I've become more empathetic and more sympathetic than I ever was before." She continues to write for the *Post*, is a popular guest on many political news shows, and is an active member of the board of directors of Children's National Medical Center in Washington.

Why the torch singer pose? "It's the one thing I couldn't do on stage—I have the most terrible voice."

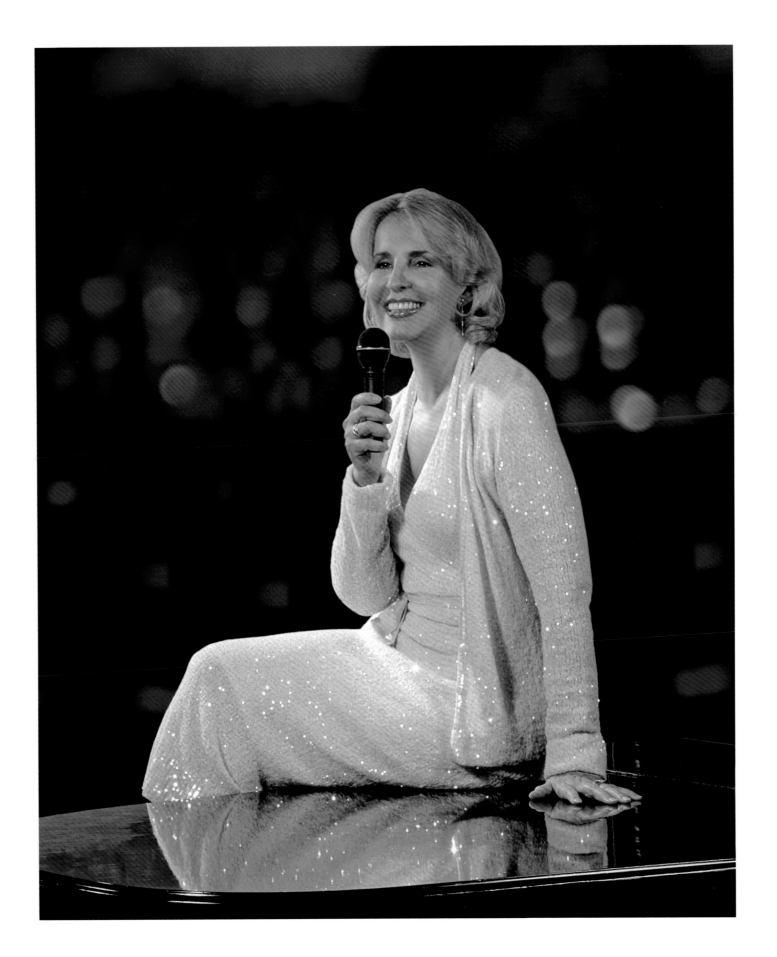

Claire Dratch · *Take an African Safari*

"America was for me indeed a land of milk and honey. Ultra-naïve in some ways and ultra-mature in others, my boundless enthusiasm opened many doors for me. I was determined to miss nothing and become Americanized as soon as possible."

She enjoyed an idyllic childhood in Seligenstadt, a small town near Frankfurt. Hitler ended that. In 1936, Claire Bachrach crossed the Atlantic, mastered English, and began a career in fashion retailing. "Starting at the very lowest rung of the ladder I got a job at a neighborhood 'dry goods store', ticketing everything from saucepans to suspenders." Within a few months she was promoted to sales. But she wanted to work on State Street in a department store. "Every Thursday morning, I would visit the personnel manager. It took months, but I landed a sales position in the intimate apparel department." Soon she was in the store's executive training program. "That was my introduction to seasonal planning, merchandising, open-to-buy, mark-up, special sales and such. Then, at Florence Tarson, a fine specialty shop on North Michigan Avenue, I learned about workmanship and careful buying, about the importance of display and eye-appeal, and, above all, customer relations.

"I cultivated 'American' friends who exposed me once again to books, music, theater, and dance—everything of intellect in this wonderful country." She married Joseph B. Dratch, also in fashion retailing, and came to live in wartime Washington DC. "I was plunged into a new life, new position, new city." She became a buyer for one of the city's finer specialty stores, but the couple wanted their own business. "With virtually no capital we leased sales space in a millinery shop." The first Claire Dratch shop opened in Bethesda. "Our hallmark was personalized service and integrity, and soon our store became a magnet for well-dressed Washington women. We moved to larger quarters, added a thriving bridal department and expanded our buying horizons beyond New York to California, Europe and wherever we found exciting things."

Add to this four children, a wonderful marriage, and a super-active life always leading to personal growth. Supremely Americanized, she saw much of the world and would now like to add an African safari to her experiences.

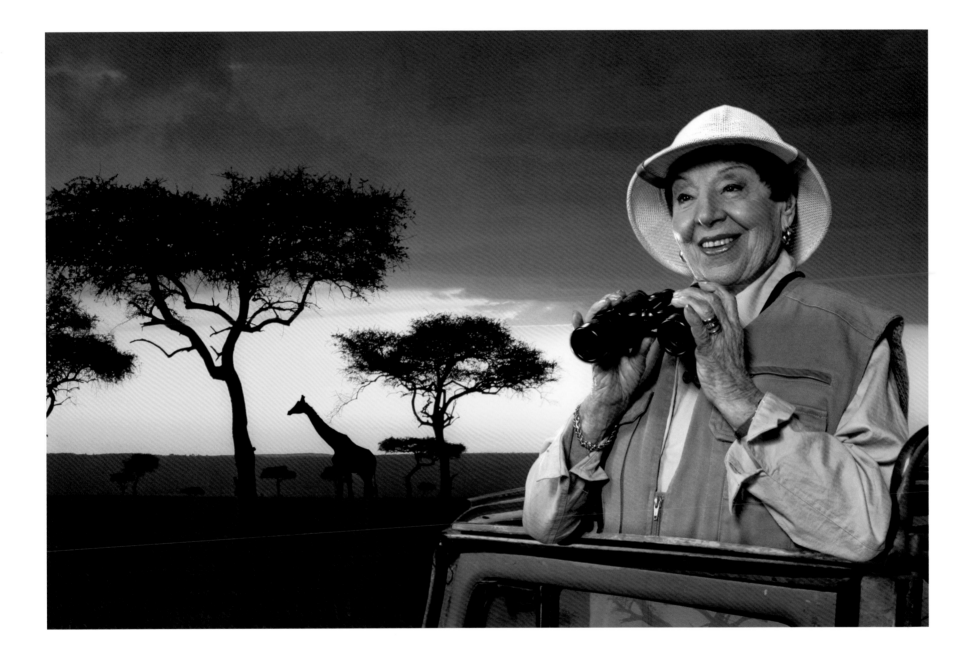

Ida G. Ruben · *Dancer*

Her intense, grassroots work for non-profit organizations was the perfect preparation for being a legislator. She knew what communities needed and wanted. From this knowledge came the nation's first legislation to protect seniors, the Adult Protective Services Act, plus the Child Support Enforcement Act and the "Covered Truck" bill—practical, community-based, life-saving.

Senator Ida G. Ruben is president pro tem of the Maryland Senate. When elected to that post at the start of the 2000 legislative session, she was the first woman to hold that title in a generation, the first person from Montgomery County in more than one hundred years.

She didn't come to it overnight. In her more than thirty years of elective office, she has been majority whip and vice chair of the Senate Budget and Taxation Committee, and has held many other state positions.

Her stated passion is public service, and her means of fulfilling that passion is through the law. As an advocate for children, the elderly, and the developmentally disabled, she has introduced and passed legislation that has made a real difference in people's lives, improving laws that enforce child support and protect victims of domestic violence. She has made Maryland's highways safer, sponsoring legislation to cover trucks, lower drivers' legal blood-alcohol levels, and enforce seatbelt use. And she used the power of her budget-committee post to provide tax credits to the arts, resulting in the growth of Art and Entertainment Districts across the state.

Her favorite quote, from Professor Aycock of the University of North Carolina, says it all: "Whatever [our children] may be able to do to cope with the multitude of challenges awaiting them, we may never know. But we may be certain that they will have a better chance if the major battle to achieve equality under the law is won before the torch is passed."

That's approaching an issue head-on, in stark contrast to her fantasy—to dance, to entertain others in Hollywood films or a Broadway musical. Her constituents, for the sake of their roads, their health, their economy and environment, hope she has a long run on the Senate floor.

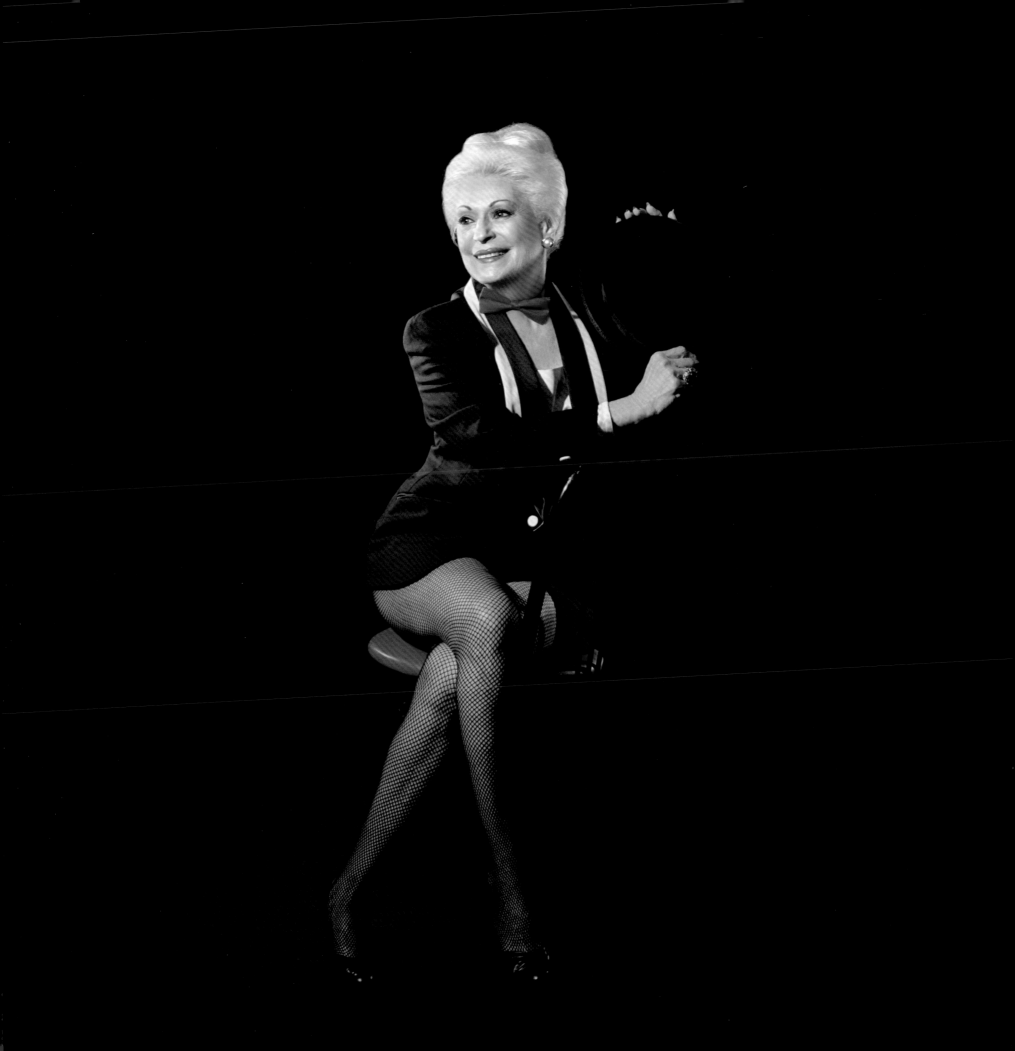

Carol Schwartz · *Trapeze Artist*

"When I was six years old I would stay at school and swing back and forth for hours, because I didn't want to go back to an empty one-bedroom apartment. That swing was my escape. When I kicked my leg out at the top of the arc, it became a trapeze, and I was a trapeze artist."

Carol Schwartz is a Republican councilwoman in the overwhelmingly Democratic District of Columbia. She keeps winning elections. Maybe because voters know those labels have little to do with caring about people and getting things done.

She came to DC from Texas to teach special education, saw she could do more by running for the school board, served there eight years and then kept running, now having been elected four times to a seat on the District of Columbia's City Council.

Carol Schwartz has always put helping people first, starting with "the most important person in my life", her older brother, a man with mental retardation.

"He defined me. I've been a public servant all my life, mainly because of Johnny." He got to see her last swearing in before he passed away. "I used to kid him and say that he's not only the president of my fan club, he's the only member." He clearly wasn't the only member. She has tutored students at Malcolm X Elementary School in Anacostia; counseled substance abusers in treatment programs; fought for services for people with AIDS; and helped to provide safe activities for District children—all as a volunteer.

Carol was the first woman president of the Metropolitan Police Boys and Girls Clubs in its sixty-two-year history and served on its board from 1981 until 2004. For her community service, she received the Whitney M. Young Award from the Greater Washington Urban League and the Local Hero Award from the Human Rights Campaign.

For her the personal is the political, as she puts the same energy into making her constituents' lives better. Her mantra is Churchill's "never, never, never give up" but she also believes you should "grow where you are planted." She says her childhood trapeze fantasy is "especially interesting because I am scared to death of heights." About the only other thing she fears is her own drive: "I'm so afraid I won't be the perfect everything."

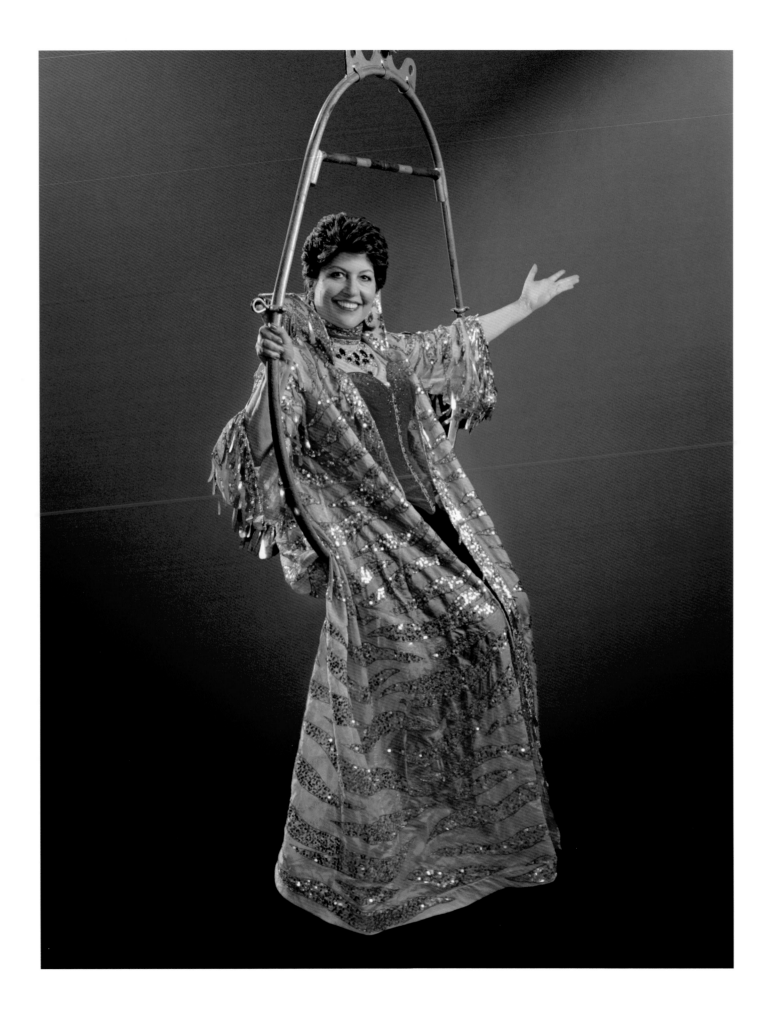

Contributors · Outtakes · Index

Ilene Leventhal

The lessons we learn as children can change the world. On Sunday house calls with her father, a doctor, Ilene experienced firsthand the real gratitude of those in need. She saw the satisfaction volunteerism brought her mother, too. As a teen, Ilene volunteered at DC's Saint Elizabeth's Hospital and The Children's Convalescent Home, and continued helping local organizations until 1989. Then, watching stories of the homeless on the news with her own three children—Lisa, Brian and Shawn—she knew instinctively what to do. She founded her own charity.

What is now the Hand To Hand Eviction Prevention Program began as one woman cooking and delivering meals to the homeless. Underneath it all lay a desire not just to feed, but to personally make a difference, by letting these people know there was "someone who cared." Soon, dozens of families were involved. By its tenth anniversary, Hand To Hand had grown into one of the most successful charitable organizations in the region, with twelve different programs assisting families and children. Ilene went on to use her experience to help many more grass-roots nonprofit organizations. Her success as a facilitator is mirrored by the recognition she received: Potomac Citizen of the Year in 1995, a March of Dimes Mother of the Year in 1998, Washingtonian of the Year in 2000. Other honors include citations from the governor of Maryland, the Maryland State Senate, and the House of Delegates.

Now administered by the Community Ministries of Montgomery County, the Hand To Hand Eviction Prevention Program is sharing with the Metropolitan Police Boys and Girls Clubs of Greater Washington DC the money raised by Ilene's latest idea—this very book.

Ilene has been married to her husband, Norm, for nearly forty years. She credits the success of her endeavors to his constant and unquestioning support—who do you think drove her downtown to deliver the first meals to the homeless? She calls him "the wind beneath my wings."

From the examples of all the adult women in this book, Ilene is moving on to crafting stories for children about self-esteem, tentatively titled "Gee, I didn't know you felt like me."

Francine Levinson

Francine Levinson is a starter. She has started a bank, a business, and a foundation. Francine Levinson is a finisher, serially stepping in as executive director or chairperson in both the for-profit and nonprofit sectors to set a direction and get things done. In a world of good intentions, she brings her solid business acumen and experience to public-service organizations and gets results. Her latest venture, to raise money for the Metropolitan Police Boys and Girls Clubs of Greater Washington DC and the Community Ministries of Montgomery County's Hand To Hand Eviction Prevention Program, is this book. It is a testament to both her out-of-the-box thinking and her organizational skills.

A founding member of the First Women's Bank of Maryland, she served on its Board of Directors for fourteen years. Concurrently, she opened and directed a two-location lingerie and apparel boutique. When the Metropolitan Police Department was in need of bulletproof vests and did not have the money to purchase them, Francine started a foundation to raise money and supplied vests to the next graduating class of the DC Police Department.

Francine has been the president of the Metropolitan Police Boys and Girls Clubs of Greater Washington DC for the past three years. She currently serves on the boards of the following: the White House Project, which promotes women for higher office; the Foundation for Contemporary Mental Health; the Hebrew Home for the Aged; the council of the Woodrow Wilson International Center for Scholars; W.O.M.E.N. Inc.; and the Washington Hospital Center Heart Board.

She and her husband, Mel, have been married for forty-two years. "Mel always backs me 100 percent. I couldn't do it all without his support." Even when the next project is still just an idea, he'll offer the same to-the-point directive: "Francine, do it!" They have three grown daughters, Stephanie, Monica, and Suzanne, each with an extremely successful career of her own. But their mother wasn't solely responsible for creating the emphasis on getting out and getting things done: "I was brought up in a family with women who never stayed at home."

Clay Blackmore

Simple and direct, Clay Blackmore's portraits make powerful statements. Working out of Washington, DC, Clay's style blends the beauty and timelessness of classical portraiture with the spontaneity and appeal of photojournalism. As a mentor, he has had an equally powerful impact on today's up-and-coming professional portrait photographers; thousands have studied under him.

His corporate clients include the PGA, USGA, and the political inaugural balls. Representing Canon as an "Explorers of Light," Clay has lectured throughout the world. His images have been published internationally, most recently to introduce Canon's newest camera, and he was selected for the first satellite broadcast of Wedding 2000.

He is a member of the elite Cameracraftsmen of America and holds a board position in the international Photography Hall of Fame.

Marcella Urioste

Marcella Urioste is a true artist; her canvases just happen to be people. Her creativity, vision, and versatility as a hair and make-up artist have helped men and women in both the entertainment and political worlds. Marcella regularly provides artistic consulting and hair and make-up service for television commercials, fashion shows, and music videos of major recording artists. Perhaps her greatest asset, however, lies in her love of her work and dedication to her clientele.

A native of Bolivia now living in Washington DC, Marcella perfected her craft by studying in internationally renowned hair design institutes, including the Tony & Guy Advanced Academy in New York City and the Alfaparf Studio in Milan, Italy.

Credits

In the Washington *Metropolitan area*:
BACKSTAGE INC., "The Performing Arts Store"; Chad Blackmore; California Tortilla, Cabin John Shopping Center, Carlos Guerrero, General Manager; Children's Hospital , Grace Hong and Daniel Weaver; Christian Dior Cosmeics, Hecht Company; Citronelle Restaurant, Chef Michel Richard, Mel Davis, Public Relations Coordinator; Clay and Company Photography Staff; Richard Cohen; Steve Davidson; District of Columbia Fire and EMS Department, William M. FitzGerald, Deputy Fire Chief and William T. Flint, Captain, Lt. C. M. Basinger, Pvt. I. C. O'Bryne, Pvt. C. O. Shyab; Debi Engle; Wendy Evans, hairstylist; Folger Shakespeare Library; The Ford's Theater, Tom Berra, Technical Director, Diana Hart, Director of Special Events; The Four Seasons Hotel, Christopher Hunsberger, General Manager; The Freedom Forum; Jaclyn Rose Friedlander; Gary Goldberg Art Studio; Michael Gordon; David Greenleigh; Amy Hagovsky; Hart Senate Office Building, Office of Attending Physician, Hart Health Unit; Hecht's Department Store, A Division of May Department Stores Company; Hillwood Museum and Gardens, Frederick J. Fisher, Executive Director, Angie Dodson, Director of Interpretation; International Spy Museum, Amanda Abrell, Media Relations Manager; the John F. Kennedy Center For the Performing Arts, Ann Stock, VP for Institutional Affairs, Mickey Berra, VP of Production, Michael Sasser, Company Manager of the Suzanne Farrell Ballet, Deidre K. Lavrakas, Production Operations Manager; La Tomate Italian Bistro; Leventhal, Senter & Lerman PLLC; Library of Congress, Sheryl J. Cannady, Public Affairs Office, Children's Literature Center; John Mason; Mayflower Florist, Courtney Zelmer; Keith Parent, NetJets Inc. onsite representative; Plants Etc., Inc., Lois Ornstein; The Prime Rib, C. Peter Beler, President; Rainforest Café, Tysons Corner, Virginia, Steve Howe, General Manager; Ringling Brothers and Barnum and Bailey Circus, Kenneth Feld; Annalisa Rosemarin, Photo Stylist; Round House Theatre, Bethesda, MD, Daniel Conway Set, Tim Swoape, Communications; Maryland State Senator Ida G. Ruben; Donald Sigmund; Christine Tony; Tux Rental, Montgomery Mall; The Honorable Cornelius J. Vaughey, District Court of Maryland, Montgomery County; Washington National Opera, Marsha M. LeBoeuf, Costume Director, Zach Brown, Designer, Jeffrey Frank & Alexander Vasiljev, Makeup & Hair Stylist; the Washington Redskins, Alex Hahn, Director, Leadership Council & Community Affairs; Washington School of Ballet, Rebecca Wright, Director; the Washington Source for Lighting, Eric Granger, Bob Waybright, Terry Michael King, Murdoch Campbell, Will Iverson, Mike Yoder; Annie Whitworth; Willard InterContinental Hotel, Barbara Bahny, Director of Public Relations.

In the Los Angeles Metropolitan area:
Dusty Barbee, The Lot; Dr. Boogie, Hairstylist; Lorrie Castro, State Park Ranger; Monica Levinson; Marilyn Matthews, Stylist; Sammy Mourabit, Makeup Artist.

In the New York Metropolitan area:
Deborah Bell, Makeup Artist; Michael H. Bennett; Café des Artistes, Jennifer Lang, Managing Director, George Lang; Central Park; Duvet Nightclub, Zakiya K. Chevassus, Events; Howard K. Elliot, Inc., Interior Decorator; Wendy Evans, Hair Stylist; IMG Artists; Gregory Outwater; Kevin Sanders, Celebrity Stylist; Matt Stewart; Paula Solomon, Executive Administrative Assistant, CNN; Tavern on the Green; Jessica Varon, Keri Levitt Communications; Kim Weinstein, Makeup Artist.

Also: Lamplight Feathers, www.tonyhill.net.

Outtakes

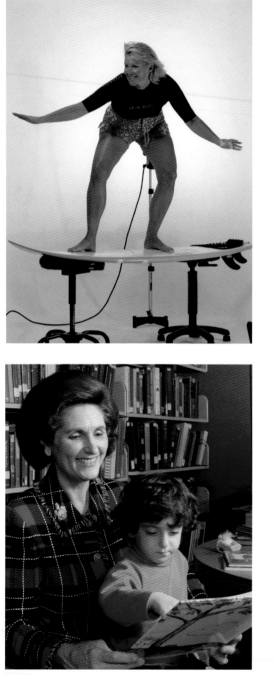

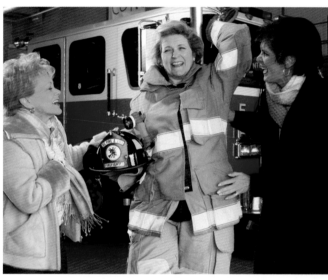

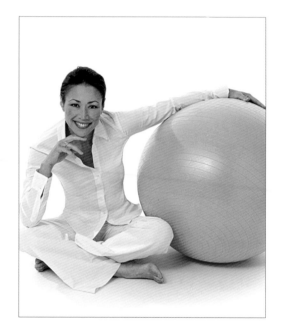

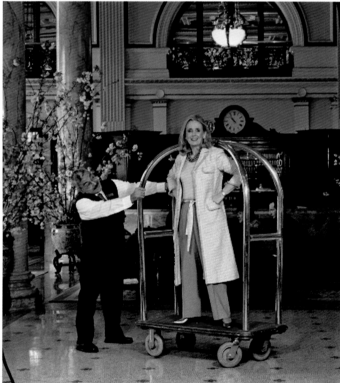

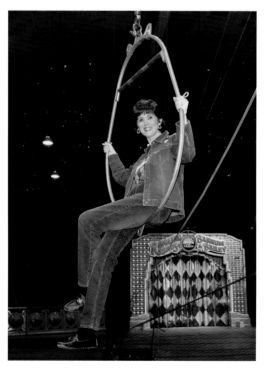

136

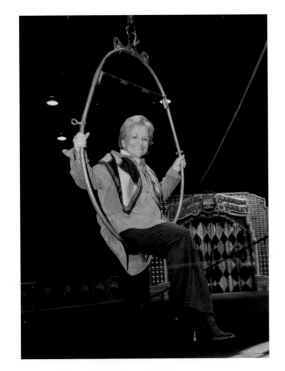
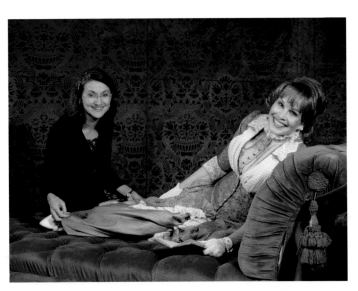
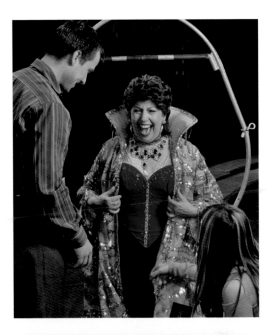
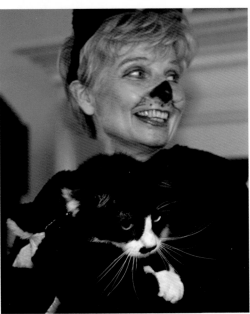

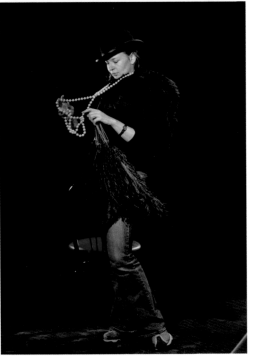

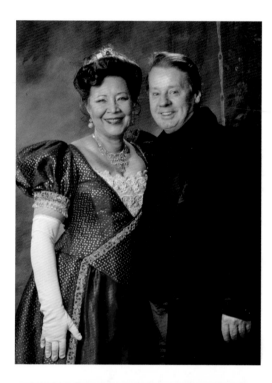

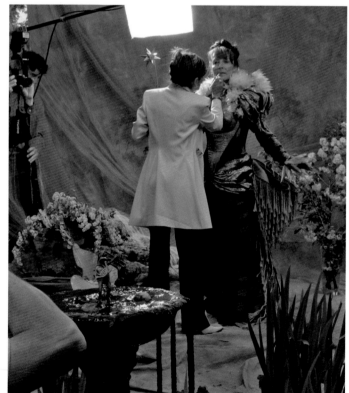

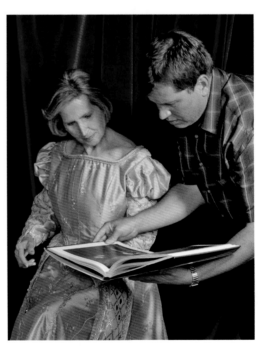

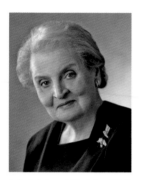

Madeleine Albright, PhD,
18

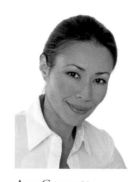

Debbie Allen, 36

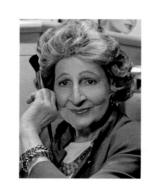

Letitia Baldrige, 62

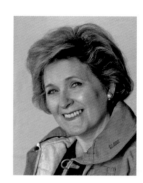

Gail Berendzen, 88

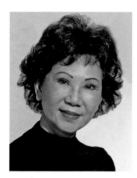

Jackie Bong-Wright,
28

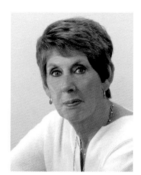

Sarah Brady, 48

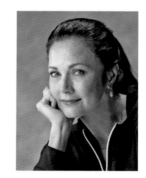

Lynda Carter, 34

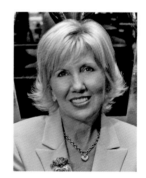

Nancy Chistolini, 120

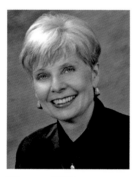

Eleanor Clift, 90

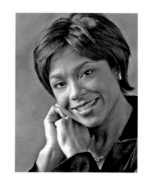

Ann Curry, 32

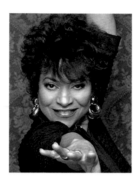

Dominique Dawes, 40

Debbie Dingell, 94

140

Claire Dratch, 124

Suzanne Farrell, 68

Betty Friedan, 72

Alma Gildenhorn, 118

Nesse Godin, 92

Denyce Graves, 24

Phyllis Greenberger,
44

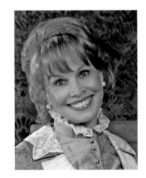

Ann Hand, 112

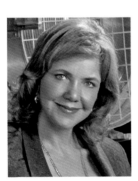

Barbara Harrison, 108

Bernadine Healy, MD
80

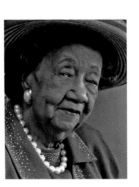

Dorothy Height, PhD,
52

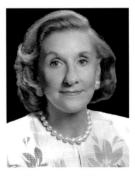

Wilhelmina Cole
Holladay, 102

Cathy Hughes, 22

Maxine Isaacs, 106

Dr. Charlene Drew
Jarvis, PhD, 116

Marie Johns, 96

Kitty Kelly, 54

Charito Kruvant, 100

Abbe Lane, 26

Jo Carole Lauder, 42

Dina Merrill, 82

Eleanor Merrill, 114

Senator Barbara
Mikulski, 78

Leslie Milk, 104

Ambassador Connie
Morella, 74

Soledad O'Brien, 16

Laney K. Oxman, 86

Nora Pouillon, 70

Alma Johnson Powell,
14

Sally Quinn, 122

Diane Rehm, 50

Catherine Reynolds,
58

Phyllis Richman, 66

Wendy Rieger, 46

Joan Rivers, 60

Lynda Johnson Robb,
30

Cokie Roberts, 76

Senator Ida G. Ruben, 126

Pat Schroeder, 38

The Honorable Carol Schwartz, 128

Ellen Sigal, PhD, 20

Sally Smith, 56

Helen Thomas, 84

Judith Viorst, 110

Judy Woodruff, 64

Joy Zinoman, 98

MA JOHNSON POWELL · SOLEDAD O'BRIEN · MADELEINE ALBRIGHT · ELLEN SIGAL · CATHY HUGHES · DENYCE GRAVES · ABBE LANE · JACKIE BONG-WRIGHT · LYNDA JOHNSON ROBB ·
GHT · KITTY KELLEY · SALLY SMITH · CATHERINE REYNOLDS · JOAN RIVERS · LETITIA BALDRIDGE · JUDY WOODRUFF · PHYLLIS RICHMAN · SUZANNE FARRELL · NORA POUILLON · BET
DEBBIE DINGELL · MARIE JOHNS · JOY ZINOMAN · CHARITO KRUVANT · WILHELMINA COLE HOLLADAY · LESLIE MILK · MAXINE ISAACS · BARBARA HARRISON · JUDITH VIORST · ANN HA
RIEN · MADELEINE ALBRIGHT · ELLEN SIGAL · CATHY HUGHES · DENYCE GRAVES · ABBE LANE · JACKIE BONG-WRIGHT · LYNDA JOHNSON ROBB · ANN CURRY · LYNDA CARTER · DE
TH · CATHERINE REYNOLDS · JOAN RIVERS · LETITIA BALDRIDGE · JUDY WOODRUFF · PHYLLIS RICHMAN · SUZANNE FARRELL · NORA POUILLON · BETTY FRIEDAN · CONNIE MORELLA ·
OY ZINOMAN · CHARITO KRUVANT · WILHELMINA COLE HOLLADAY · LESLIE MILK · MAXINE ISAACS · BARBARA HARRISON · JUDITH VIORST · ANN HAND · ELEANOR MERRILL · CHARLE
EN SIGAL · CATHY HUGHES · DENYCE GRAVES · ABBE LANE · JACKIE BONG-WRIGHT · LYNDA JOHNSON ROBB · ANN CURRY · LYNDA CARTER · DEBBIE ALLEN · PATRICIA SCHROEDER ·
ERS · LETITIA BALDRIDGE · JUDY WOODRUFF · PHYLLIS RICHMAN · SUZANNE FARRELL · NORA POUILLON · BETTY FRIEDAN · CONNIE MORELLA · COKIE ROBERTS · BARBARA MIKULSKI
WILHELMINA COLE HOLLADAY · LESLIE MILK · MAXINE ISAACS · BARBARA HARRISON · JUDITH VIORST · ANN HAND · ELEANOR MERRILL · CHARLENE DREW JARVIS · ALMA GILDENHORN
NYCE GRAVES · ABBE LANE · JACKIE BONG-WRIGHT · LYNDA JOHNSON ROBB · ANN CURRY · LYNDA CARTER · DEBBIE ALLEN · PATRICIA SCHROEDER · DOMINIQUE DAWES · JO CAROL
Y WOODRUFF · PHYLLIS RICHMAN · SUZANNE FARRELL · NORA POUILLON · BETTY FRIEDAN · CONNIE MORELLA · COKIE ROBERTS · BARBARA MIKULSKI · BERNADINE HEALY · DINA ME
ESLIE MILK · MAXINE ISAACS · BARBARA HARRISON · JUDITH VIORST · ANN HAND · ELEANOR MERRILL · CHARLENE DREW JARVIS · ALMA GILDENHORN · NANCY CHISTOLINI · SALLY QU
ONG-WRIGHT · LYNDA JOHNSON ROBB · ANN CURRY · LYNDA CARTER · DEBBIE ALLEN · PATRICIA SCHROEDER · DOMINIQUE DAWES · JO CAROLE LAUDER · PHYLLIS GREENBERGER ·
UZANNE FARRELL · NORA POUILLON · BETTY FRIEDAN · CONNIE MORELLA · COKIE ROBERTS · BARBARA MIKULSKI · BERNADINE HEALY · DINA MERRILL · HELEN THOMAS · LANEY OX
BARA HARRISON · JUDITH VIORST · ANN HAND · ELEANOR MERRILL · CHARLENE DREW JARVIS · ALMA GILDENHORN · NANCY CHISTOLINI · SALLY QUINN · CLAIRE DRATCH · IDA RUBEN
I ROBB · ANN CURRY · LYNDA CARTER · DEBBIE ALLEN · PATRICIA SCHROEDER · DOMINIQUE DAWES · JO CAROLE LAUDER · PHYLLIS GREENBERGER · WENDY RIEGER · SARAH BRADY
JILLON · BETTY FRIEDAN · CONNIE MORELLA · COKIE ROBERTS · BARBARA MIKULSKI · BERNADINE HEALY · DINA MERRILL · HELEN THOMAS · LANEY OXMAN · GAIL BERENDZEN · ELL
RST · ANN HAND · ELEANOR MERRILL · CHARLENE DREW JARVIS · ALMA GILDENHORN · NANCY CHISTOLINI · SALLY QUINN · CLAIRE DRATCH · IDA RUBEN · CAROL SCHWARTZ · ALM
DA CARTER · DEBBIE ALLEN · PATRICIA SCHROEDER · DOMINIQUE DAWES · JO CAROLE LAUDER · PHYLLIS GREENBERGER · WENDY RIEGER · SARAH BRADY · DIANE REHM · DOROTHY H
NNIE MORELLA · COKIE ROBERTS · BARBARA MIKULSKI · BERNADINE HEALY · DINA MERRILL · HELEN THOMAS · LANEY OXMAN · GAIL BERENDZEN · ELEANOR CLIFT · NESSE GODIN · D
RRILL · CHARLENE DREW JARVIS · ALMA GILDENHORN · NANCY CHISTOLINI · SALLY QUINN · CLAIRE DRATCH · IDA RUBEN · CAROL SCHWARTZ · ALMA JOHNSON POWELL · SOLEDAD O
RICIA SCHROEDER · DOMINIQUE DAWES · JO CAROLE LAUDER · PHYLLIS GREENBERGER · WENDY RIEGER · SARAH BRADY · DIANE REHM · DOROTHY HEIGHT · KITTY KELLEY · SALLY SMI
ARBARA MIKULSKI · BERNADINE HEALY · DINA MERRILL · HELEN THOMAS · LANEY OXMAN · GAIL BERENDZEN · ELEANOR CLIFT · NESSE GODIN · DEBBIE DINGELL · MARIE JOHNS · JO
LMA GILDENHORN · NANCY CHISTOLINI · SALLY QUINN · CLAIRE DRATCH · IDA RUBEN · CAROL SCHWARTZ · ALMA JOHNSON POWELL · SOLEDAD O'BRIEN · MADELEINE ALBRIGHT · E
VES · JO CAROLE LAUDER · PHYLLIS GREENBERGER · WENDY RIEGER · SARAH BRADY · DIANE REHM · DOROTHY HEIGHT · KITTY KELLEY · SALLY SMITH · CATHERINE REYNOLDS · JOAN
E HEALY · DINA MERRILL · HELEN THOMAS · LANEY OXMAN · GAIL BERENDZEN · ELEANOR CLIFT · NESSE GODIN · DEBBIE DINGELL · MARIE JOHNS · JOY ZINOMAN · CHARITO KRUVA
STOLINI · SALLY QUINN · CLAIRE DRATCH · IDA RUBEN · CAROL SCHWARTZ · ALMA JOHNSON POWELL · SOLEDAD O'BRIEN · MADELEINE ALBRIGHT · ELLEN SIGAL · CATHY HUGHES ·
LLIS GREENBERGER · WENDY RIEGER · SARAH BRADY · DIANE REHM · DOROTHY HEIGHT · KITTY KELLEY · SALLY SMITH · CATHERINE REYNOLDS · JOAN RIVERS · LETITIA BALDRIDGE
EN THOMAS · LANEY OXMAN · GAIL BERENDZEN · ELEANOR CLIFT · NESSE GODIN · DEBBIE DINGELL · MARIE JOHNS · JOY ZINOMAN · CHARITO KRUVANT · WILHELMINA COLE HOLLA
IRE DRATCH · IDA RUBEN · CAROL SCHWARTZ · ALMA JOHNSON POWELL · SOLEDAD O'BRIEN · MADELEINE ALBRIGHT · ELLEN SIGAL · CATHY HUGHES · DENYCE GRAVES · ABBE LANE ·
GER · SARAH BRADY · DIANE REHM · DOROTHY HEIGHT · KITTY KELLEY · SALLY SMITH · CATHERINE REYNOLDS · JOAN RIVERS · LETITIA BALDRIDGE · JUDY WOODRUFF · PHYLLIS RICH
· BERENDZEN · ELEANOR CLIFT · NESSE GODIN · DEBBIE DINGELL · MARIE JOHNS · JOY ZINOMAN · CHARITO KRUVANT · WILHELMINA COLE HOLLADAY · LESLIE MILK · MAXINE ISAACS
WARTZ · ALMA JOHNSON POWELL · SOLEDAD O'BRIEN · MADELEINE ALBRIGHT · ELLEN SIGAL · CATHY HUGHES · DENYCE GRAVES · ABBE LANE · JACKIE BONG-WRIGHT · LYNDA JOHNSO
OROTHY HEIGHT · KITTY KELLEY · SALLY SMITH · CATHERINE REYNOLDS · JOAN RIVERS · LETITIA BALDRIDGE · JUDY WOODRUFF · PHYLLIS RICHMAN · SUZANNE FARRELL · NORA POL
SE GODIN · DEBBIE DINGELL · MARIE JOHNS · JOY ZINOMAN · CHARITO KRUVANT · WILHELMINA COLE HOLLADAY · LESLIE MILK · MAXINE ISAACS · BARBARA HARRISON · JUDITH VIOR
· SOLEDAD O'BRIEN · MADELEINE ALBRIGHT · ELLEN SIGAL · CATHY HUGHES · DENYCE GRAVES · ABBE LANE · JACKIE BONG-WRIGHT · LYNDA JOHNSON ROBB · ANN CURRY · LYND,
EY · SALLY SMITH · CATHERINE REYNOLDS · JOAN RIVERS · LETITIA BALDRIDGE · JUDY WOODRUFF · PHYLLIS RICHMAN · SUZANNE FARRELL · NORA POUILLON · BETTY FRIEDAN · CO
· MARIE JOHNS · JOY ZINOMAN · CHARITO KRUVANT · WILHELMINA COLE HOLLADAY · LESLIE MILK · MAXINE ISAACS · BARBARA HARRISON · JUDITH VIORST · ANN HAND · ELEAN
DELEINE ALBRIGHT · ELLEN SIGAL · CATHY HUGHES · DENYCE GRAVES · ABBE LANE · JACKIE BONG-WRIGHT · LYNDA JOHNSON ROBB · ANN CURRY · LYNDA CARTER · DEBBIE ALLEN ·
HERINE REYNOLDS · JOAN RIVERS · LETITIA BALDRIDGE · JUDY WOODRUFF · PHYLLIS RICHMAN · SUZANNE FARRELL · NORA POUILLON · BETTY FRIEDAN · CONNIE MORELLA · COKIE R
OMAN · CHARITO KRUVANT · WILHELMINA COLE HOLLADAY · LESLIE MILK · MAXINE ISAACS · BARBARA HARRISON · JUDITH VIORST · ANN HAND · ELEANOR MERRILL · CHARLENE

Treating Pneumonia

Pneumonia can be treated in a variety of ways. If the pneumonia is caused by **bacteria**, it can be treated with **antibiotics** (say an-TIE-buy-OT-iks). If the pneumonia is caused by a **virus**, antibiotics will not work. Viral pneumonia is treated by resting, taking drugs to reduce fever, and drinking plenty of liquids. This gives the body the best chance of fighting the disease. Babies and very old people who get pneumonia are often treated in the hospital.

Pneumonia Vaccine

There is a **vaccine** for pneumonia caused by one type of bacteria called *Streptococcus pneumoniae*. This vaccine is given to people who are most likely to be badly affected by pneumonia, including the very young, the very old, and people with breathing problems such as asthma.

Streptococcus pneumoniae (magnified here) is the bacteria that causes pneumonia.

Did You Know?

A person with pneumonia should rest in a sitting position, instead of lying down. This position helps clear the liquid from the lungs.

GLOSSARY WORDS

blood vessels	tubes, such as veins or arteries, which blood travels through
symptoms	signs that a person may be suffering from a particular disease or illness
bacteria	microscopic, single-celled living things
antibiotics	substances that can kill bacteria
virus	microscopic living particles that stop cells from working properly
vaccine	a small dose of a virus or bacteria injected into patients to help their bodies fight off disease

9

Poisons

Poisons are any substances that cause serious harm to humans, other animals, or plants.

Types of Poisons

There are many different poisonous substances that affect the body in different ways. A person can be poisoned by household chemicals such as medicines or cleaning products. They can also be poisoned by **venomous** animals and poisonous plants. Poisons can enter the body if a person breathes them in, eats them, absorbs them through the skin, or absorbs them in the bloodstream through a cut, bite, or sting.

Accidental Poisoning

Young children are most at risk for accidental poisoning, because they often learn about new things by playing with them or putting them in their mouths. If poisonous substances are left within reach of children, they may accidentally poison themselves. Different poisons work in different ways, so unless someone knows what poison a child has taken, it is difficult to know how to treat the child.

Household substances such as pesticides, bleach, and cleaning products can be poisonous.

HEALTH PROFESSIONALS: Toxicologists

Toxicologists study poisons and develop medicines and drugs to counteract them. They look at the way a poison works, the dosages that cause harm or death, and how to treat poisonings.

Toxins and Venoms

Toxins and venoms can both cause poisoning. Toxins are poisons produced by plants or animals. Some plants, such as foxglove and oleander, have toxins in their leaves. Some types of frogs secrete toxins from their skin. Venoms are poisons that are injected under the skin through bites or stings. Some animals, such as spiders and snakes, produce venom which they inject when they bite. Jellyfish have poisonous stinging cells that inject venom.

The box jellyfish produces the most deadly animal venom in the world.

Treating Poisonings

Many countries have a special phone number to call if a person has been poisoned. Trained people answer the phone and ask questions to try to find out what poison might be involved, so they can advise what to do next. If the poisoned person is very ill, an ambulance should be called.

GLOSSARY WORD

venomous producing a type of poison called venom

Quarantine

Quarantine (say khwor-UHN-teen) is when humans, other animals, or plants are placed in **isolation** to stop the spread of disease.

Preventing the Spread of Disease

Quarantine has been used to prevent the spread of disease for hundreds of years. Since ancient times, people have known that some diseases are infectious and can easily spread from person to person. Today, people travel between countries much more than in the past. Most countries ask that people do not travel if they have an **infectious disease**. In some countries, government officials can detain people and quarantine them if they may be carrying a contagious disease.

Quarantine during the Black Death

In the 1300s and 1400s, there was an outbreak of a contagious disease called the Black Death. In some cities, if a ship arrived it had to stay out at sea for 30 or 40 days before anyone could come ashore. After that time, the ship could land only if there was no sign of the Black Death in any of the passengers or sailors.

In the late nineteenth and early twentieth centuries, migrants arriving in New York were kept in quarantine at Ellis Island, off the coast of New York.

Did You Know?

The word "quarantine" comes from the Italian word *quarantena*, which means "forty-day period."

Quarantine Laws

Many countries have strict quarantine laws. Animals that come to these countries are kept in quarantine to make sure that they are healthy. People traveling to these countries are not allowed to bring meat, cheese, eggs, and other foods that could carry pests or diseases. Sick people are sometimes also quarantined. In 2009, people in many countries were quarantined for up to two weeks if they had swine flu or had come into contact with infected people. These quarantine measures helped slow the spread of swine flu while a vaccine was being developed.

Quarantine Inspectors

Government quarantine services are staffed by quarantine inspectors. They check baggage and explain quarantine laws to travelers. Some quarantine inspectors work with specially trained quarantine dogs.

Quarantine dogs, or detection dogs, are trained to sniff out illegal foods at airports and docks.

Did You Know?

The first astronauts to visit the Moon were quarantined in a special **laboratory** when they returned to Earth. This was to make sure that they did not carry any unknown diseases from the Moon.

GLOSSARY WORDS

isolation kept away from others
infectious disease disease that spreads easily from one person to another
laboratory a room in which scientists conduct experiments and research

A rash is any change in the appearance of the skin caused by an infection, an allergy, or a disease.

Types of Rashes

There are many types of rashes. Different rashes cause different **reactions** in the skin. Rashes may cause skin to:

- change color
- feel itchy, hot, or painful
- become bumpy
- become dry and cracked
- swell or develop blisters

Causes of Rashes

Rashes have many different causes. They can be a **symptom** of another disease, such as chicken pox or measles. Some rashes, such as hives and eczema, are caused by skin allergies. Rashes such as impetigo and ringworm are caused by skin infections. Other rashes can be caused by stress or anxiety.

This baby has a red rash on his face.

Did You Know?

People are allergic to urushiol (say yoo-ROO-shee-ol) oil, which is found in poison oak and poison ivy plants. Anyone who touches these plants will develop a rash.

Hives

Hives is a common rash that about one in six people will have at least once during their lives. People with hives develop round patches of red, itchy, swollen skin. The patches can develop anywhere on the body. As one red patch gets better another one forms, so hives can last for days or even weeks.

Hives can be caused by infections, medicines, insect bites, and food allergies. The body reacts by making more of a chemical called histamine (say hist-UH-meen), which causes the skin to become itchy and swollen.

Diaper Rash

Babies get diaper rash when they are left in wet or dirty diapers for too long. Germs on the baby's skin and in the diaper change the chemicals in urine into other chemicals, such as ammonia. These chemicals irritate babies' skin.

People with hives develop red, swollen patches on their skin and feel very itchy.

HEALTH PROFESSIONALS: Dermatologists

Dermatologists are doctors specially trained to **diagnose** and treat skin diseases such as rashes. They can treat rashes that cover the whole body and those that cover just one part of the skin.

GLOSSARY WORDS

reactions	responses or changes
symptom	a sign that a person may be suffering from a particular disease or illness
diagnose	decide whether someone has a disease by examining them

Relaxation

Relaxation is important to keep the mind and body healthy and to help people overcome stress.

The Benefits of Relaxation

Relaxation is an important part of a balanced lifestyle. When people are relaxed, their heart rate and blood pressure go down. They can concentrate and think clearly. If people are very relaxed, their brains starts making a chemical called serotonin (say ser-OH-tohn-IN), which makes them feel happy and contented. Being able to relax helps people to cope with stress.

Stress

Stress is the body's way of preparing to meet a challenge. A little bit of stress makes the brain more alert and able to cope with a difficult situation. Too much stress, however, can affect how a person copes with everyday situations. People suffering from stress may have difficulty sleeping, feel suddenly sad or angry, have frequent headaches and stomach aches, or feel anxious a lot of the time.

Relaxation is important for a healthy mind and body.

Did You Know?

Scientific studies have found that owning a dog or a cat can reduce stress and make a person feel more relaxed.

Ways to Relax

There are many different ways to relax. Some people might listen to music, go out with their friends, read a book, or play games to relax. Other people might have a massage to relax their muscles.

Meditation

Some people use meditation to relax. Meditation often involves concentrating on breathing, thoughts, and emotions. Scientific studies involving **brain scans** have shown that meditation has a relaxing effect on the brain.

Exercise

Many people relax by exercising. After people exercise, their muscles feel less tense and their brain produces chemicals called endorphins (say en-DAW-fihns), which dull pain and make people feel happy and relaxed. Yoga is one form of exercise that incorporates meditation and helps the brain produce endorphins.

Meditation is a form of relaxation.

Did You Know?

Acupuncture, a form of Chinese medicine where needles are inserted into the skin, assists the brain to produce endorphins.

GLOSSARY WORD

brain scans images of the brain, showing which parts are being used at certain times

Sanitation

Sanitation is the way in which people protect themselves from dangerous wastes that can cause disease.

Waste

For thousands of years, people have known that it can be very unhealthy when groups of people live together and produce large amounts of waste. There are many sources of waste that can cause disease, including:

- food wastes
- human **feces** and urine
- waste water from sinks, bathtubs, and showers
- waste from industries and farming

Sewage

Sewage is waste from toilets, sinks, bathtubs, showers, washing machines, and dishwashers. It can contain harmful **bacteria** that cause disease, or **nutrients** that help disease-causing bacteria grow. In cities, homes are connected to a system of pipes, called sewers, which take the sewage to a place where it is treated to make it safe. Sewage is treated by allowing good bacteria to "digest" the waste and break it down until it is harmless.

Sewage is treated at sewage treatment plants such as this.

Did You Know?

In the Middle Ages, some streets in towns were ankle-deep in feces and trash. At night, people went to the toilet in pots, and in the morning they tipped the contents of the pots into the street. These poor sanitation practices meant that many people became sick.

Garbage is collected and taken to dumps, where it can decompose away from people.

Garbage Collection

Garbage is collected to prevent the spread of disease. Food wastes attract pests, such as flies and rats, which carry disease. Trash and food wastes are usually sorted into bins and taken to garbage dumps, where they can **decompose**. Some food wastes can be put into a compost bin, where they rot and turn into a rich soil that can be used on the garden.

Natural Disasters

When natural disasters occur, services often break down, resulting in poor sanitation. During floods and earthquakes, sewage systems are often destroyed and garbage cannot be collected. Disease often spreads quickly because there is no clean drinking water, and disease-causing bacteria can grow in uncollected wastes.

John Harrington (1561–1612)

British author John Harrington is believed to have invented the first flushing toilet. His godmother was Queen Elizabeth I, and he made one for her and one for himself.

GLOSSARY WORDS

feces	waste material that comes from the intestines
bacteria	microscopic, single-celled living things
nutrients	substances that help something to survive and grow
decompose	rot or break down

Skin

The skin is the body's largest organ. It acts as a protective barrier and helps control the body's temperature. It is an important sense organ.

Layers of the Skin

The skin has three layers.

- The top layer, or epidermis, makes new skin cells to replace the dead skin cells that flake off.
- The middle layer, or dermis, contains millions of nerve cells that sense touch, pain, pressure, and heat. It also contains sweat **glands**, hair **follicles**, and oil glands.
- The bottom layer, or subcutaneous (say sub-kyu-TAY-ne-yus) fat, helps keep the body warm and absorb shocks.

epidermis

dermis

subcutaneous fat

sweat gland

hair follicle

fat cells

Each 1/6th of a square inch (1 sq cm) piece of skin contains about 3 million cells, 100 sweat glands, 13 feet (4 m) of nerves, 150 nerve endings, 10 hairs, 10 oil glands and 3 feet (1 m) of blood vessels.

Goose Bumps and Sweat

When people are cold, they may get goose bumps. Tiny muscles pull on the hairs in the skin, making them stand up very straight. This traps warm air between the hairs. When a person is hot, the **blood vessels** in the skin get wider so that more blood gets to the surface of the skin, where it can cool off. The sweat glands make a lot of sweat, which cools the skin as it evaporates. Sweat also contains germ-killing chemicals.

Did You Know?

The skin replaces between 30,000 and 40,000 dead skin cells every day.

Skin Color

Melanocytes (say mel-A-no-SITES) are cells in the epidermis that make a brown coloring called melanin. The more melanocytes a person has, the darker his or her skin will be. Melanin is a natural sunblock that helps filter out ultraviolet (UV) rays from the sun. If a person goes out into the sun, the melanocytes make more melanin. UV rays can cause damage to all types of skin, even those with lots of melanin. People should always wear sunblock when in the sun.

People have different colored skin because their bodies make different amounts of melanin.

HEALTH PROFESSIONALS: Plastic Surgeons

Plastic surgeons operate on skin to correct skin problems such as burns, scars, and birth defects. The word "plastic" comes from the Greek *plastikos*, meaning "to mold or shape."

GLOSSARY WORDS

glands	organs or cells that filter bacteria from the blood
follicles	small holes in the skin from which hair grows
blood vessels	tubes, such as veins or arteries, which blood travels through

Sleep

Sleep is a normal part of the body's daily cycle.
Regular sleep is needed to keep the body healthy.

Stages of Sleep

There are different stages of sleep, and in each stage the brain behaves differently. The first stage is light sleep. During light sleep people sometimes have sudden twitching movements. Sleepers gradually move from light sleep into deep sleep, and some people "sleep talk" during this stage. Eventually, they move into rapid eye movement (REM) sleep. This is the stage where body repair and growth happen. Dreams also occur in REM sleep. Each night, a person goes through these stages over and over.

Amounts of Sleep

People need different amounts of sleep at different times in their lives. Newborn babies need about 16 hours of sleep each day. Children and most adults need about seven or eight hours each night, while teenagers need nine or ten hours. Older people may need only five or six hours of sleep each night.

The body grows and recovers during REM sleep, so this type of sleep is especially important for mental and physical health.

Did You Know?

People's sense of smell partially shuts down while they are asleep. This is one reason why it is important to have **smoke detectors** in the home, close to bedrooms.

Insomnia

Insomnia is when a person has trouble falling asleep or staying asleep. It can be caused by many things, including stress, sleeping in a different bed, or taking certain drugs. To help prevent insomnia, people should not take afternoon naps or consume drinks such as coffee close to bedtime. Exercising during the day may also help some people sleep at night.

Snoring and Sleep Apnea

During sleep, the muscles in the back of the throat relax and **vibrate** as a person breathes, making a noise called snoring. Sleep apnea occurs when the walls of the throat collapse and block the airway. The person stops breathing for up to a minute, before the brain wakes the person, so he or she begins breathing again. This can happen many times during the night, causing unsettled sleep.

Sleep apnea sufferers can use the nasal continuous positive airway pressure system (NCPAP) to help them breathe while they sleep.

Colin Sullivan (1945–)

In 1980, Australian doctor Colin Sullivan invented the nasal continuous positive airway pressure system (NCPAP). This is a mask and pump that people with severe sleep apnea (say ap-NEE-ah) can wear at night to help with breathing.

GLOSSARY WORDS

smoke detectors	devices that respond to smoke and sound an alarm
vibrate	shake uncontrollably

Smoking

Smoking cigarettes is an addictive habit that can be very difficult to break.

Tobacco

Tobacco smoke contains a mixture of harmful chemicals, including tar, nicotine, carbon monoxide, ammonia, and arsenic. When people start smoking, they soon become addicted to nicotine. Their bodies feel the need for regular doses, so they begin to smoke cigarettes regularly.

Smoking-related Diseases

Smoking causes many different diseases. More than 50 of the chemicals in tobacco smoke are known to cause cancer, including lung, tongue, throat, and stomach cancer. Smoking also causes damage to the heart and **blood vessels**. Nicotine increases the buildup of fatty **plaque** in the blood vessels, which can lead to high blood pressure and heart disease. Smoking also damages blood vessels.

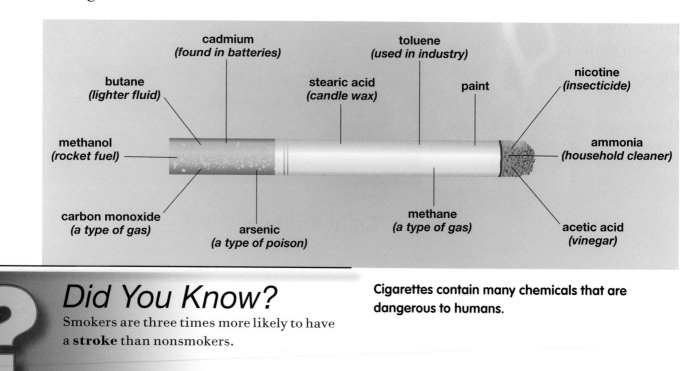

cadmium
(found in batteries)

toluene
(used in industry)

butane
(lighter fluid)

stearic acid
(candle wax)

paint

nicotine
(insecticide)

methanol
(rocket fuel)

ammonia
(household cleaner)

carbon monoxide
(a type of gas)

arsenic
(a type of poison)

methane
(a type of gas)

acetic acid
(vinegar)

Cigarettes contain many chemicals that are dangerous to humans.

Did You Know?

Smokers are three times more likely to have a **stroke** than nonsmokers.

Passive Smoking

Passive smoking occurs when a person breathes in tobacco smoke from other people's cigarettes, or secondhand smoke. Although it is not as harmful as smoking a cigarette, it can still cause health problems. Many countries have banned smoking in offices, restaurants, and on public transportation so that nonsmokers do not have to breathe secondhand smoke.

Quitting Smoking

Because nicotine is addictive, it is hard for many smokers to quit smoking. Smokers who quit have **withdrawal symptoms** such as poor sleep, headaches, food cravings, anxiety, and restlessness. It takes several weeks for these side effects to stop. Some people use nicotine patches, which deliver small amounts of nicotine to the body through the skin, to help them quit smoking. Many smokers try to quit several times before they are successful.

Nicotine patches come in packs, and different patches have different amounts of nicotine. People use the patches to gradually quit smoking, as they slowly move from stronger to weaker patches.

Did You Know?

Tobacco smoke contains more than 4,000 chemicals, many of which are poisonous.

GLOSSARY WORDS

blood vessels	tubes, such as veins or arteries, which blood travels through
plaque	buildup of cholesterol and fatty material within a blood vessel
stroke	brain damage that occurs when blood flow to the brain is reduced or blocked
withdrawal symptoms	physical and mental symptoms a person gets when they are trying to stop using a drug

Stomach

The stomach is part of the **digestive system**. It churns food and mixes it with **gastric juice**.

How the Stomach Works

When food is swallowed, it travels down the **esophagus** (say uh-SOF-uh-GUS) to the stomach. The stomach is a muscular bag that stretches as a person eats more food. There is a circular muscle called a sphincter at the top of the stomach, and this stops food from traveling back up toward the mouth. The food stays in the stomach for about three hours, and then it is squeezed through another sphincter into the first part of the intestines.

Gastric Juice

Gastric juice is a strong acid that helps to break down food and kill germs that might be in food. It contains chemicals called enzymes, hydrochloric acid, and **mucus**. The mucus protects the stomach from the strong acid. The stomach begins to make gastric juice when a person puts food in his or her mouth, and it makes more when the food reaches the stomach.

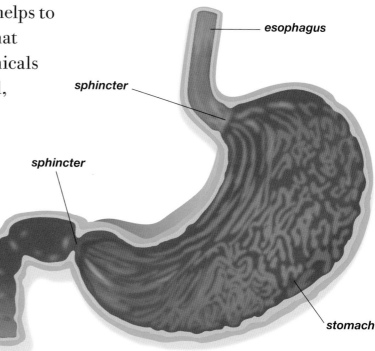

esophagus

sphincter

sphincter

stomach

The stomach plays a key role in the body's digestive system.

Did You Know?

The lining of the stomach contains special cells that neutralize the acid in the stomach so that it does not digest itself.

Indigestion

Indigestion, which is sometimes called an upset stomach or dyspepsia (say dis-PEP-see-uh), is a burning feeling in the chest. It sometimes makes people burp a lot or feel like vomiting. Indigestion occurs when the contents of the stomach squeeze back up into the esophagus. This is called reflux. The burning feeling is quite close to the heart, so some people call it heartburn, even though it has nothing to do with the heart. Indigestion can be caused by stress, some diseases, eating too much too quickly, and allergies to certain foods.

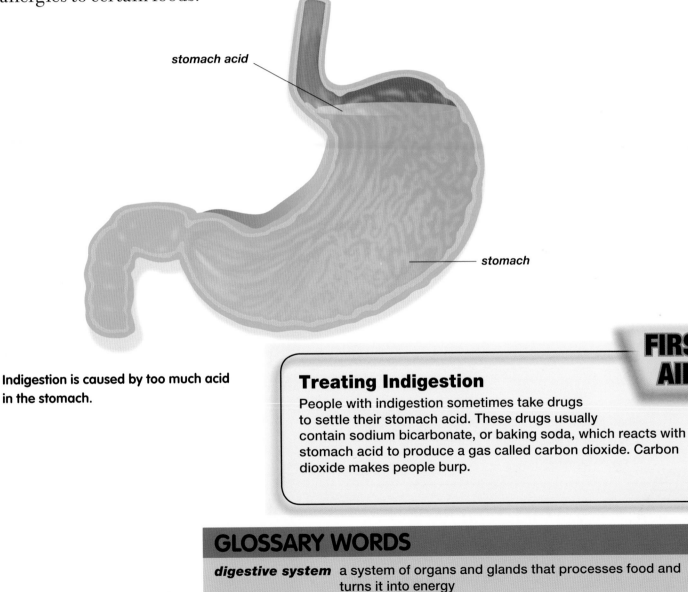

stomach acid

stomach

Indigestion is caused by too much acid in the stomach.

FIRST AID ✛

Treating Indigestion

People with indigestion sometimes take drugs to settle their stomach acid. These drugs usually contain sodium bicarbonate, or baking soda, which reacts with stomach acid to produce a gas called carbon dioxide. Carbon dioxide makes people burp.

GLOSSARY WORDS

digestive system	a system of organs and glands that processes food and turns it into energy
gastric juice	a fluid made by the stomach to help with digestion
esophagus	a passage in the throat that food travels down to enter the stomach
mucus	a thick, slimy body fluid

27

Sunlight

Sunlight keeps the body healthy, but too much can damage the skin.

Ultraviolet Light

Sunlight is made up of the light that humans can see and invisible light, including ultraviolet (UV) light. There are different types of ultraviolet light in sunlight, including ultraviolet A (UVA) and ultraviolet B (UVB).

Vitamin D and Sunlight

The skin produces vitamin D when it is exposed to the UVB rays in sunlight. Vitamin D is essential for strong bones, and it also helps keep the **immune system** healthy. If people do not get enough sunlight, they could become unwell because their immune systems are weakened. A lack of vitamin D can also cause bone diseases such as rickets and osteoporosis (say ost-EE-oh-PUH-ro-SIS).

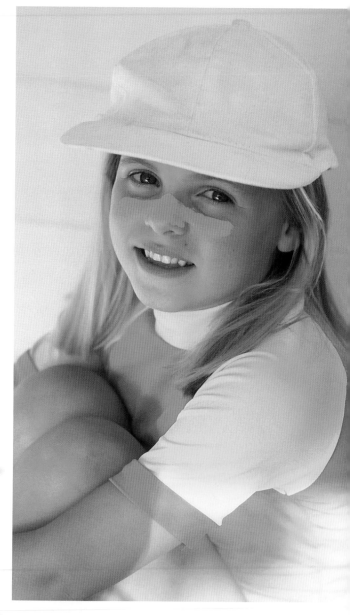

When people go out to play in the sun, they should remember to wear suitable clothing, hats, and sunblock to protect their skin.

Did You Know?

Some people take vitamin D tablets in winter when there is less daylight. This is because they do not get enough sunlight to make normal amounts of vitamin D.

Skin Cancer

Too much sunlight can damage skin, causing skin cancer. There are many types of skin cancer. Some skin cancers grow slowly while others grow quickly. In countries such as Australia, skin cancer is very common because it is very sunny, and people enjoy being outdoors.

Both UVA and UVB light can cause skin cancer. UV light can pass through clouds, so it can still damage skin on cloudy days. The best ways to protect skin from damage are to wear a hat, sunblock, and clothing, and to stay out of the sun in the middle of the day. Some skin cancers cannot be seen, so people who are at risk should have their skin checked by a **dermatologist** to look for early signs of skin cancer.

Skin cancer can look like dark, ugly patches on the surface of the skin.

Did You Know?

Tanning beds are places where people can go to get a tan, but the UV light in tanning beds is much more harmful than in sunlight.

GLOSSARY WORDS

immune system	a network of systems in the body that fights germs and diseases
dermatologist	a doctor trained to treat skin conditions and diseases

Surgery

Surgery is any medical operation performed by a surgeon. It usually involves cutting or repairing some part of the body.

Types of Surgery

People have emergency surgery to set broken bones and stitch up wounds after a serious accident. People have major surgery, such as heart bypass surgery, to mend or replace a part of the body that is diseased or has worn out. Major surgery can also remove cancerous parts of the body and prevent cancer from spreading. Sometimes people have exploratory surgery, in which the surgeon tries to find out if there is anything wrong.

Surgical Instruments

There are hundreds of different types of surgical instruments designed for different operations. These tools must be carefully **sterilized** between operations to prevent the spread of infection. They are carefully counted before and after surgery to make sure that they are not accidentally left inside a patient during an operation.

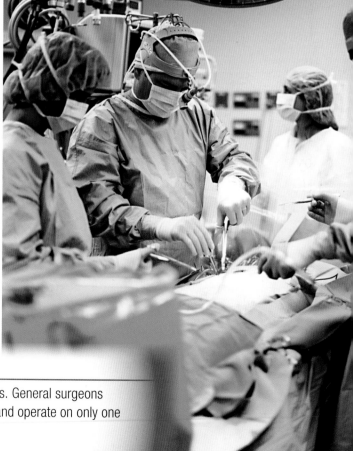

Surgeons operate to repair parts of the body.

HEALTH PROFESSIONALS: Surgeons

Surgeons are specially trained doctors who perform operations. General surgeons perform all types of operations. Other surgeons specialize in and operate on only one part of the body or one group of people, such as children.

Keyhole Surgery

Keyhole surgery is where the surgeon uses miniature video cameras, lights, and surgical instruments on flexible rods. The surgeon only makes a tiny cut and performs the operation by looking at the camera image on a monitor.

Stitches

At the end of an operation, stitches are used to sew up the cuts that the surgeon made. Absorbable stitches break down and are absorbed by the body, so they do not have to be taken out. They are usually used to stitch up wounds inside the body. Nonabsorbable stitches are usually used on the skin, and they have to be removed by a surgeon one or two weeks after the operation.

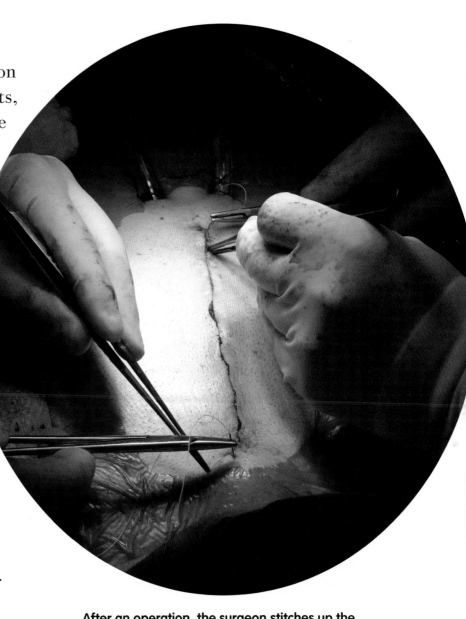

After an operation, the surgeon stitches up the wound so that it can heal.

Did You Know?

Absorbable stitches were originally made from sheep intestines, but they are now made from a type of plastic.

GLOSSARY WORD

sterilized cleaned thoroughly to remove all bacteria and germs

Index

Page references in bold indicate that there is a full entry for that topic.